VIETNAM WAR PORTRAITS

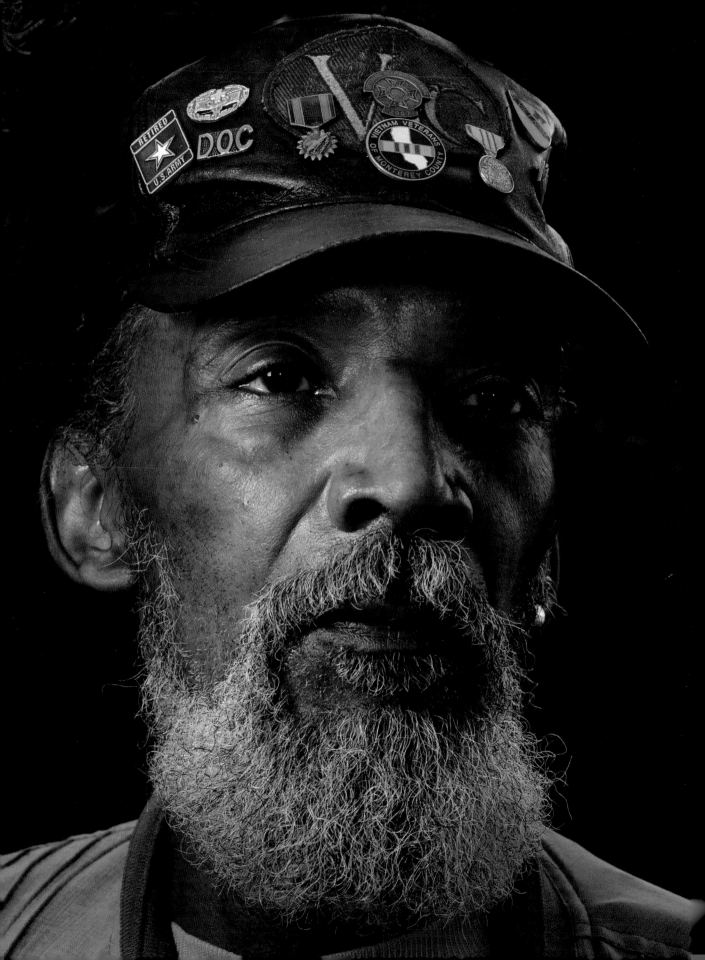

THOMAS SANDERS

VIETNAM WAR PORTRAITS
THE FACES AND VOICES

CASEMATE

Philadelphia & Oxford

Published in the United States of America and Great Britain in 2020 by
CASEMATE PUBLISHERS
1950 Lawrence Road, Havertown, PA 19083, USA
and
The Old Music Hall, 106–108 Cowley Road, Oxford OX4 1JE, UK

Hardcover Edition: ISBN 978-1-61200-703-8
Digital Edition: ISBN 978-1-61200-704-5

A CIP record for this book is available from the British Library

Typeset by Casemate Publishers

Printed and bound in India by Replika Press

For a complete list of Casemate titles, please contact:

CASEMATE PUBLISHERS (US)
Telephone (610) 853-9131
Fax (610) 853-9146
Email: casemate@casematepublishers.com
www.casematepublishers.com

CASEMATE PUBLISHERS (UK)
Telephone (01865) 241249
Email: casemate-uk@casematepublishers.co.uk
www.casematepublishers.co.uk

PAGE 2: ZEBEDEE WHINDLETON JR.

TO OSLA AND FIONA,
MAY YOU BOTH NOT FORGET OUR PAST AND
REPEAT ONLY THE GOOD FOR THE FUTURE

ACKNOWLEDGMENTS

Before thanking the people that helped me with this book, I must thank all Vietnam veterans for their sacrifice and courage.

To my editors, Ruth Sheppard and Lee Johnson, thank you so much for your hard work and understanding the importance of making sure the Vietnam veterans' voices were heard in this book. I know you both made many sacrifices while the book was being worked on and you have contributed to honoring and preserving history.

I want to give a very special thanks to Vietnam veterans Ernie Bergman, Paul Cox, and Ray Mullin for dedicating their time in helping me find Vietnam veterans and allowing me to use spaces to photograph veterans for my book.

I am truly grateful for San Jose State University, MFA program, and the San Jose State Strategic Communications and Marketing department in supporting my Vietnam veterans series while in grad school. I appreciate the support from my professors and colleagues in guiding me on continuing this body of work.

Thank you to the PR team at Casemate in making sure my book got the press and coverage needed.

To everyone at Casemate Publishers, who worked on the book that I have met and not met, I am appreciative of your efforts.

Thank you to my literary agent, Peter Beren, for your stoic wisdom.

Lena Tabori, if it was not for you giving me a chance on my first book, I am not sure I would be able to make this second book, a very sincere thank you.

To Belmont Village Senior Living, thank you for your continued support on supporting our ongoing veterans photo series and preserving our veterans.

And thank you to my wife for always being supportive and taking care of our gorgeous and intelligent girls on this adventurous journey.

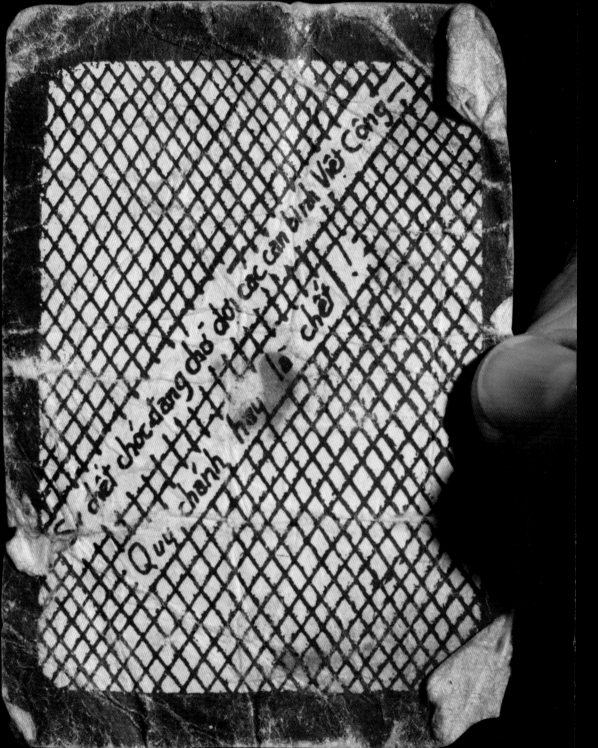

FOREWORD

There have been numerous books written about the Vietnam War, but not many in the veterans' own words. This book is an enlightening exception.

For many Vietnam veterans, myself included, it has been over 50 years since we left Vietnam. Many of us went peacefully into the night when we returned because no one wanted to hear our story. In more recent years the nation has begun to realize how badly we were treated, as compared to how they have received the veterans coming home from the wars in Iraq and Afghanistan. As a result, many Vietnam veterans have come out of the closet. Tom Sanders' book gives an opportunity for many of the varied participants in the Vietnam War to tell their stories.

The tales are as varied as the different people who went to Vietnam in service to their country. As Mr. Sanders has illuminated, the Vietnam War varied significantly depending upon the branch of service, activity, and year of service. I was also glad to see the inclusion of Vietnamese and those dealing with the aftermath of the war back home.

No one book can capture every angle of the Vietnam War, but this book gives us a good look back after the passage of time by those who were there. I thank Mr. Sanders for bringing us these voices.

JOHN ROWAN, PRESIDENT & CEO
VIETNAM VETERANS OF AMERICA

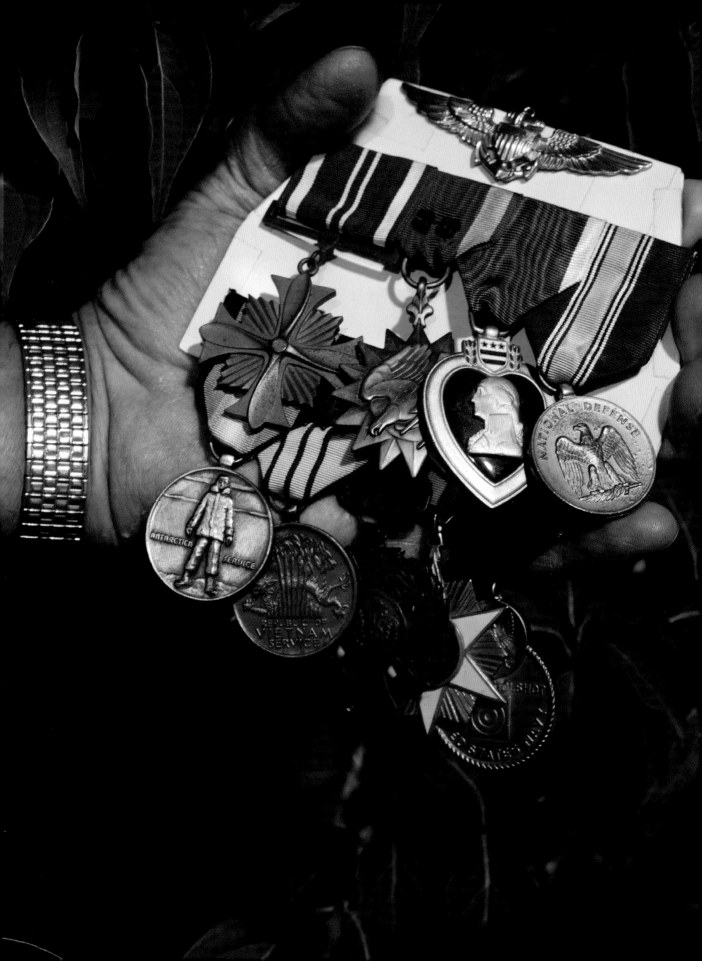

INTRODUCTION

When I started working on this Vietnam veteran book and photo series in grad school, one of my professors asked me why my series on these Vietnam veterans was important. There had been movies, songs, books ... all on the Vietnam war, what made my project different? I thought about this question for at least a year. Over time, history is told and retold, it is our responsibility to continue to ensure history is retold from a variety of perspectives, in order that the events of the past do not slide into obscurity and as a reminder not to repeat the bad things from history and repeat the good.

 This book is the first collection of modern-day Vietnam veteran portraits and their stories reflecting on their experiences and how it has affected them to this day. The experience of these men and women is in stark contrast to that of the thousands of World War II veterans I photographed and interviewed over the four-year making of my first book, *The Last Good War: The Faces and Voices of WWII*. World War II veterans came home glorified as heroes; Vietnam vets experienced a very different reception. This contrast in experiences between WWII and Vietnam veterans is what compelled me to do a book about Vietnam veterans, show how they made the same sacrifices, and are heroes just like WWII veterans.

 Some Vietnam veterans grew up hearing the heroic stories of WWII from their family, many of whom would have served themselves, and they wanted to volunteer to follow in their footsteps. Other veterans had no choice and were drafted. And some conscientious objectors left the country or served jail time. Almost all of the veterans in this book lost comrades. And when some of the veterans returned home, they did have things thrown at them. One veteran had a cup of coffee dumped on him while attending junior college. And some of the veterans were left alone, blended back into society, and protested the war.

 The portraits of the Vietnam veterans are in a surreal jungle environment. I want the viewer to feel the darkness and uncertainty of what those who experienced the war might have felt. In different scenes, the subject is holding an object that correlates to their role or experience during their time in the service. I included war objects by themselves to add nostalgia and mystery, and to further historically educate the viewer about the Vietnam War. The objects help tell a deeper story of a dark and confusing war: the common cigarette pack smoked by the vets while in the jungle, a grenade made by the northern Vietnamese made of a milk can, bamboo, a wick, fish hooks and screws, and a very real "order to report" document – a piece of paper that truly changed many a life.

 Involvement in this project has served as a form of catharsis for many people involved in the Vietnam War. It honors them in a way they have not previously been honored, giving them an opportunity to tell their story and bearing witness to their service, experiences, and its aftermath. Some of the vets share stories they have never even told their family.

 To all Vietnam veterans, thank you for your honor and sacrifice.

THOMAS SANDERS

was drafted into the Army in May of 1968. I was 21 years old and had quit college and lost my academic deferment. I did not want to go to Vietnam but I knew when I quit college in December of 1967 that I would eventually be drafted. Then Tet happened and I knew I would be drafted sooner. My first night in base camp I was given no instructions as to what I should do or expect. That night, there was machine-gun fire from some of the perimeter guard towers, and Cobra helicopters flying back and forth along the camp perimeter firing their mini-guns.These were electric-powered Gatling guns with every fifth round a tracer that glowed red. The miniguns fired so fast the tracer bullets made them look like they were firing laser beams.

In early July of '69 we conducted a multi-day recon mission during which all we found were the best tasting bananas I ever ate. I was troop point jeep driver as we lined up our vehicles on the dirt trail to go back to base camp. This was always a time to look forward to the hot meal, shower, and bed (with netting) that we would enjoy on our return. Sergeant Charles Smith's jeep pulled up beside me and told me to pull out of line and take his place as fourth jeep in the column. I didn't care—I thought he just wanted to avoid eating the dust of the jeeps ahead of him. However, he had a veteran replacement medic on his jeep who told Sgt. Smith about a short cut (that we already knew) so the sergeant agreed they should be the point jeep driving back to camp. I pulled out of line and when the order came to move out, I pulled back into the fourth spot. Not a minute later, we heard a muffled boom and saw a spinning black circular object fly high across the tree tops. Then our radio started blaring unrecognizable screaming. Our jeep commander got on the radio. He was told the point jeep had been destroyed by a command-detonated mine and all four occupants were killed. The black object was the point jeep. The two jeeps ahead of me raced to the front. I pulled off the road to my left and was told by the jeep commander to man our machine gun while he and our gunner sprinted to the front. The jeeps behind me alternated turning off the road right and left to form a defensive position. I crouched behind the .50 caliber machine gun and scanned the tree line. After what seemed like forever, I saw someone to my right coming toward me. Two soldiers appeared bearing a stretcher. They set the stretcher beside my jeep, saying "guard this body." It was Sergeant Charles Smith, lying face down. His back looked like he had been filleted from the base of his spine to the base of his skull. I was standing up in the back of the jeep looking for movement in the tree line. His mutilated body was in my vision for more than 20 minutes, but it seemed like hours. It was horrific. I do not remember anything after that until the next morning. In order to survive and continue to serve, I erased the memory. The replacement medic had only three weeks left in country. He had a baby daughter he had never seen. He was blown in half. The point jeep's gunner had both legs blown off at the hip joints. The gunner in the second jeep tried to get a tourniquet on his legs but there was nothing left of his legs to put it on. The driver (which should have been me) was blown over 100 yards into a tree line. It is also likely that the driver died from the blast or when he hit the ground. I have replayed the incident many, many times with the sergeant's body as vivid today as on that terrible day. I wonder "Why was I spared? Why did I live and four others die?" I know it is war, but the mental image and the pain remain.

My coming home was a shock. My parents met me at the airport at night in Indianapolis. I did not have a clue as to what was happening back in the States. It was night and we got in the car for a 30-minute ride home to Anderson. I had been home for about 15 minutes and got a phone call from Roger, my best friend and also a 'Nam combat vet. He asked what had been said in our car during the ride home. It was then I realized that not a word had been spoken, no questions had been asked. He said only that he would be over to pick me up in 10 minutes. He and another friend picked me up in Roger's Corvette, and I finally felt free. Of what, I don't know. I asked him how he knew I was home and he said my folks told him when I was due to arrive, and he kept driving by the house to see when I got there. He said he had the same silent ride home when he got back a year earlier and wanted to save me from his identical experience after his ride. I started to realize it would be weird for a while, but I had no idea what lay in store. My dad got me a job in an auto factory making lead acid batteries for cars. My workmates were young men so I felt pretty normal. We ate lunch in one of their cars. It was fun. But when I started to tell a funny story of one of my 'Nam experiences, there was no laughing. They just clammed up and looked down or away. I wondered what was happening but let it pass. When it happened again, I felt very confused but decided that I could not tell anyone that I didn't know well that I had been in Vietnam. Then one Veteran's Day, around 2005, when I worked at UCSF, a young woman came up to me and asked if I was a veteran. I looked at her suspiciously but said yes, and she said, "I want to thank you for your service, I look for a veteran to thank every Veteran's Day." I was stunned and almost cried, but managed a smile and quietly said a very sincere "Thank you so much" to her. Even now, I only mention Vietnam when I know I'm talking to other veterans.

It was only recently, talking to a non-veteran friend that's my age, that he explained how scared most young men were around the time of the war. The nightly news was frightening. They did not want to go to Vietnam. They did not know what to do or how to act around a Vietnam veteran. I now understand why my fellow workers responded the way they did. They were afraid of the war, not scared of me.

JERRY NEAL

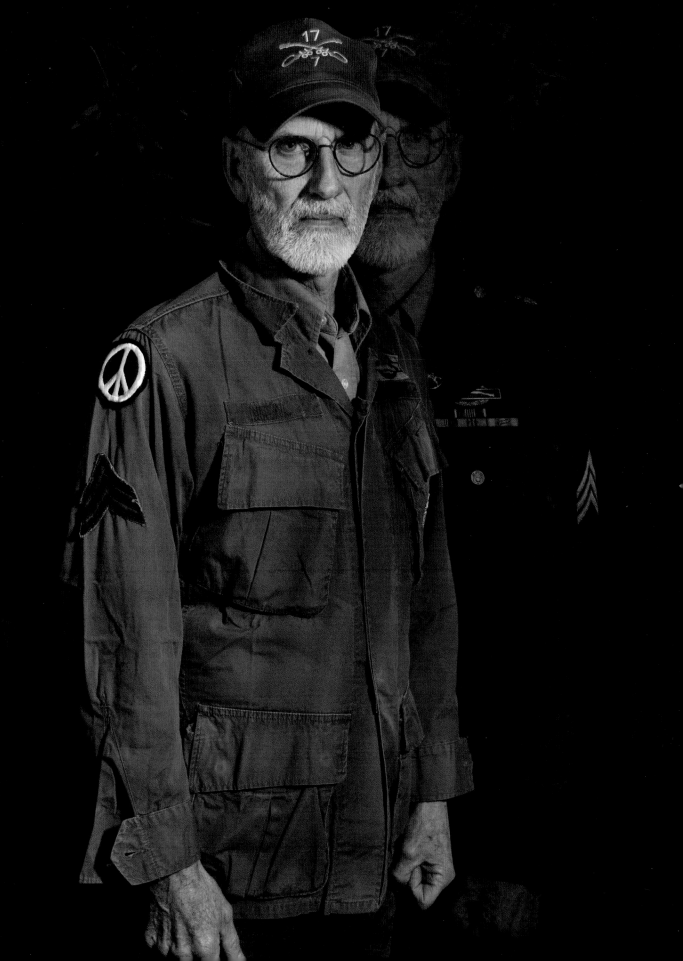

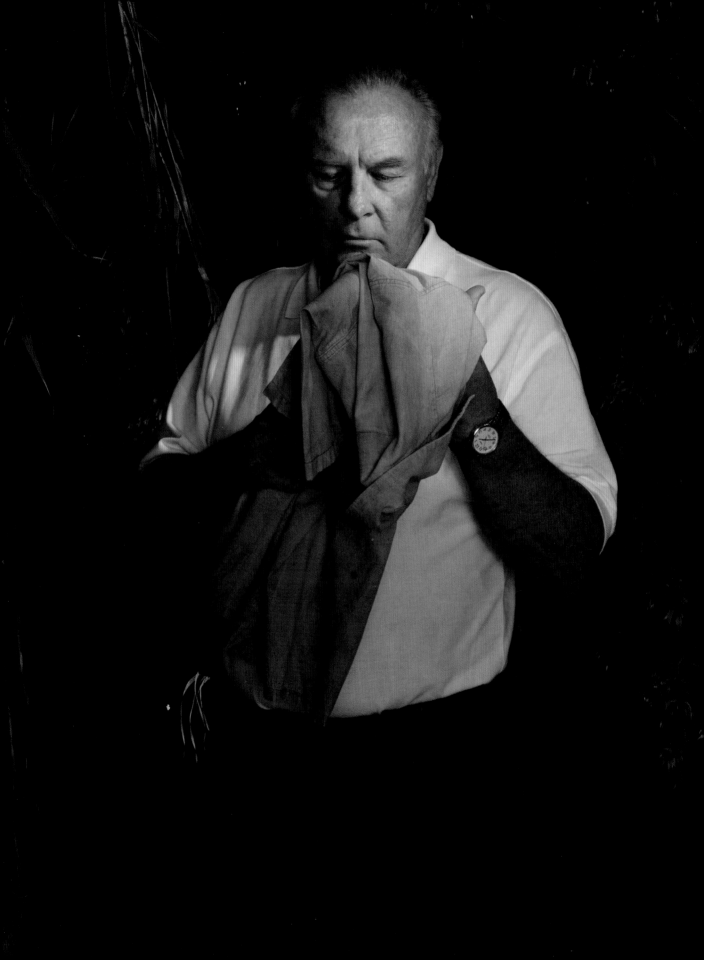

In 1965, shortly after turning 19, I volunteered for the US Navy. My Dad had been in the Navy during World War II and was at Pearl Harbor when the Japanese attacked on December 7, 1941. The day he took me to the bus stop to be picked up for boot camp, he looked at me, shook my hand and started to cry. I was joining the Navy during the Vietnam conflict and, as a veteran, he knew what might be in store for me.

I worked on aircraft at Cam Ranh Bay in Vietnam. During my second deployment, I moved every two weeks between three bases working on aircraft. My younger brother and I were serving "brother duty." He was on a flight crew and every time they told me to pack up and grab my tool box, that I was moving out of Vietnam, I knew my brother's plane and crew would be flying in.

MICHAEL SLATTENGREN

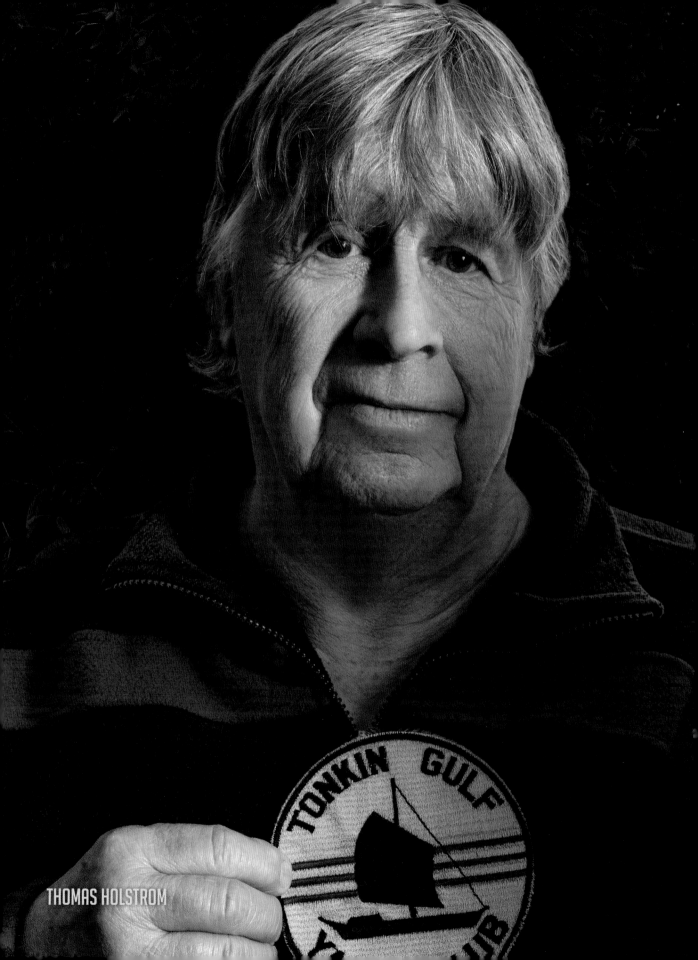

THOMAS HOLSTROM

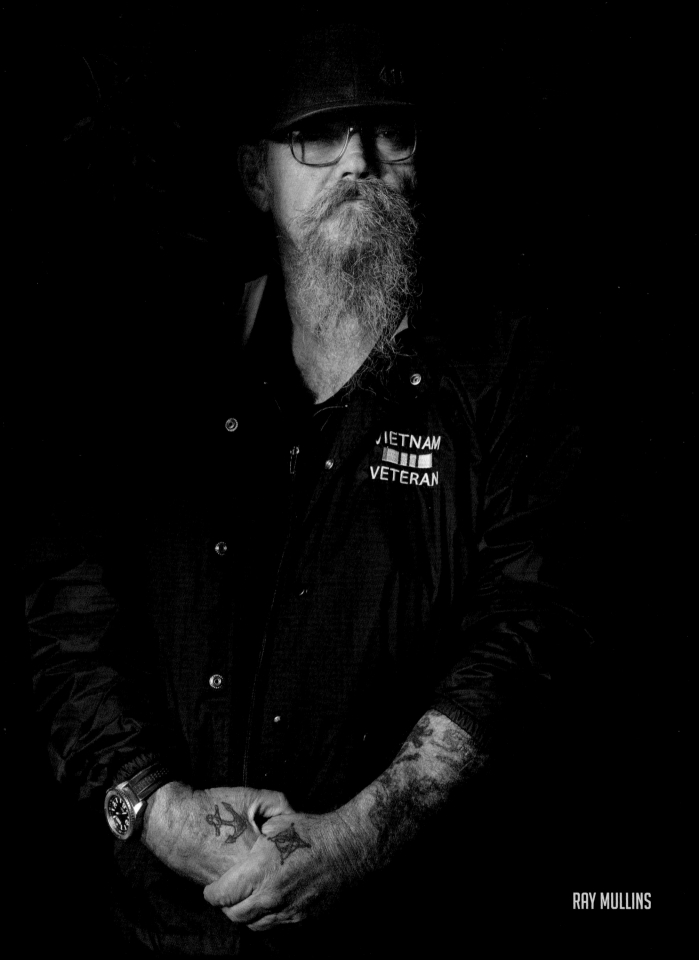

RAY MULLINS

My unit was Bravo Company, 1st Battalion, 5th Marines, 1st Marine Division, stationed at An Hoa Combat Base. My first night there, I am sent on a listening post. I am 18 years old and have to stay up all night surrounded by relentless NVA. This was my welcome to a hardcore Marine rifle company.

April 21, 1969, we were on a platoon-sized patrol. By this time, I was a PFC, machine gunner and team leader. I was in "Bush shape" meaning I could hump with ease and go without water. On this particular day, the weather was sweltering. We were on a trail when suddenly there was a big explosion, followed by machine-gun fire. I heard, "guns up, corpsman up" and all I wanted to do was turn and run. We charged forward and when we reached the front of the patrol there were several wounded and dead. After identifying the direction of the ambush, I began to return fire. By this time, it wasn't up to us what our fate would be, we just fought with all our might. Corpsman Robert Gillies was aiding wounded when he was shot in the jaw. He kept his cool as he was dying, he gave me a thumbs up. We had five dead and two wounded by the time the medevac arrived. It was shot down so we called in close air support from F-4 Phantoms to drop 500lb bombs. Marine Cobra gunships were also used to provide air support—this marked the first use of the Cobra by Marines. While still under relentless enemy fire and with my ammunition expended, I resorted to hand grenades to help keep the NVA as immobilized as possible. As the second medevac arrived, I moved across the landing zone under heavy enemy fire and helped guide in the chopper. Sgt Dave Marks was the first one out to us, I asked him for some water because we had used all of ours for the wounded. We got out the wounded and two of the dead on the second medevac and humped the three other KIAs back to Liberty Bridge. After we got back to the bridge, I was standing watch and got the chance to reflect. At that moment, I realized that I was going to make it because there wa[s] no way it could get worse than what had unfolded befor[e] me on this day. Out of the 21 of us that went out, we los[t] seven. Our lieutenant was Ken Rauser, from Georgia. I wa[s] "put in" for the Silver Star for giving cover to the medevac[.] I received the Bronze Star with a Combat V.

In July, we went to "Arizona," which was a name for th[e] bad lands, and stayed out for 90-some-odd days. One day[,] Capt. Gene Castagnetti took 14 of us on a reconnaissanc[e] mission. As we made our way back to our battalion w[e] went way up into the hills and ran into 25 NVA that wer[e] on their way to join their battalion. They were planning o[n] decimating 1st Battalion, 5th Marines. We killed them all i[n] a ravine, then headed back to hook up with our compan[y.] We began moving into a village that was occupied b[y] NVA as their battalion headquarters. My A-gunner, Jo[e] Labranche, was the first to fire on the NVA. We set up[,] knowing we had to take action and my gun was hit by [a] NVA round, putting it out of commission. The battle laste[d] the rest of the day and into the night, and we had thre[e] medevac choppers shot down.

On July 20, 1969, I watched Neil Armstrong land on th[e] moon while I was on R&R in Hong Kong. In November, [I] went on my second R&R. During that time, my A-gunne[r] and dear friend, Mike Rutherford, was carrying the gun[.] He was killed. He just wanted to go home to Alabama an[d] play football.

I had a bad attitude for my last two months in Vietnam[.] I was put on mess duty at An Hoa, but that only laste[d] two days, then I hopped on a resupply chopper back t[o] the Bush. In mid-December 1969, I flew to Okinawa then [El] Toro. To this day, I am a Marine.

BRUCE CADER

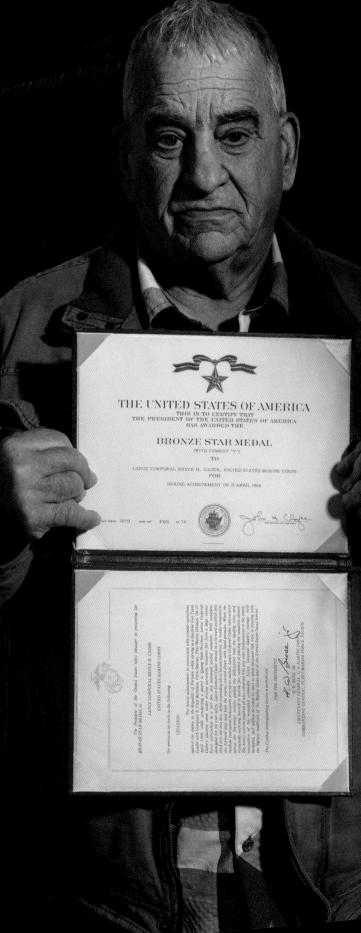

did not understand what Vietnam was all about. It was something that was on everybody's lips. All through high school, it was on the six o'clock news. It was in the newspaper every day. I did one year of college at University of Colorado and protests and pro-war and antiwar and I couldn't wrap my head around either side.

When I flunked out of my freshman year, I knew I was going to get drafted. It was a forgone conclusion. This is 1968. I thought, "Well, if I really want to see what this is all about, maybe I go see." I walked down to the recruiter and I said, "Cool, let's do it." He said, "What do you want to do?" There was a big picture, Special Forces, up on the wall so I said, "I want to do that." Ultimately, I didn't join Special Forces because I got out too soon, but I became a Ranger of sorts. I got to Vietnam in January/February 1969. I was a mortar gunner. I had one year at college so they thought I was smart, because it takes a certain knowledge base to set up a mortar. My platoon sergeant saw something in me. I don't know what. He said, "We're going to start a new unit. I think you would fit into it and you get out of carrying the mortar." I asked what I was going to do and he said I was going to be a LRRP. "It sounds great. I'll do it," I replied, "What's a LRRP?" I had no idea! They were the Long-Range Reconnaissance Patrols, so sort of like a Ranger.

So, after this particular patrol, we were at Firebase Airborne, one of the firebases associated with the "Hamburger Hill" battle. On May 13, 1969 the NVA launched an all-out attack. I was on guard duty and at about two o'clock in the morning I heard movement outside my post down in the jungle. My platoon sergeant came over and heard it too. We both pulled a grenade. I threw mine one way, he threw his another. We heard screams and thought we took care of the problem but there were a whole lot more of them. They overran our position and cut through our wire. I had already been wounded by this time and it was four o'clock in the morning, so very dark.

I was hit either by a mortar round or a satchel charge. My feeling is that it was a mortar round because they were laying mortars in on top of us first and then the wave of infantry came right behind them. The NVA were jumping over me. I was just a lump on the ground, basically paralyzed from the waist down, my cheek and calf already gone. (I don't look pretty in a bathing suit.) They basically destroyed the firebase and we lost a lot of men. They carried me out that morning, around six or seven o'clock I think, after the sun came up. When they carried me out it looked like something from World War I.

I was in hospital for the rest of May and a good part of June. Then I was moved to Japan for more surgery and then to Fitzsimons Army Hospital, Denver, via Travis Air Force Base, where they finally put me back together—lots of surgery and skin grafts. I have pain every day from the shrapnel that's in me between my stomach and my feet; all little pieces and I was told they were too small to dig out so they left them. I set off the security scanners at the airport. In September 2017, I flew to Florida for Hurricane Irma and I set off the electronics. They took out the wands and did the whole thing and the guy said, "You're carrying metal." I said, "Yes I am. I've got a pound of it in me."

MARK WESTON

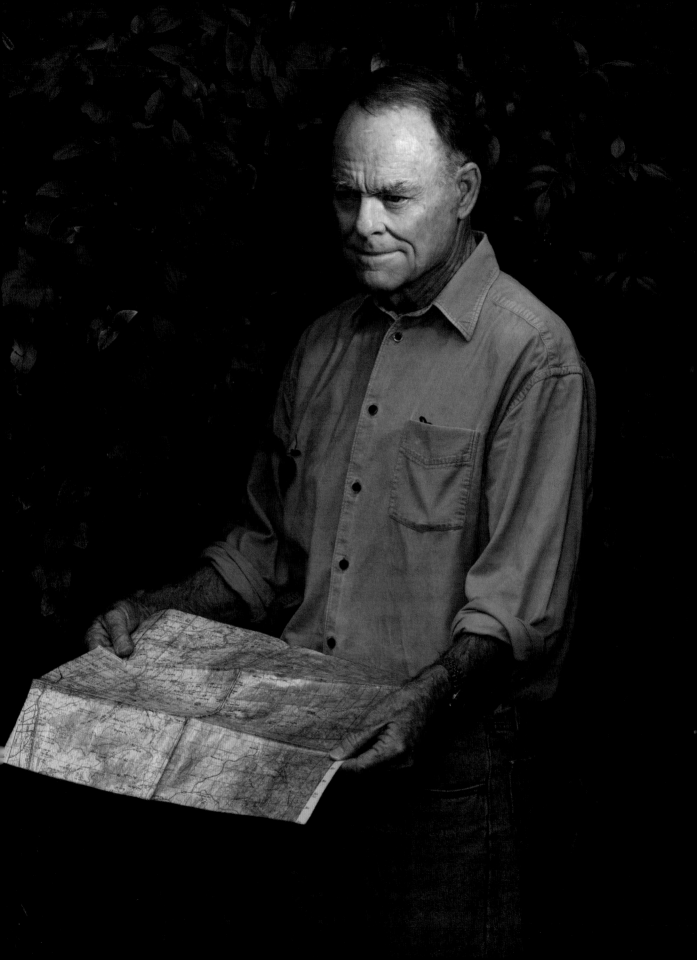

A Marine ran inside the XO bunker yelling, "Lt. Wells, there's a body outside." A sapper had been about to throw one of the giant fruit-juice can grenades, when he was shot by one of the cannoneers.

The grenade dropped to his chest and detonated, blowing the upper half of his body 50 feet away, landing outside the entrance to our bunker.

JACK WELLS

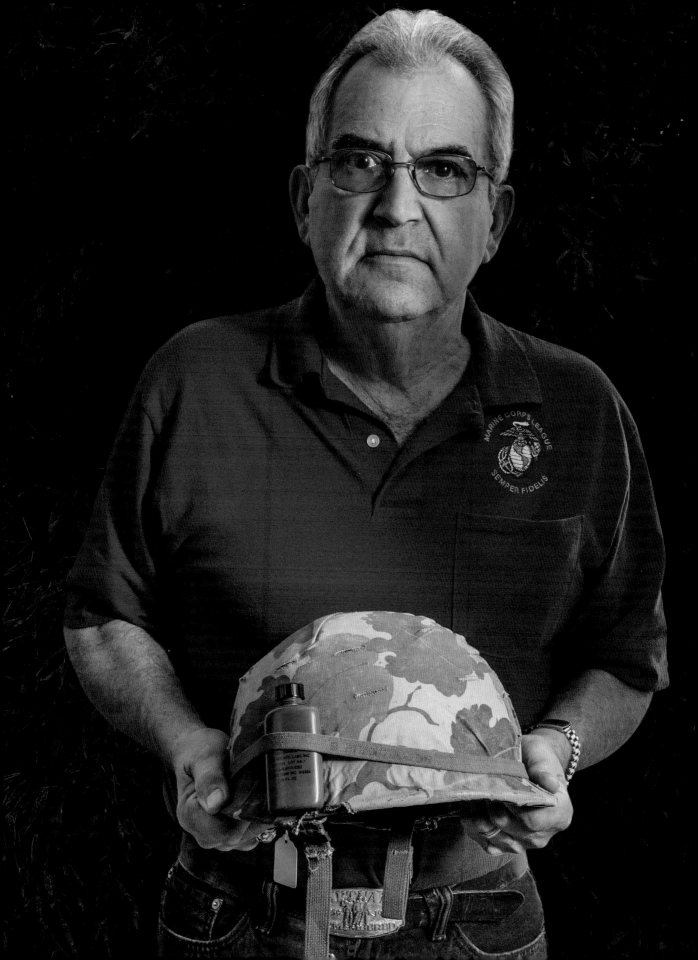

I didn't much think about it. I enlisted when I was 21 years old. My younger brother enlisted in the Marines the day after he turned 18. After training and assignment to my first duty station, I got orders for Vietnam. My brother saw action and came back home so I figured the chances would be on my side. After all, being a Marine, with all that training, I thought I had a pretty good chance of being alright. My dad and all my uncles fought in World War II and all came back. When you are young you think you are invincible especially if you're a Marine. Today at 74 I know better.

My tour was only five weeks. To this day I can't remember any names of the Marines I served with in Vietnam, except the one who help me to the LZ when I was medevac'd.

GARY ESTRELLA

When I received my order for Vietnam, I was scared to death. I had no idea what lay in front of me. When I stepped aboard the chartered airliner for the flight from Fort Lewis to Vietnam, I was a 20-year old "cherry." On arrival, I was assigned to a 155mm howitzer unit of the 2nd Battalion, 11th Field Artillery Regiment of the 101st Airborne Division. This wasn't what I had been trained for but the Army sent me where they needed me. I ended up driving a truck delivering munitions to the division's various firebases. I was "boots on the ground" and afraid for my life every day.

Many of my memories of my time in Vietnam are snapshots of episodes. I was driving Service #10 (a 5-ton truck) from Camp Eagle to Phu Bai to pick up munitions for the 155mm howitzers. For the entire journey I was afraid of hitting a landmine, getting hit by a grenade or a sniper—any one of the range of things that could have ended my life. But I did my job. As I was heading to Phu Bai on Highway 1, there was the most awful stench. The terrible odor grew worse as I passed through a Vietnamese village. There, at the side of the road, were several piles of VC bodies. Decomposing, swollen and bloated by decay. Still clothed in the black pajamas of the VC, they had been shot up and burned. It was common practice to leave bodies in piles as a warning to other VC but this horrific scene still haunts me each and every day.

This particular evening at Camp Eagle I had pulled guard duty. I put on my flak jacket, grabbed my gas mask, ammo and M-16 and a truck dropped me off at a bunker in our primary line. The four men in the bunker each took turns for a two-hour watch. This night, like many others, was pitch black, warm with not a breath of wind. Our bunkers were 40–50 yards apart and it was so quiet that you could hear someone sneeze in another bunker. We spoke in whispers and anyone smoking had to keep the cigarette below the parapet or go behind the bunker for fear of drawing fire.

As I stood watch, the fear of what might erupt from the darkness at any moment gripped me. Sometime around 0300, as I looked through the Starlight scope, I thought I saw movement on the hill. Adrenalin flooded my body; I was sweating I was so scared. I popped an illumination round and grabbed my weapon, ready to fire. Our instructions were not to fire unless fired upon—it didn't make sense to me at the time and still doesn't. The illumination round fell to the ground, still burning, reflecting off the hillside.

The phone connecting the bunker to the command post rang and I explained why I had popped an illumination flare. The voice at the other end told me not to fire unless I was sure I saw something. I went back to the scope and, a little later, thought I saw a silhouette. I popped another flare. The phone rang again and this time an officer came to the bunker and chewed my ass for popping the flares. After the officer returned to the command post, an 81mm mortar shot off some illumination rounds. For the rest of that frightening night all four of us stayed awake keeping watch. Although nothing else occurred, this scenario replays in my head over and over. To this day, I have nightmares, clearly visualizing the scene and reliving the fear that swept over me.

I was transferred to a mortar team where my job was to unpack the munitions—illumination rounds, white phosphorus and high explosive. The CP (command post) had called with list of targets for a fire mission. An attack was expected on our position and, this night, we fired more rounds than usual. I started dropping rounds into the tube and one misfired. This was a very dangerous situation as the round has a point-detonated charge that could explode if touched or compressed. My buddy, Mike, the guy who set the distance and elevation, carefully tilted the tube and slowly slid the mortar round down the tube. I had to catch the round without detonating it. I was terrified I would touch the "nose" and the round would go off. One wrong move and I could kill myself and my entire unit. Moving very gingerly, I carried the round about 20 yards away to a Vietnamese graveyard where we put misfired rounds. The Ordinance Disposal Team would come and deal with them. I was hugely relieved once I had moved this round to a safe distance. This happened on two occasions and it still comes back to me in my dreams. I toss and turn soaked in sweat and my wife, hearing me cry out, wakes me to snap me out of the awful dream.

Once I had dealt with the misfire, Mike and I returned to our fire mission. We were facing the foothills of the mountains in Hotel Sector and, as we looked, we saw a stream of flame coming straight at us—a 122mm rocket fired at our mortar. I was yelling, "Incoming!" and the sirens went off indicating the base was under attack and on Red Alert. As the guys were running from their hooches to our secondary bunker line, I was yelling, "Get down!" I could hear the incoming rockets before they hit. After

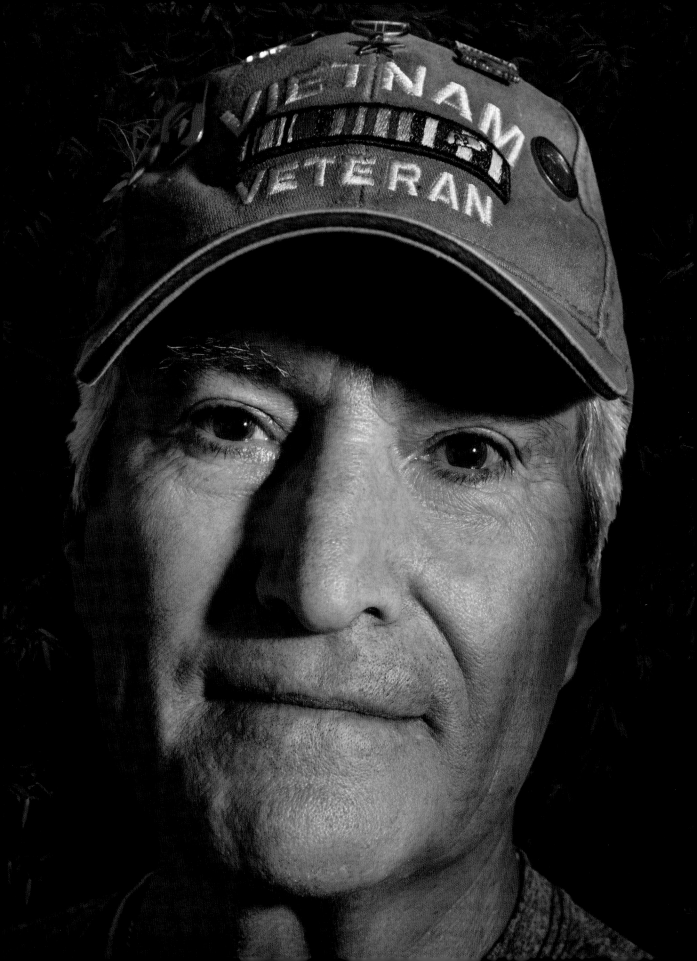

the second rocket hit, I yelled for the guys to get in the bunker before the third one hit. The first rocket hit above our ammo bunker, the second impacted just below the graveyard. The third landed alongside the bunker where we slept. We were awake for the rest of the night hoping to God that another rocket didn't score a direct hit on us.

I lost two friends in Vietnam and, although I can no longer recall their names, I still carry their loss. They were in my company, we worked together, then they were gone.

One was killed in an accident when his truck went off the side of a mountain in bad weather. He was delivering munitions to Firebase Arsenal and I can still see the wrecked truck when it was returned to the motor pool. The other got tangled in a cargo net slung under a Chinook that was airlifting supplies to one of our firebases. He had three children and turned to alcohol to cope with the war. He was drunk all the time. To this day, I wonder how he perished. It is painful to remember them.

When I was discharged from Fort Lewis, Washington, I was advised not to wear my military uniform on the way home. I said no. I was proud of my uniform and of serving my country and felt I had earned the honor of wearing my uniform home. I boarded a late flight from Fort Lewis to San Francisco and can still remember being stared down by the people around me at San Francisco Airport. I couldn't understand this treatment; people staring at me like some sort of war-monger. I grabbed a cab and got home around 2330, walking up the stairs to my front door with my duffle bag. I was not good at writing and had no contact with my family for the year I was away. Finally seeing my mom and dad for the first time after that year in a combat zone, I was so thankful to God I was home.

Sometime around 1997, I was working on my regular job as a journeyman floor installer at San Dominico Girls' School in Sleepy Hollow, California. At lunch, I went to my truck parked in their dirt parking lot. The surrounding terrain reminded me greatly of Vietnam. Suddenly, about 15 yards ahead of me, a Vietcong soldier appeared. I saw him raise his AK-47, taking aim at me and I "hit the deck"— the floor of my work van. I lay there for a very long time; afraid to raise my head for fear of being shot. Eventually, I looked up and he was gone. I was anxious, my temperature skyrocketed and I broke out in a sweat. I couldn't go back

to work. I drove home and began drinking. When my wife came in, she found me in bed with the covers pulled over my head—crying.

Even if I knew it was just in my mind, that image of the Vietcong was very real to me. I knew that I needed help. My wife was very worried about my sanity and my physical wellbeing. To deal with my anxiety, for quite a while I met weekly with a counselor. Eventually, he suggested I try group counseling. The other vets in the group seemed to revel in their discussions of "killing the enemy." I couldn't handle their bragging and their laughter. I found the discussions disgusting and stopped attending. For the next few years, I withdrew from our social circle. My wife and son attended social events without me. I did go back to work, the one "normal" thing I was able to maintain. In time, my wife convinced me to participate in couples' therapy with her. We saw two marriage, family and child counselors together. One specialized in vet issues and the other tried to help my wife and I with our strained marriage. I quit going to both counselors.

For 50 years, I have tried to forget this war. Tried to wipe away so many terrible scenes that remain vivid in my head to this day—there is no way. I left part of my soul "in country" as a young man and it has taken me this long to reach a point in my life where I can revisit my memories of Vietnam without falling apart.

About two years ago, I reached out for help from the VA and began seeing a psychologist and, little by little, he helped me to develop coping skills that I did not have before. When I get "triggered" by overwhelming thoughts, I now have tools to help me come back to reality. For so many years, I struggled with depression, grief, anger and trauma to the point that my survivor's guilt often led me to consider suicide. This counseling journey has not been easy but it has made me stronger and helped me put my Vietnam experience into perspective. A smell, a sound, a song a phrase, a noise—each can trigger me at any time. I carried all this with me back from the war and it remains ever present. My wife has stood by me through all this and, but for her, I would not be here today.

NICHOLAS GUZMAN

SELECTIVE SERVICE SYSTEM

ORDER TO REPORT FOR INDUCTION

Approval Not Required.

LOCAL BOARD NO. 38
SELECTIVE SERVICE SYSTEM
100 McALLISTER STREET
SAN FRANCISCO, CALIFORNIA 94102

(LOCAL BOARD STAMP)

The President of the United States,

To William Joseph Green
453 Myra Way
San Francisco, California 94127

July 18, 1967
..
(Date of mailing)

SELECTIVE SERVICE NO.			
4	38	47	395

GREETING:

You are hereby ordered for induction into the Armed Forces of the United States, and to report

at ... LOCAL BOARD NO. 38
(Place of reporting) SELECTIVE SERVICE SYSTEM
100 McALLISTER STREET
onAUG 16 1967........ at6:45 A.M......... SAN FRANCISCO, CALIFORNIA 94102
(Date) (Hour)

for forwarding to an Armed Forces Induction Station.

..
(Member or clerk of Local Board)

IMPORTANT NOTICE
(Read Each Paragraph Carefully)

IF YOU HAVE HAD PREVIOUS MILITARY SERVICE, OR ARE NOW A MEMBER OF THE NATIONAL GUARD OR A RESERVE COMPONENT OF THE ARMED FORCES, BRING EVIDENCE WITH YOU. IF YOU WEAR GLASSES, BRING THEM. IF MARRIED, BRING PROOF OF YOUR MARRIAGE. IF YOU HAVE ANY PHYSICAL OR MENTAL CONDITION WHICH, IN YOUR OPINION, MAY DISQUALIFY YOU FOR SERVICE IN THE ARMED FORCES, BRING A PHYSICIAN'S CERTIFICATE DESCRIBING THAT CONDITION, IF NOT ALREADY FURNISHED TO YOUR LOCAL BOARD.

Valid documents are required to substantiate dependency claims in order to receive basic allowance for quarters. Be sure to take the following with you when reporting to the induction station. The documents will be returned to you. (a) FOR LAWFUL WIFE OR LEGITIMATE CHILD UNDER 21 YEARS OF AGE—original, certified copy or photostat of a certified copy of marriage certificate, child's birth certificate, or a public or church record of marriage issued over the signature and seal of the custodian of the church or public records; (b) FOR LEGALLY ADOPTED CHILD—certified court order of adoption; (c) FOR CHILD OF DIVORCED SERVICE MEMBER (Child in custody of person other than claimant)—(1) Certified or photostatic copies of receipts from custodian of child evidencing serviceman's contributions for support, and (2) Divorce decree, court support order or separation order; (d) FOR DEPENDENT PARENT—affidavits establishing that dependency.

Bring your Social Security Account Number Card. If you do not have one, apply at nearest Social Security Administration Office. If you have life insurance, bring a record of the insurance company's address and your policy number. Bring enough clean clothes for 3 days. Bring enough money to last 1 month for personal purchases.

This Local Board will furnish transportation, and meals and lodging when necessary, from the place of reporting to the induction station where you will be examined. If found qualified, you will be inducted into the Armed Forces. If found not qualified, return transportation and meals and lodging when necessary, will be furnished to the place of reporting.

You may be found not qualified for induction. Keep this in mind in arranging your affairs, to prevent any undue hardship if you are not inducted. If employed, inform your employer of this possibility. Your employer can then be prepared to continue your employment if you are not inducted. To protect your right to return to your job if you are not inducted, you must report for work as soon as possible after the completion of your induction examination. You may jeopardize your reemployment rights if you do not report for work at the beginning of your next regularly scheduled working period after you have returned to your place of employment.

Willful failure to report at the place and hour of the day named in this Order subjects the violator to fine and imprisonment. Bring this Order with you when you report.

If you are so far from your own local board that reporting in compliance with this Order will be a serious hardship, go immediately to any local board and make written request for transfer of your delivery for induction, taking this Order with you.

SSS Form 252 (Revised 4-28-65) (Previous printings may be used until exhausted.) U.S. GOVERNMENT PRINTING OFFICE 1965 O—765-761

joined the Air Force in 1966, right after high school and my 18th birthday. I had no particular feelings about going to war in Vietnam but was excited to see the world. Upon arriving outside Saigon, I realized I was in a world of shit. The area smelled bad—real bad—like garbage and death with stagnant, humid, hot air. A world of shit, literally and figuratively, with ditches all over carrying the waste away and people just urinating and crapping wherever convenient.

I did not go to battle really. Battle came to me. Occasional incoming rockets fired into the base I was at, until January 31, 1968, when all hell broke loose with the enemy's Tet Offensive. Laying on my stomach in my hooch, the shrapnel from the "incoming" sounded like hail; heavy hail on the tin roof. The swishing of fast-paced shrapnel cutting through the air all around scared the shit out of me.

On the base, we were overrun and it was the Marines and the Army who saved us. The VC, NVA and others breached our perimeter. We did lose five brave souls of the Air Police on the perimeter at bunker O-51. With daylight, the enemy bodies were cleared and the dead were piled up in the taxi ways, prior to being bulldozed into mass graves. After they had lay for hours in the sun, the stench was beyond sickening. We had to retrieve many of the dead with grappling hooks, as their bodies lay in the various minefields around the perimeter.

Once Tet began, I was in full battle gear running convoy duty from dawn until dusk, up and down Highways 1 and 4 for weeks. I drank some bad, non-potable water on the route, which resulted in a horrible infection. I suspect the Vietnamese who sold it to me for a nickel was a VC. It took weeks to heal as the left lymph node in my groin swelled to the size of a large orange. Nice way to see the world and learn medicine. Riding through Cholon and Saigon was the worst, with the smell of death and cordite all around and smoke billowing all over. Just me and my 5.56mm girlfriend and the driver.

One of my duties as an emergency response person, was to respond to air crashes, as the fire and rescue personnel were part of Civil Engineering as well. One night, while I was working "POGO one," I saw a horrific fireball and billowing mushroom cloud of orange and yellow/black coming from one of the runways. When I arrived, I found a C-123 had been sitting on the runway with engines at full throttle, when an F-105 "Wild Weasel" coming out of the clouds hit the C-123 on the port side. It was raining like holy shit at the time. The collision ignited the fully fueled C-123. Aircraft parts were scattered a good 800 yards or more down the runway, as were body parts of the F-105 pilot. His body, from the waist down, was strapped into the cockpit.

I then had to run to our CES area, where guys were watching a movie, and get all I could in my step van and up to the crash site (Men in their white shorts underwear and flip flops hanging all over my truck) to clear the runways and taxi ways. It was hard to clean up, as the fire-retardant was primarily sheep guts based, so Vietnam really was a world of shit. As a young 18-year-old this was a psychological wound not to be forgotten—real war, blood and guts.

I suffered numerous injuries, with resulting sutures in various body parts. After I returned home, I lost a good friend when I said I had been wounded as I had suffered "wounds" but not at the hands of the enemy. I guess the exposure to "Agent Orange" doesn't count either but the pain and neuropathy that results are mind-boggling and have driven some vets to suicide.

Coming back to the "US of A" was just like in the movies—I kissed the tarmac. I had trouble with trust, anger and PTSD on my return. I will always remember the five members of Lindblom High School class of 1966 who died in combat in 'Nam. I was functional, thank goodness, on my return, so I didn't go completely nuts … just a little. God Bless America and the stupid loss of 58,000 guys and gals.

DAVE SANDERS

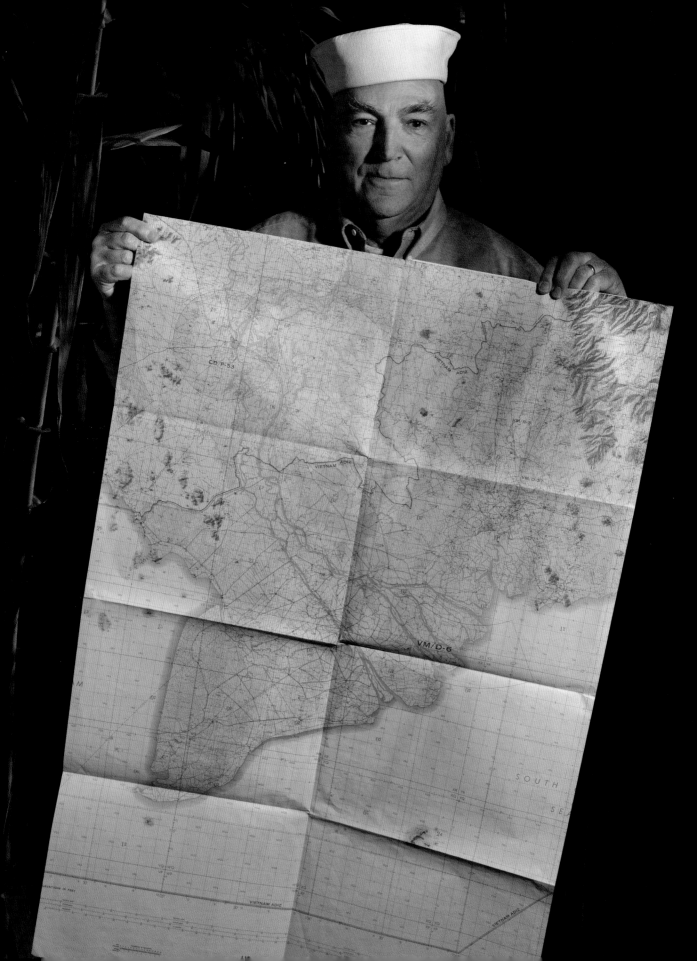

I enlisted when I was 17 with two high school friends. You might ask, "why the Navy?" Well I guess I just watched too many *Victory at Sea* shows on TV when I was growing up and it seemed like a very good idea to know where your bunk was and get three square meals a day. My first ship was the USS *Mount McKinley* (AGC-7), a WWII vintage command and communication ship. We were one of only three ships in Danang harbor when the Tet offensive exploded in 1968. In April 1968 I was transferred to the USS *Nueces* (APB-40).

The USS *Nueces* was enough to deflate anyone's image of a Navy fighting ship. She was a WWII LST (Landing Ship, Tank) that had been converted into a barracks, command post and flagship to support Mobile Riverine Forces in the Mekong Delta. I transferred to the USS *Albert David* (DE-1050) in July 1969, which was the flagship for Destroyer Squadron 29 which consisted of six ships; two Garcia-class destroyers and four WWI O'Brien-class destroyers. We did so much shore bombardment in Vietnam that the ship's helicopter hanger started to come apart. Over 50 per cent of the welds in the aluminum structure had failed and the hanger was pulled about ten degrees out of alignment.

ROBERT ROGERS

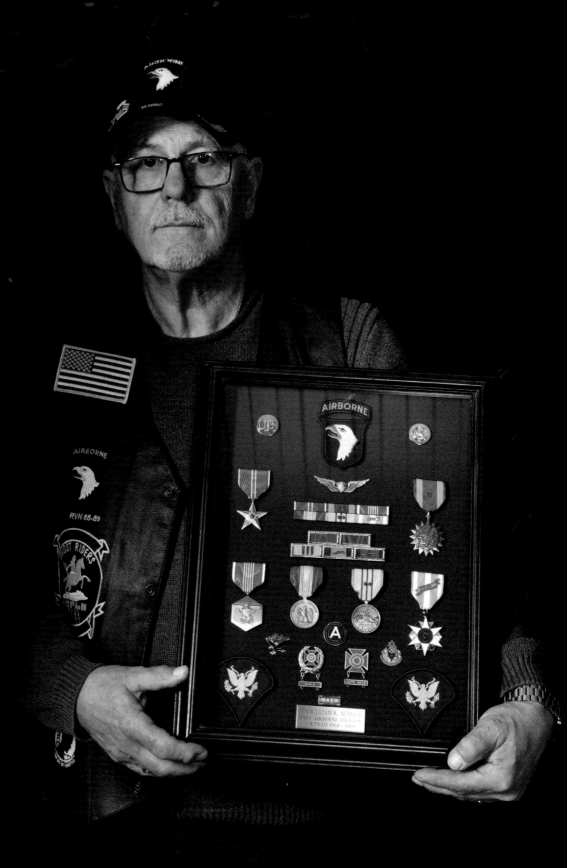

I grew up fighting in the streets of an industrial city, Springfield, Massachusetts. In my second year of high school, I was arrested for disorderly conduct. The judge gave me a chance to join the military and I chose the Army. I remember leaving over the Connecticut River, looking back at the Memorial Bridge and Springfield, and saying to myself, "I am never coming back."

I was a 67N20 helicopter mechanic and flew with Company A, 158th Aviation Battalion, the "Ghostriders." I spent most of my missions over the A Shau Valley, an NVA stronghold known by the Vietnamese as the Valley of Death and the site of the battle of "Hamburger Hill."

One mission I will never forget was a resupply mission, bringing in ammo and C-rations. The jungle was so thick we could not see them. They popped a smoke grenade and we hovered above the yellow smoke as I threw the cases of ammo and food out of the door of my helicopter only to see all the cases sitting in the treetops. The jungle was so thick that the ammo and food got stuck up in the trees. I felt so f'n bad. It haunted me for a while.

BILL ALDRICH

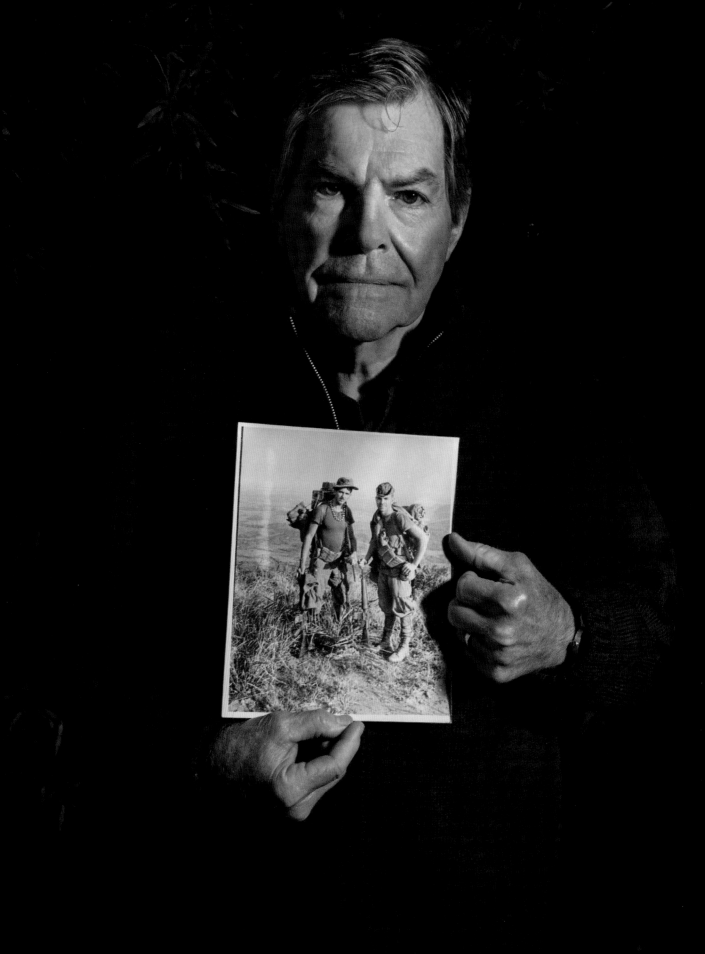

uring college I worked in a club and every night, on the evening news, there was footage of combat in Vietnam. I was an Air Force brat, so war was in my genes and, watching events, I felt that history was being made and I wanted to experience it. I volunteered for infantry. After OCS I went to Airborne Training and Officer's Special Forces training at Ft Bragg. I was expecting to be assigned to the 5th Special Forces Group in Vietnam, but these duties were being turned over to ARVN Rangers. I ended up as a platoon leader with the 23rd (Americal) Division and was soon promoted to platoon leader of the battalion reconnaissance platoon; a group of 12 to 15 personnel.

On one occasion, we were assigned to join a unit across a river. My platoon was looking for a river crossing. The point man opened fire and gave out a scream. I was third in line but up front in a flash. The point man was extremely shaken. A "creature" had attacked him. When it fired it retreated into the grass. I fired into its location and, when all the thrashing had finally stopped, I pulled out a 60lb.,

7-foot Asian monitor lizard. A photo and story were put in *Stars and Stripes*.

The 196th Brigade was based at Chu Lai. When the Marines moved out of Danang our battalion took over their AO (area of operation). On a morning patrol we jumped two NVA but one got away. We were scheduled to be resupplied that morning but it kept getting delayed. I was extremely worried as we were stuck in the same spot all day—a

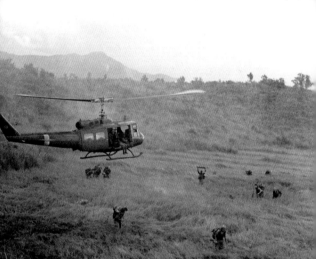

perfect chance for the enemy to set an ambush for us. We usually walked trails, but not this time. We cut through the jungle staying off trails. We broke into a little clearing with a trail through it. The scout hit a trip wire, gave out a yell and ran forward. I turned and ran, colliding with my radio operator so couldn't get clear. The blast threw me into the jungle. I felt the shrapnel slap against my skin like hot mud. I just lay there, mentally taking inventory of my body. I was wounded in the leg and finger and sent to Camp Zama, Japan. As I was wheeled into the ward, *Suicide is Painless*, the theme song to the movie *MASH*, was playing. I felt like I was in the movies. After three weeks I was back with recon. My platoon said they got the guy that got me, they booby-trapped the site. Curiosity killed the cat.

Once back in the real world, I found that I was not as tolerant of people as before. It took a year to calm down. I joined the army reserves and, with a network of veterans around me who spoke the same language, found it helped me make a healthy transition. As I have moved on in life, I have found the army experiences have helped in handling life's challenges. I believe I am far better for it.

JIM DOWLING

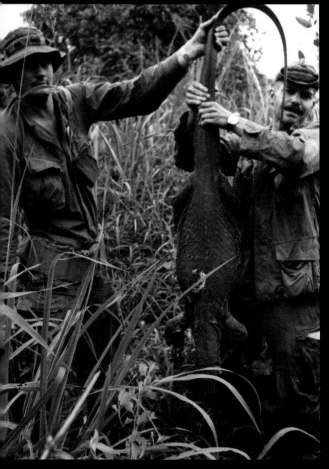

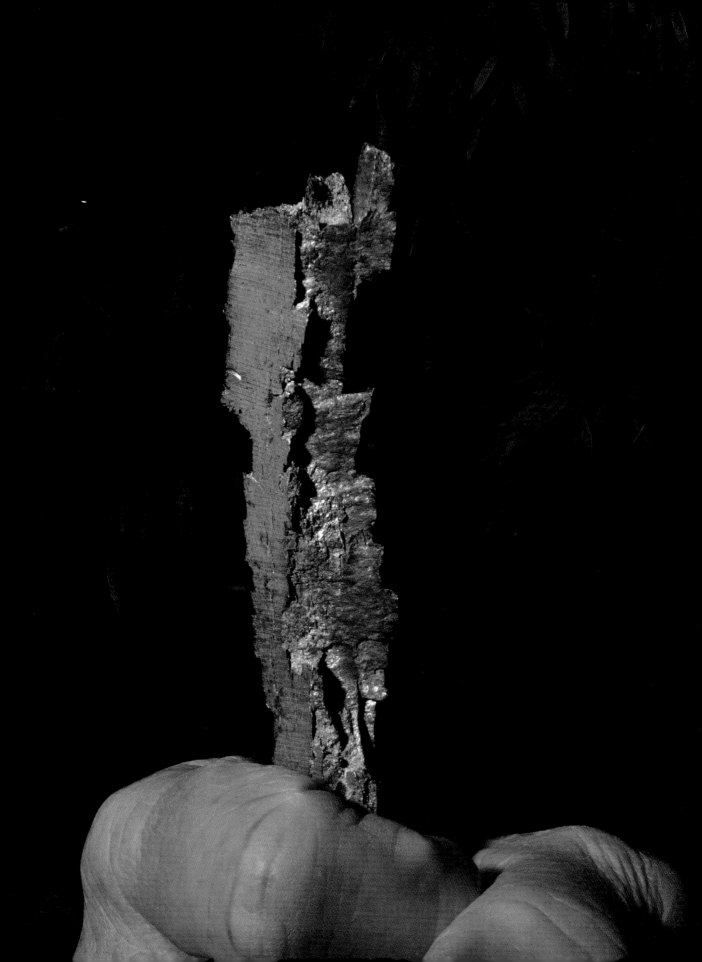

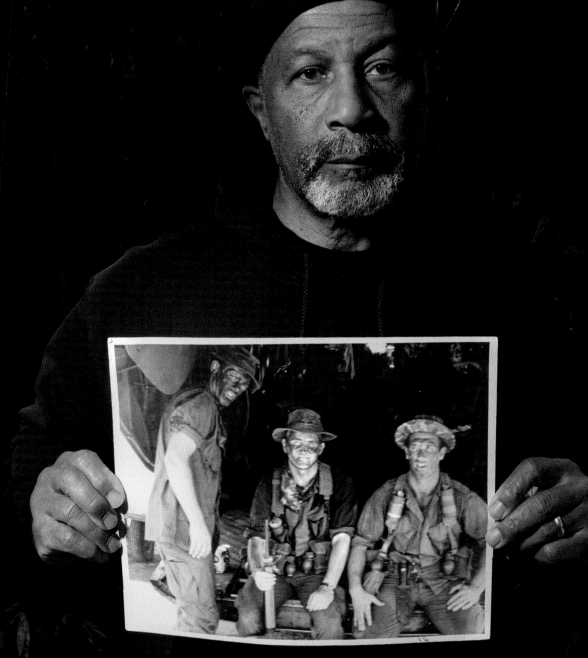

followed our valiant JFK's call to "Ask not what your Country can do for you, ask what you can do for your Country." Although when he made his call, I don't think he was imagining the quagmire of an endless, unjustified war in Southeast Asia and would have been horrified by the escalation after the phony "Gulf of Tonkin incident," I felt military service was the route for me.

I began basic training at the Marine Corps boot camp in San Diego, a factory to process Marines and prepare them for the harsh combat conditions of Vietnam, on August 21, 1967. We graduated in October, with almost the entire platoon having orders to report to WestPac (Western Pacific command). Next stop was ITR (Infantry Training Regiment) at Camp Pendleton, California followed, for me, by Amtrac (amphibious tractor) school at Del Mar base at Camp Pendleton. On February 14, 1968 we flew from El Toro Marine Corps Air Station in Orange County to Okinawa where, after three days processing, we were flown "down south" to Vietnam.

On arrival at Danang, I received orders to the 1st Amtrac Battalion presently at Cua Viet, about seven miles south of the DMZ. A number of body bags were unloaded from the C-130 that would fly us north to Dong Ha, Marine fatalities from the fierce engagements around Khe Sanh, Dong Ha, Con Thien and other areas being fought in the aftermath of the Tet Offensive. Our first attempt to fly in to Dong Ha was unsuccessful due to heavy ground fire at this forward base and we returned to Danang. After a sleepless night in a tent adjacent to a busy artillery battery, we boarded an aircraft for another attempt to get to Dong Ha. This time we were successful, jumping off the C-130, each of us with one sea bag containing all our possessions, as it taxied very slowly down the runway. I was sent down to the boat ramp to get a boat upriver to Cua Viet. Both at Cua Viet and on the LCM-8 "Mike" boat I saw a number of Marine veterans. I was in complete awe of these survivors of numerous engagements with their NVA web gear souvenirs from those unlucky enough to have encountered them. This "green" Marine was, in so many ways, scared of these dirt-caked, tough-looking men.

I cannot now remember exactly how many days it was before I received notification that I was to be sent out of country. The government was sensitive about the embarrassment and upset news of 17-year-old casualties could cause back home and servicemen under 18 were being taken out of the country. I waited out my time on Okinawa and, with other 17-year-olds from 1st Battalion of the 27th Marines, was assigned to FSR (Force Service Regiment) for support duties. As we each turned 18, we were ordered immediately to return to our units in Vietnam. I was the youngest there and had a considerable wait after the last of the others left. Sadly, the casualty listings in the *Stars and Stripes* military newspaper attested to just how soon after they returned to their unit many of these young Marines fell. I found out "Bucky" Blaylock was killed in April 1968. I knew this 21-year-old from our Amtrac school days and knew his and his wife's favorite song. There were few married Marines, most of us being too young. When I heard about his death, I cried. As a Marine, I was expected to put on a brave face but, privately, I cried.

I think of these fallen Marines each and every day. The years I have been able to enjoy come with a lot of "survivor's guilt" when I think about these young lives lost at such an early age. I have made efforts, over the years, to speak to the parents about their sons. With time many of them have passed on as well. In particular one young Marine, a black PFC from the rough streets of Philadelphia, I think about so often. I do not want these young men to be forgotten and I will, with all my remaining days, honor their memory.

EUGENE B. MCCANDLESS

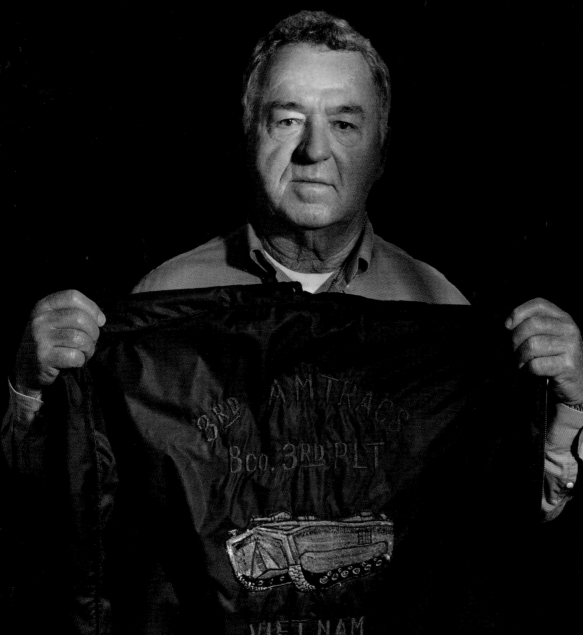

In January of 1961, I was 22 years old and within one semester of graduating from college in Missouri. I was at that time not much interested in graduate school; but very much wanted to see the world. Military service for the males in my family was an honorable choice. My father had served in Europe with the 89th Infantry Division. My two older brothers had served briefly with the US Navy during the Korean War. On the 20th of that same month, I watched the inauguration of John Kennedy as President of the United States and heard his exhortation to all Americans to, "Ask not what your country can do for you. Ask what you can do for your country." He was speaking directly to me. I was sincerely touched by his words, and the very next day, I visited the nearest Navy Recruiting Station and applied to become an officer. At that moment, I had only the vaguest idea of what Vietnam was. I was probably still thinking of that area as French Indochina.

The *Montrose* and her sister ships were aging, all of them hastily built in the early 1940s for use against the Japanese. Twenty-some years later, we were about to use the same equipment and the same tactics against the Communists in South Vietnam. If we in the western Pacific were preparing for a war against foes whom we did not understand, did our leaders back in Washington know much better? By October of 1964 I was serving aboard the USS *Montrose* somewhere in the South China Sea when we made our absentee ballots for the Presidential Election between incumbent Lyndon Johnson and his opponent Barry Goldwater. Hostilities were already underway between US forces in South Vietnam and the VC. At the wardroom dinner table, I remember hearing my officer shipmates discuss their feelings about the candidates. The overall opinion was that Lyndon Johnson would end the war quickly, as he had promised. I voted for Johnson—a choice I would soon regret. My period of service was due to end but I sensed that the situation in South Vietnam would continue to deteriorate. If I left the Navy now, I reasoned, I would likely be recalled soon and, for that reason, I extended my active duty commitment. I was sent to a fleet oiler on station in the Tonkin Gulf about 30 nautical miles off the shore of South Vietnam—an ocean site named "Yankee Station." We spent a year coordinating the constant resupply of the aircraft carriers and other ships supporting our troops ashore. This involved the transfer at sea, while both ships were underway, of munitions, bombs, fuel, and stores—a method known as "highlining." While the two ships steam on a parallel course about 30 to 40 yards apart, a lightweight cord is shot across to the receiving ship and used to rig a cable with a trolley attached. The cargo is slung from the trolley and then manually hauled across to the receiving ship. The process sounds straightforward enough but, with two vessels both steaming on the high seas, is inherently dangerous to both the ships and personnel involved. For the sailors aboard the supply and the receiving ships, this was very tiring and sometimes dangerous work repeated day after day. Those men earned their shore leave. With my security clearance and access to the ship's radio gear, I began to learn much more about the war in South Vietnam. I read daily reports of combat throughout South and North Vietnam, Laos, and Cambodia. When I received my personal mail from home, sometimes including magazines, I began to read conflicting reports about these activities. It was unsettling to read about our casualty rates, planes shot down, scandals in the South Vietnamese government, body counts and particularly about civil unrest back home. When our mail caught up to us, we read magazines and newspapers that increasingly disagreed with our presence in Vietnam. In 1968 I left active duty for civilian life. That was not a very good year for returning Vietnam veterans. If it was irritating for me, it was certainly worse for those vets who had been ashore in combat. After all, I had never been personally shot at. I remembered from my childhood the honor and respect with which all WWII veterans had been treated, without even knowing where or how they had served. But in 1968, very few people were saying "Welcome home." No one was saying, "Thank you for your service."

I quickly found a job with a large manufacturer of construction products and began my new job in Phoenix, Arizona. I was working alongside guys my own age and on social occasions, took the opportunity to talk with them about what I had experienced in the Navy. What I heard back from many of them, however, was how they had dodged the draft and otherwise found ways to avoid going into uniform. It felt like they were saying to me, in effect, that I was stupid to have volunteered for military duty. I received a phone call from the Commanding Officer of the Naval and Marine Corps Reserve Station in Phoenix. He asked me to stop by so that he could tell me about opportunities in the Navy Reserve. Unlike my John Kennedy moment, I had no intention of obligating myself. I committed to just one evening per week and two weeks in the summer. I had, however, at last found people with whom I could discuss and who understood my experiences. All Americans who served in the Vietnam War received a green and white medal and ribbon from the South Vietnamese government that acknowledged their contribution to the struggle against the Communists. The clasp on the ribbon reads, "1960– ." The intent was that the final date would be added after the war's conclusion. The collapse of the South Vietnamese government and communist takeover meant the clasp remained unfinished. I am a veteran of that unfinished war. I remained in the Naval Reserve until 1984 but it was my year of service in the Tonkin Gulf that was of the greatest consequence. I am proud to have done what I could for my country.

ROBERT KUCHEM

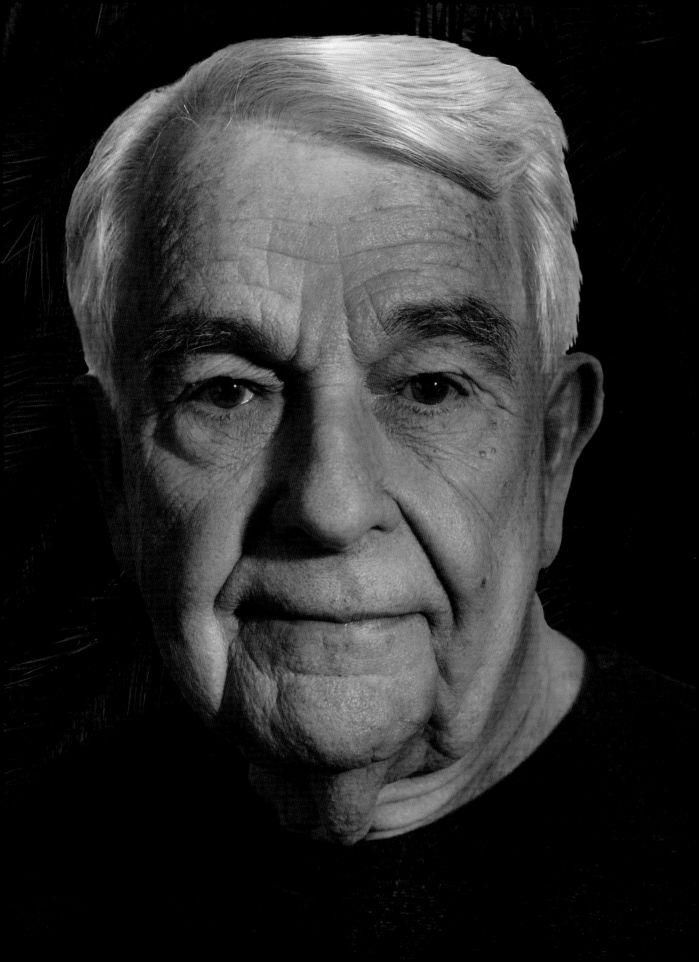

was born in the Bronx, on Valentine's Day 1945, to a staunchly Catholic and patriotic family. When I was accepted by Marine Officer Candidate School in Quantico, Virginia, my brother-in-law assured me that I was not tough enough to make it through. I never told him that his remark was what kept me going when things got tough in OCS.

A year after signing on the line I was a fresh "brown bar" second lieutenant, the only officer on a flight of 230 Marines heading for Vietnam. About midnight the pilot called me to the cockpit and told me we had a problem, pointing to Danang Air Base, which was under rocket and mortar attack. He got approval from the tower to do a "dump and run." Without lights, we hit the end of the runway, lowered the rear ramp, quickly disembarked and the plane made an abrupt U-turn and roared off leaving us on the tarmac. We had no idea where we were or where the enemy was, as the base was still taking mortar and small-arms fire. We jumped in a drainage ditch near the perimeter fence and one of my companions, a 20-year gunnery sergeant, turned to me and said "welcome to Vietnam Lieutenant." The next day, I checked out the daily casualty list and found one of my OCS brothers listed; he arrived in country less than 48 hours before me. In one of our last briefings stateside, they reminded us that the average lieutenant was wounded or KIA in the first 30 days in 'Nam.

There are lots of things about war that are hard to explain to someone who has never served. For example, under the Geneva Convention you can shoot or toss a grenade or burn an enemy out with napalm one minute but the second he signals surrender you're not allowed to insult him. A lot of guys had a problem with that, especially if they had just lost buddies to this same enemy.

Rotating home and leaving my buddies behind was a strange experience and, like most, I felt really guilty leaving. We landed at Norton Air Base in southern California and around midnight we boarded half a dozen buses and were warned to keep our heads down. As we ran the base gates at high speed, my lead bus began to take hits from eggs, tomatoes, sticks and finally a couple of bricks that shattered two windows. Sitting in the front seat, I turned to see a startled and confused group of combat-hardened Marines. There was no angry reaction, just a disillusioned, silent pain on their faces. It was one of those sights that gets burned into your brain. I've had lots of dreams about that—not nightmares, just dreams.

Like most vets, I kept a low profile about having been in 'Nam because of the stigma it carried. Then in 1991, I was in a Safeway in San Francisco wearing a jacket with a Marine Corps emblem and a woman approached me and asked if I had been in 'Nam. When she shook my hand and thanked me for my service, I was totally shocked. It was the first time anyone had said that in 20 years and I was numb and so overcome emotionally that I was unable to respond. My wife took my arm and we drove home in silence. I never went to bed that night, I just sat looking out of the window until the sun rose.

I am proud to be from The Bronx. I'm proud to be a Vietnam Veteran. I'm proud to be a Marine.

THOMAS J. CORBETT

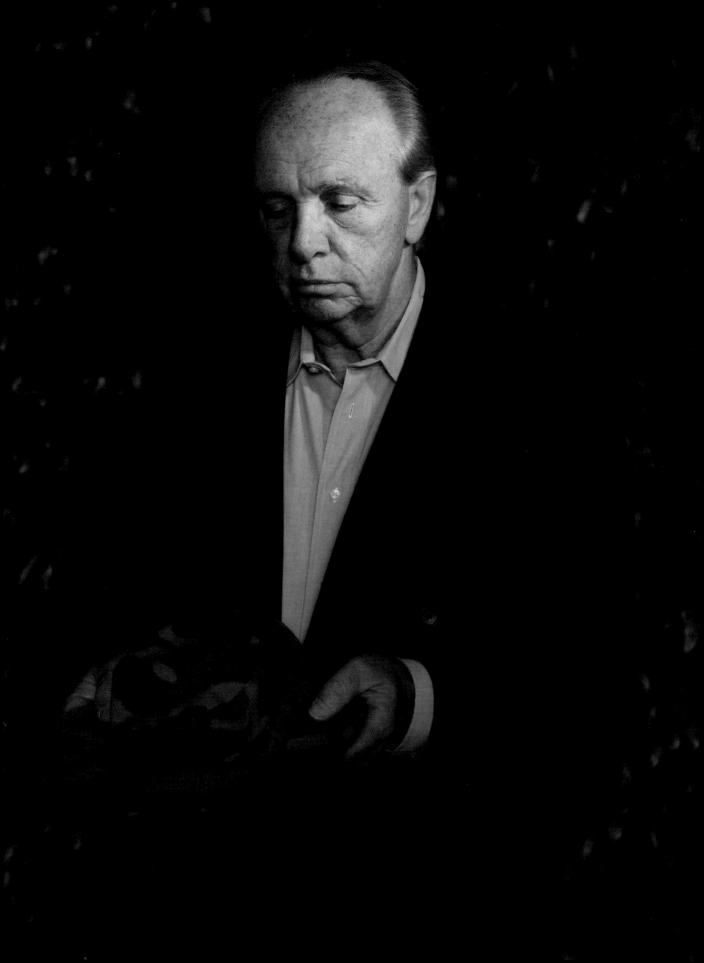

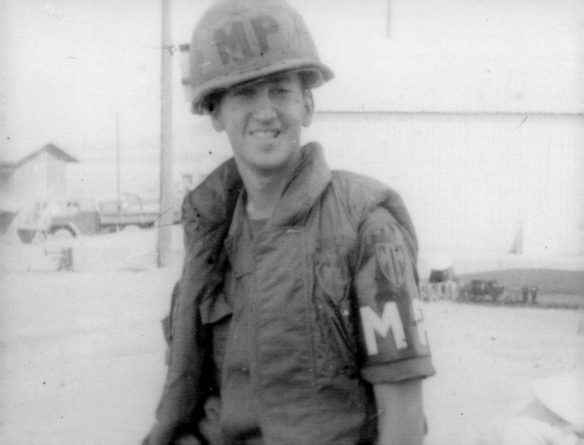

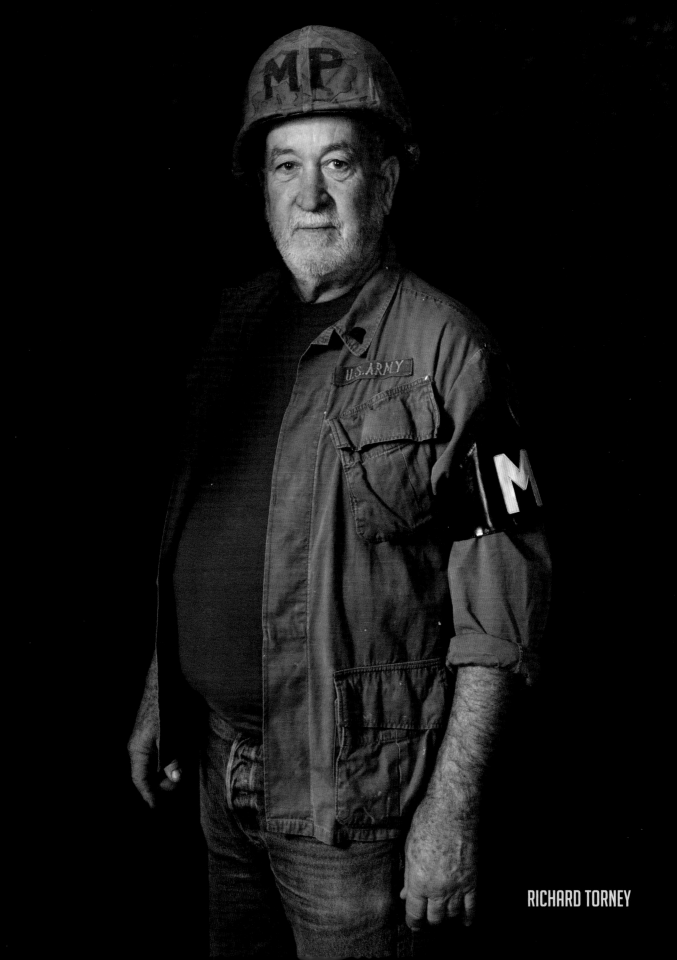

RICHARD TORNEY

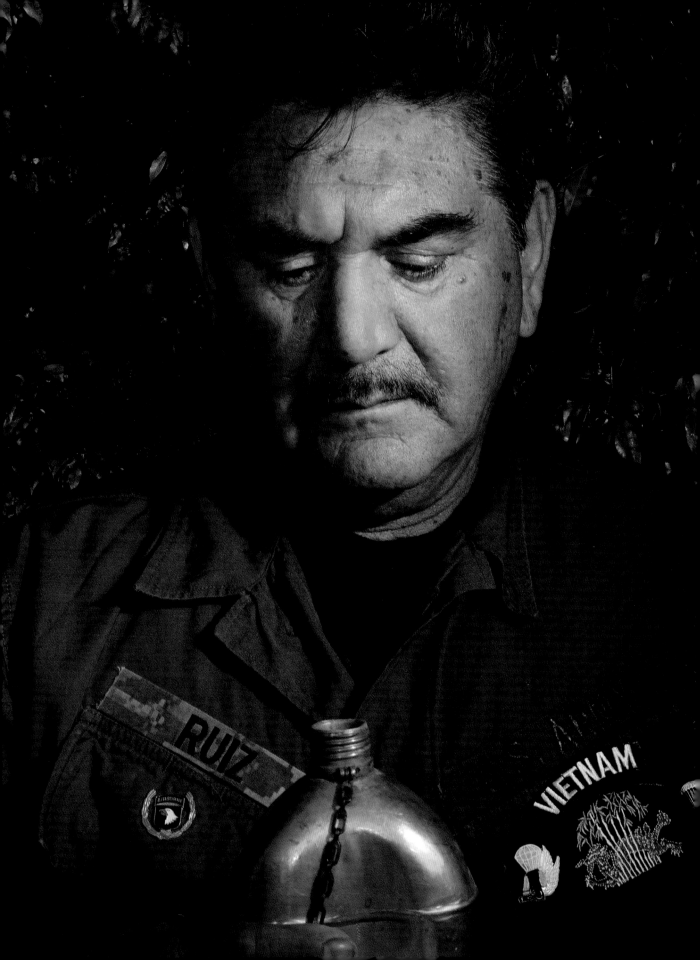

felt really good being a Hispanic in Vietnam. I was proud to go and fight for my country. I was 21—young, full of life, eager to do my part and ready to defeat an enemy of the States. I was tired of party life and always fighting in the streets against rival gangs. We believed the Hispanic male was a macho man that would never surrender or quit fighting in any situation. I was drafted. My older brother had served five years before me and was a paratrooper, so I was eager to become a trooper in jump school. My younger brother was also in the army at the same time, so I was glad I kept him from going to Vietnam. Only one family member at a time was allowed in Vietnam. My mother was relieved that two sons would not go together fighting a war she didn't approve of.

We were all on edge when we arrived in Vietnam. I was afraid, we all were, but were glad to be going after "Charlie." The first night, we received incoming mortar fire. We all jumped up in our underwear and bottlenecked at the door fighting and trying to get out first. We were green and didn't know anything. Five or ten minutes after scuffling at the door with my fellow soldiers, we laughed and ran back for our equipment and clothes. We quickly learned to be combat ready at all times, day and night. The fear leaves after a while and turns into anger and courage. We learned fast as we fought the VC in the fields of rice paddies and in their own villages. The VC simply blended into the population.

One learns to have only acquaintances for friends when you don't know if your comrade will be dead tomorrow. The foot soldier endured an endless cycle of being tired and fatigued. The worst feeling was when we were airlifted into a battlefield and hot lead was flying everywhere. We would jump out of the choppers. They wouldn't touch the ground for fear of staying there too long and being hit by RPG rockets. As I watched them leave, I felt so alone and knew there was no way out but to kill those people shooting at us. Every day was filled with death and you learn to walk hand in hand with its grip.

I remember feeling bad for the people there, they had nothing and truly lived off their land. They had flocks of chickens and ducks running through their villages. I guess they belonged to the entire village. I remember one occasion when I was very hungry after being out in pursuit of the guerrilla units, so I started chasing a duck to eat. One of the elders saw what I was doing, so she caught one for me and offered it to me as a gesture of goodwill and peace. I guess she was afraid I was going to burn down her village. We had burned down many villages to keep them from being used as enemy outposts. I learned many things from the people there as I interacted with them. They showed me what wild fruit to eat and how to see a trail that had been tampered with. I treated them with respect and listened to them as equals, they loved that and would call me "number one GI." I gave them my C-rations and money when I could, in return they gave

me a monkey, which I eventually released back to the jungle—I couldn't fight a war with a monkey on my back!

There was a local barber who would come into base and cut our hair week after week. Oh, everyone knew him. We would tip him well and really liked the guy. One night we were hit hard at our base. They came at us from every direction. They knew where our mines were and avoided them. They knew the least guarded areas. Well, after a three-hour battle they slipped back into the night. At daybreak, we found the dead VC all around and guess who was among the dead? Yep, our barber, he was a double agent. They were all like that. You couldn't trust anyone. This tension was always there. You could feel it. Someone was always out to get you. We didn't belong there; we were strangers in a strange land. The men we spoke to during the day might prove our attackers at any moment, day or night. We used to say, for those who believe God has a favor the protected never know.

I was with members of D Co. 506th Infantry at Phuoc Vinh, Vietnam. We conducted search-and-destroy missions daily. In February 1968, we were airlifted to Song Be and engaged in a tough three-day battle. The fighting was heavy and we had many wounded. We were back in Song Be in around March of '68 in company strength. We were caught in an L-shaped ambush with fire coming from the front and rear. We fought our way out but our machine gunner and assistant were taken out along with Lieutenant Park. I remember thinking this was real bad for the morale of our company. The two squads we had in support were also taken out by RPGs. The third squad had just two men standing. Lieutenant Solor was the only officer left and he regrouped all the remaining platoons and pulled us back, calling for air support. The following day we were credited with 70 killed. We had four dead and 14 wounded. I don't remember their names but they died fighting alongside us.

In July 1968, we were flown in to reinforce B Co. Immediately we hit the landing zone we received small-arms fire. We were in the open and you could hear the rounds singing past our heads. We scrambled for the tree line and received RPG fire. The enemy was well dug-in and in spider holes. We had to move forward and dig him out. I remember passing dead soldiers from B Co. and thinking to myself, "Why didn't the enemy take and remove their weapons and personal belongings?" Then I realized that they were using our dead soldiers as bait to lure us in. We had seven casualties in D Co. but B Co. had 10 killed and 13 wounded.

When I came back and landed in the USA at Travis Air Force Base, I kissed the ground.

BOBBY RUIZ

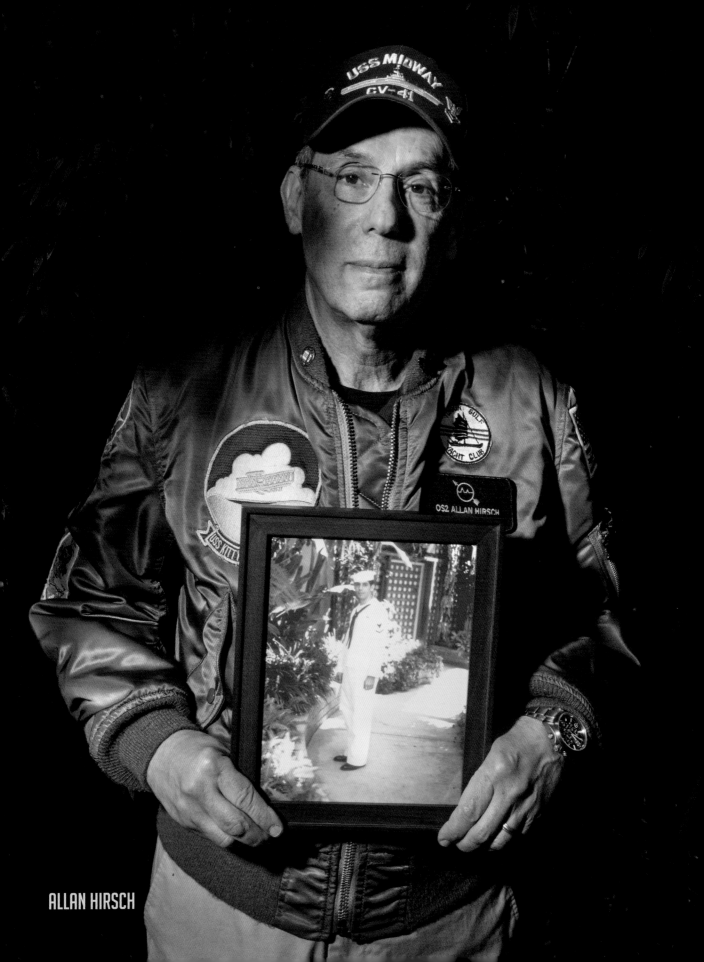

ALLAN HIRSCH

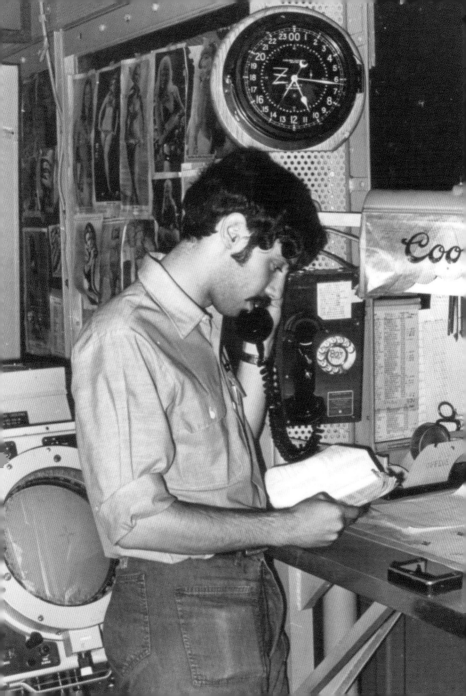

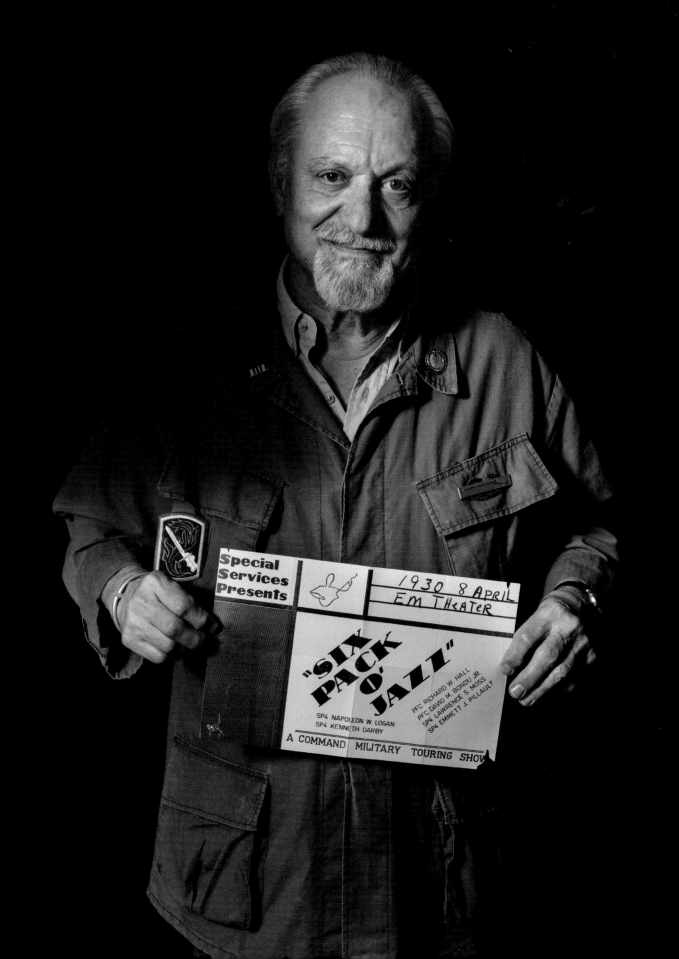

Growing up in an affluent, predominantly Jewish suburb of Chicago, I didn't acquire many skills that would help prepare me for soldiering in Vietnam. I had never once gone camping, hiking or hunting. I knew nothing about guns, knives, tents, maps … anything related to survival. I never even went to overnight camp. I did have one skill; I knew how to play the piano but I would never have guessed that talent would help me survive the war in Vietnam.

After high school, I diddled around in college for a couple of years, but wasn't really much of a student. No surprise, I was drafted in March of 1968. For some unknown reason, I volunteered to be a paratrooper. To this day, I don't know what possessed me to do so. This made Basic Training look like a two-month vacation. After enduring eight weeks of endless running, marching and infantry training, I decided to "unvolunteer" from Airborne—a decision I've never regretted. Upon completion of the training, I was given a few weeks leave and sent right to Vietnam.

I arrived in Vietnam in September of 1968. Having been trained as an infantryman, I was assigned to the 198th Light Infantry Brigade, and sent to LZ Gator in Chu Lai, just south of Danang. From the day I arrived, my unit spent most of the time humping the boonies of I Corps conducting search-and-destroy and search-and-seize missions. We saw action regularly and thankfully, by now, I had learned a great deal about guns, knives, maps, mortars and survival.

One day, after about six months in country, I heard an announcement on AFVN Radio about Command Military Touring Shows. The Army's Special Services section was looking for GIs who played musical instruments. With my CO's blessing, I went to Saigon to audition. A month later, back in the boonies, I got the news that I had been selected to join a six-man jazz band called "The Six-Pack Of Jazz". Blissfully, I was choppered to Saigon to meet and rehearse with my new bandmates.

We put together a very tight show and hit the road for four months putting on one or two shows a day. We were sent all over the country, from the DMZ to Vung Tau and from the Cambodian border to the South China Sea to provide some much-needed musical entertainment to units at remote bases and to the wounded in hospitals—places where it was way too unsafe to send a USO group. After all, you can't write off Bob Hope or Ann Margret, but we were merely GIs on temporary duty. A number of our shows were cut short by incoming mortars or rockets.

Being a part of that touring show was unquestionably one of the most rewarding experiences of my life. It felt so good to do something to lift the spirits of my fellow soldiers. And, selfishly, it kept me out of harm's way for a couple of months and I was able to finish out my tour and get home safely.

Now, nearly 50 years later, I remain eternally grateful for the piano lessons my parents insisted I take as a child. I'm pretty sure they are the reason I am alive today. Thank you Mom and Dad.

LARRY MOSS

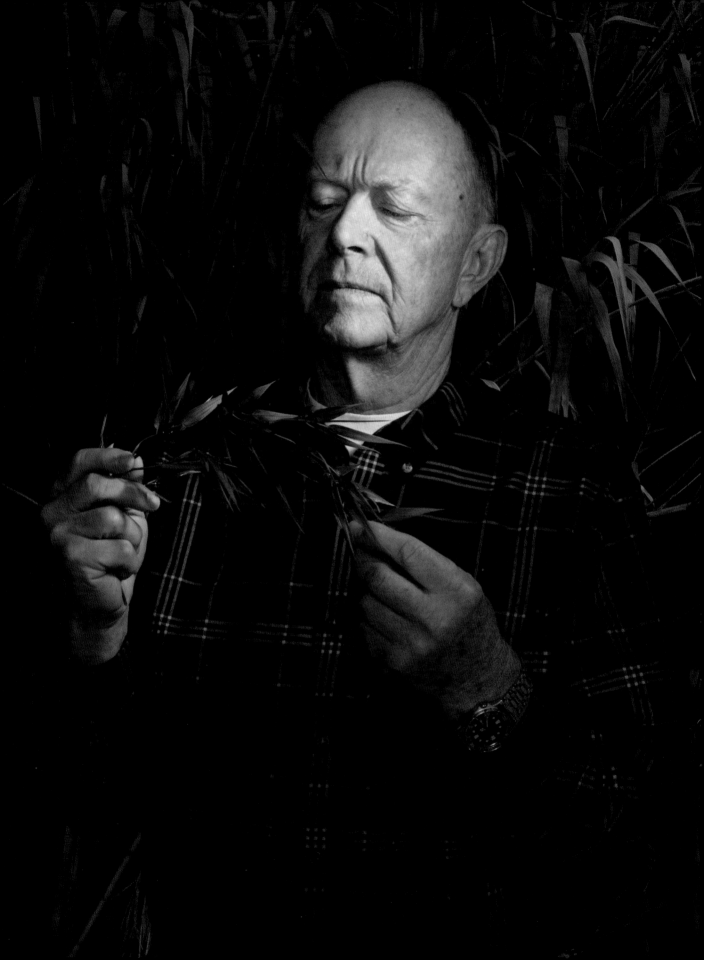

was very fortunate to have been given the 12-week Vietnamese language course before being assigned as an adviser in Vietnam. I wasn't sure I knew much Vietnamese at the end of the course but later, in Vietnam, when I got into a conversation the words just magically surfaced in my head. Without that language ability, I would not have been able to get to know the Vietnamese people as well as I did. They appreciated my efforts to speak their language, and they responded warmly.

On one occasion I was in a village with a visiting American officer of Asian descent who spoke no Vietnamese. We were in a jeep in the middle of the village when a group of young boys approached us. They clustered around the jeep in a very friendly way. I told them, in Vietnamese, that, "I am a Vietnamese person and this other officer is an American." They said, "No no no—he is Vietnamese and you are American." Later, I told him about the interchange and we had a good laugh.

Several years later, while waiting in transit in Tokyo airport, I found myself in the midst of a large group of Vietnamese refugees. They were en route from a Vietnamese relocation camp in the Philippines to cities in the United States where they would begin a new life. I sat quietly for a while, as the children played around me. Eventually, I said something to one of the children in Vietnamese. He ran off to his parents yelling. Soon I was surrounded by Vietnamese adults. They all had papers indicating the cities to where they were being relocated. They wanted to know about the cities— were they big or small, hot or cold, and on and on. What a wonderful experience.

RONALD L. LOWE

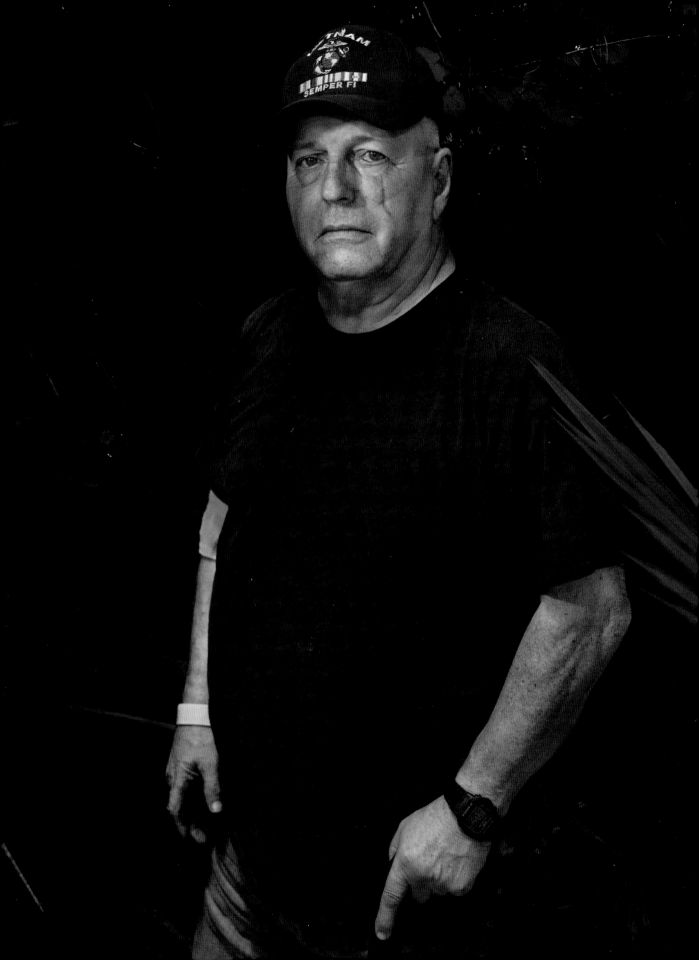

Why did I sign up for the Marines? It's real simple. We are the greatest fighting force in the world. Marines have fought against overwhelming odds throughout our history. I had every intention of going into combat as a Marine Infantryman. My company was awarded three Presidential Unit Citations for valor. No other unit has three. We are very proud of that. My men fought exactly like every Marine unit. That is why I can say that "I walked among heroes."

On my third day in Vietnam I was buried by an NVA 82mm mortar. Even my squad leader thought I was dead. If I had a dollar for every time I almost died I could retire. My company lost 207 Marines and Corpsmen.

There is no worse fear than having artillery or mortars dropping on you like raindrops. One afternoon we were out in the open and came under heavy mortar fire. As we lay there praying, my best friend Duke asked Frank Torres for a cigarette. Frank held the cigarette out to Duke and a piece of shrapnel went through Frank's forearm. Frank immediately yelled, "Fuck you Duke I am never going to give you another cigarette!" Everyone within earshot began to laugh. That is what we all needed at that moment. I am talking about real release-of-fear belly laughter.

After the NVA lost so badly during the Tet offensive in Feb 1968, they followed up with a May offensive. They sent the two regiments that had been guarding Hanoi to destroy Danang Airbase. They were known as the "Palace Guard" because they were the units that defeated the French at Dien Bien Phu in 1954. If Danang fell, the war would have ended in 1968. That is how important it was to stop them. The NVA were just south of Danang on Go Noi Island. On May 4, Golf Company was sent out onto the island to seek out the NVA command post. Golf Company had 150 Marines and Corpsmen and the enemy had thousands of soldiers. On the 7th, they ambushed our tanks and amtracs. As soon as the vehicles came under fire, our company ran forward and attempted to roll the enemy's flank. It was during this battle that I ordered my platoon to attack the complex of bunkers and machine guns. As my men were cut down by the machine guns, AK-47s, RPGs, snipers and grenades, I began picking them up and carrying them to safety. My dear friend "Nip" (George Detablan) was shot through his thigh by a heavy machine gun and it shattered his leg. He was carrying a full combat load but I picked him up in my arms and ran, carrying him

like a child, to safety. He was so heavy and I was so upset because my men were being cut down and I could not run fast enough to save them all. I did not even have time to fire my weapon because there were so many dead and wounded. That would come later after my men were safe. You must understand that I died that day. I have never been the same. It is at times like this, during the intensity of battle, that everything fades to black and white. Time seems to almost stand still and every effort is in slow motion. I for one was in total denial of what was going on.

Why did I die on May 7, 1968? I gave the order to assault the bunkers that day. The first man hit was right next to me. His name was PFC Kenneth Benedict Orizulak. He was a Polish kid from Chicago. Being a good Catholic boy, he entered the Seminary to become a Jesuit priest. He left there to join the Marines. He met a wonderful girl by the name of Judy. She had lived in an orphanage until her 18th birthday. Six months later she met and fell in love with Ken and three months later they were married. Two weeks after that, he shipped out to Vietnam. We all called him "Spanky." He was our "mascot" and we all loved him dearly. He was out of place in Vietnam. He was small in stature and very funny. He gave all of us nicknames and we gave him his. He called me "Jake," as in Jake the Snake from Hoboken N.J. To this day all of my men only know me as "Jake." We made a pact that "Spanky" was to make it home. He was the only married man in our unit. He was never allowed to walk point or carry the radio because that was too dangerous. However, on that day I was so focused on the situation at hand it did not occur to me to have "Spanky" stay back with our gear. We had dropped our packs on the outside of the village prior to attacking. As I gave the order my entire platoon stood and charged into certain death. Not one man paused. The din of the battle was so overwhelming we could not hear anything but twenty-plus machine guns and automatic weapons shooting at us. My men were being cut down and we kept moving forward.

As I write this, my eyesight is blurring. Memories are coming out of my eyes and rolling down my cheeks.

As for coming home, It Sucked. It hasn't changed in 50 Years.

JACK PARSONS

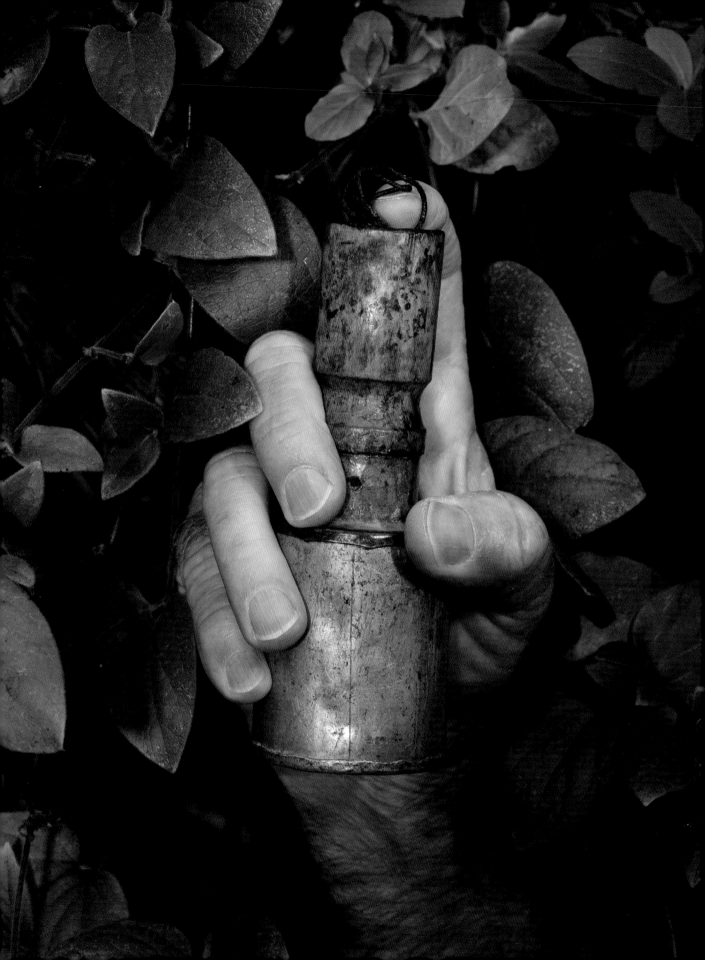

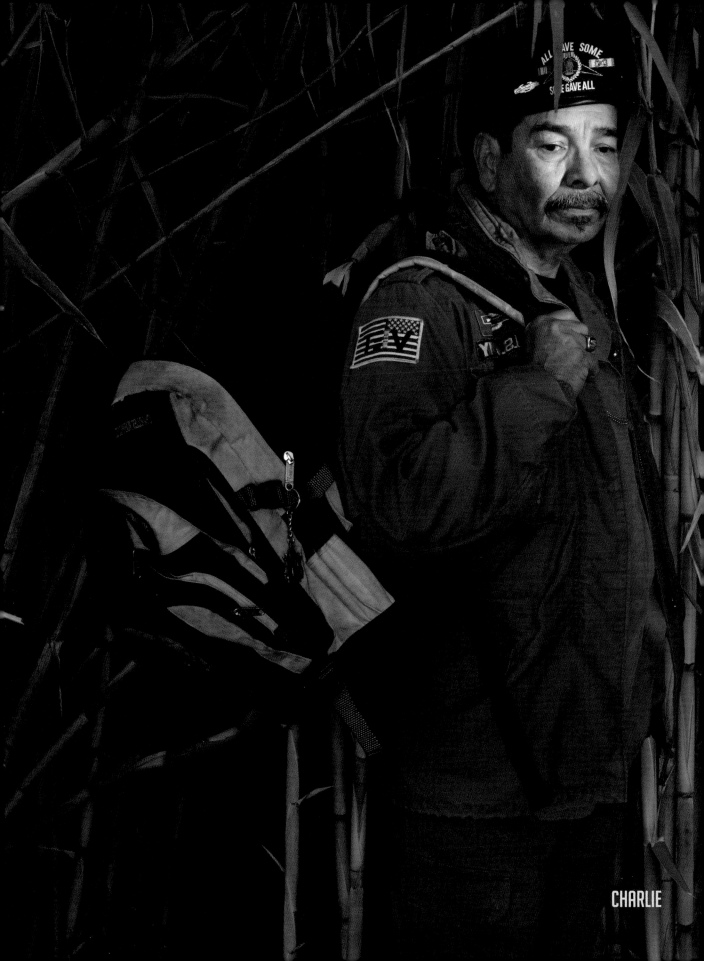

CHARLIE

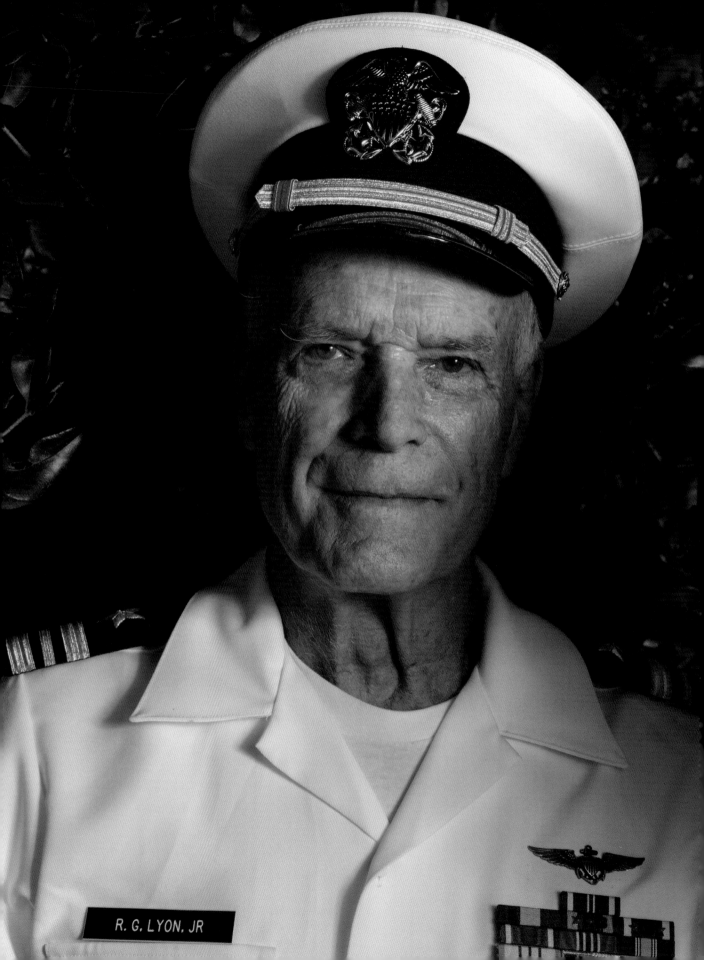

R. G. LYON, JR

A pilot joined our squadron during my second combat cruise and became my roommate. His name was John Wayne Andrews. He didn't particularly care that he was named after John Wayne and consequently went by the name "Wayne." Because I was the "schedules" officer for VF-53 and because he was my new roommate,

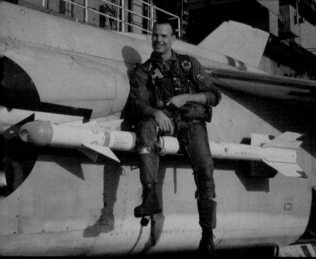

I put him on the schedule with me for a BARCAP (Barrier Combat Air Patrol) for his first flight. It was kind of a "nothing" flight. We simply patrolled the sky between our task force and Vietnam. I thought that I'd just point out various points in North Vietnam for him so he could get a feel for the territory. We were just flying up and down the coast and I was pointing out various ingress and egress points as well as some of the cities, when suddenly Red Crown (the controlling ship in that area) informed us that an Air Force F-105 had just been shot down. As we were the two closest aircraft to the pilot's last known position, they asked if we would go "feet dry" and look for him.

Now one of the most rewarding things a pilot can do is to help another pilot in trouble. I said, "of course" and we headed inland to a point about 10 to 12 miles south and slightly west of Hanoi. We had gone from a "nothing" flight to flying into what was the most highly defended area in the world. We had everything you can possibly imagine fired at us: 37mm, 57mm, 75mm, and even 100mm AAA (anti-aircraft artillery) as well as more than a dozen SAMs (surface-to-air missiles) and small-arms fire for good measure. I located the downed pilot pretty quickly, as I could see his parachute on the ground, so as soon as we found him, I started an SAR (search and rescue) effort in the hopes of keeping him from being captured by the enemy. However, it was not to be.

Shortly after locating his parachute, we flew directly over him and it was obvious that he was completely surrounded by the enemy. He was talking to me on a hand held radio and told me that he was about to be captured and that he was going to destroy the radio to prevent it from falling into the hands of the enemy. It was one of the most sickening feelings that I've ever had in my life. My first thought was that before we even crossed the coast on the way out, he would be a POW and all that went with it, while we were headed back to the carrier where good food, clean sheets, hot showers, and movies in the ready room awaited us. I canceled the SAR effort as it was hopeless, and we got out of there as fast as we could.

During our flight back to the USS *Hancock*, I had plenty of time to think about what had just taken place. Although by this time I had flown just under 100 missions, this had been the worst. Not only was it unsuccessful because we were not able to save the Air Force F-105 pilot, we had more AAA and more SAMs fired at us than I had ever experienced before.

Remember, this was Wayne's first mission. So, I got the bright idea that, when we got back to the ship, I'd just pretend that this was nothing more than a normal flight. That's exactly what I did. After debriefing at AI (air intelligence), Wayne and I went to get something to eat. I told Wayne, "Oh yeah, that's just the way it is every day." Poor Wayne, he was sure that he'd never see his wife and kids again. It wasn't until we were getting ready to get some sleep that I told him that it was the worst flight I had ever been on. We both made it home.

ROBERT LYONS

I joined the army in July 1966 at age 17. I was certainly young, stupid, and innocent. When I got out in 1969, I was not even old enough to drink and got kicked out of *Caesar's* in Reno. I had certainly changed and was also perhaps a little less stupid.

Being a Vietnam vet in 1969 was not politically correct. At junior college one young lady spat at me and called me a baby killer. At least one other declined to go have a soda because I had not gone to Canada to avoid the war. And no one thanked me for my service or going to war.

Sometimes when I am in DC I stop by "The Wall" and say hello to friends and former colleagues. I never have understood why my name is not on the wall when so many smarter people are listed.

THOMAS EMMETT BOYD

he month I arrived in country we lost eight Marines. In a company of 120 men, that was a lot.

Recon is a different mentality than the infantry. The infantry is strength in numbers. Recon is all about stealth. Our motto was "Swift, Silent and Deadly." Stealth in enemy territory is a complex process. It's impossible to sum up in a few words but basically you have to move almost constantly but make no noise nor reflect any light; move without attracting any attention. It's hard to imagine what it is like to be deep in enemy territory, completely surrounded by hundreds of NVA who know you are there! We caused the NVA so much trouble that they put a bounty on our heads.

I ran 20 of these four-man, deep recon patrols. They usually lasted three days, sometimes four. When the enemy found us, there would be a gun fight and an emergency extraction. The only reason any of us lived through these missions was because of emergency extracts—almost always by helicopter. With only four Marines, your survival window in a gun fight with a large number of enemies was very small. The first thought that went through my head was something like, "OK, this is it. I'm dead. I won't live through this." Then the adrenaline would kick in—pounding heart, heightened awareness, rapid breathing. Adrenaline is a very powerful drug. Some people became jittery and nervous. I didn't. I was one of those people who became very calm. It was almost an out-of-body experience. Bullets were flying all over the place, enemy hand grenades were coming at us … and yet there I was, calm and with my mind's eye above the fray. In that way, it makes perfect sense. I had, after all, started with the thought that my living body was within moments of its death and so a part of my spirit was already leaving; hovering above me just in case the body did survive. To be clear, these are biologically controlled reactions—in my conscious, thinking brain I was scared shitless all the time. Why wouldn't any sane person be scared to go out in a very small group long distances inside enemy territory? I still don't know why I did it, but there it is.

LOUIS KERN

AMERICAN G.I's!

W do you involve in the unjust war
of Washington?
H do you have to face TERROR and DEATH
in this war up to now, in spite of the fact
Y that the U.S administration promised to
bring you home in late 1967?

BECAUSE the Wall Street capitalists want much profit.
BUT you simply get DEATH and TERROR.

- Demand the U.S Govn't to stop the war and
restore peace in S.V.N now!
- Demand immediate repatriation!
- Let the Vietnamese people settle their own
affairs themselves!

Truyền đơn này thay giấy thông hành

WHAT'S IN WASHINGTON'S WAR FOR YOU?

**This leaflet can be used as a
safe-conduct pass**

CHIÊU HỒI

CÙNG CÁC BINH
SĨ, SĨ QUAN VÀ
CÁN BỘ ĐANG
CHIẾN ĐẤU
CHỐNG LẠI CHÍNH
PHỦ QUỐC GIA

ĐÂY LÀ LỜI KÊU
GỌI CỦA CHÍNH
PHỦ VIỆT-NAM
CỘNG HÒA
CÁC BẠN HÃY
TRỞ VỀ VỚI
CHÍNH NGHĨA
QUỐC GIA QUA
CHÍNH SÁCH
CHIÊU HỒI
CÁC BẠN SẼ
ĐƯỢC TIẾP
ĐÓN NỒNG HẬU.

About two months prior to completing Flight Training, I completed my "Dream Sheet" and volunteered for a new squadron of helicopter gunships I had heard was forming in Vietnam. To my surprise I got my wish. Why did I volunteer for combat duty? I figured I just spent 18 months learning to be a warrior and it was time to put that training to use.

After additional training at Fort Benning, GA, San Diego and NAS Whydby Island, WA and some leave, I reported to Helicopter Attack (Light) Squadron Three—HA(L)-3—headquartered at Vung Tau, South Vietnam on July 27, 1967 along with about 24 other pilots. The CO told us that he had nothing for us to fly. Instead we were sent down to Soc Trang and I spent my first month in Vietnam flying combat assault missions carrying troops in and out of battle zones with the Army's 336th Aviation Company. My first combat assault mission was around August 1 to a hot LZ and was the first time I came under enemy fire. Fortunately, there was a heavy fire team of five Huey gunships circling the LZ to suppress enemy fire and we took no hits that day. Seal Team 1 was only five miles away in My Tho and once in a while would come over to Dong Tam to have a few drinks with us in our bar. The leader of this group was a guy known as "Moose." Moose was about 6' 4" and about 250lb. of solid muscle. One day late in 1967, Moose and a bunch of his guys were over having a few when we asked Moose where they were planning their next mission. He promptly pulled a map out of his back pocket, unfolded it on the table, covered his eyes with his left hand, twirled his right hand around and dropped his finger on the map and, without looking and said, "there." He was pointing to an area known as the Coconut Groves—a known VC stronghold. We said: "No way you're going in there." Three days later we got a Seal Ops message—they were going into the Coconut Grove! It turned into quite a major operation and we had to go rescue them at midnight.

I flew daily missions as a UH-1D co-pilot until I reported to my own squadron, HA(L)-3, Detachment 6, at Dong Tam on August 31. At Det 6, I was assigned as lead ship co-pilot and was responsible for all navigation and radio communications. In addition to any scramble missions we were called on to fly, we also flew normal patrols in our area. Taking small-arms fire became routine. Usually, the heaviest fire we took was on scramble missions that were supporting PBRs or SEALs already under fire. The Huey gunships we flew had very little armor. The pilots had armored seats, which protected you from the bottom, back and somewhat from the side but, since we were normally facing the enemy who was firing back, all we had in front of us was plexiglass, which would hardly stop a peashooter let alone an AK-47 round. The heaviest sustained fire we took was during the Tet Offensive. We were assigned to support the MACV compound at Ben Tre—the heaviest hit city in Viet Nam with over 3,500 VC attacking the city/MACV compound. For the first three days of the Tet Offensive our two-aircraft Light Fire Team was the only air support Ben Tre had. We were flying around the clock and quickly changed our duty day to 12 hours on, 12 hours off. We were doing hot refuel/re-arm with occasional trips to our small maintenance detachment at Vin Long to get battle damage repaired. It was scary having three or four lines of enemy tracers coming at us on every rocket run but I mostly was too busy to concern myself with it. I was well aware, however, that we were in some heavy crap and I might not survive it but it was my duty to do my job the best I could. With all the fires on the ground there was a lot of smoke in the air and at night when we turned off target and away from city lights it was like turning into an inkwell.

On one particular night mission, just as we rolled in on a rocket run a line of .50 caliber tracers came at us—at night, those .50 cal tracers look as big as basketballs! The pilot made a violent left diving turn away from the .50 cal fire into the black void and immediately got vertigo. I took control of the aircraft and went on instruments and was able to pull the aircraft out of its perilous dive and level us out about 100 ft. above the trees. We were in and out of retreating blade stall the whole time, which shook the aircraft quite violently. Upon hearing that Dong Tam was under heavy attack, we decided to try to get aboard one of the barges that was home to another detachment. I made the first approach to the small barge deck but had to wave off. Depth perception at night to a small, red-lit deck is very difficult.

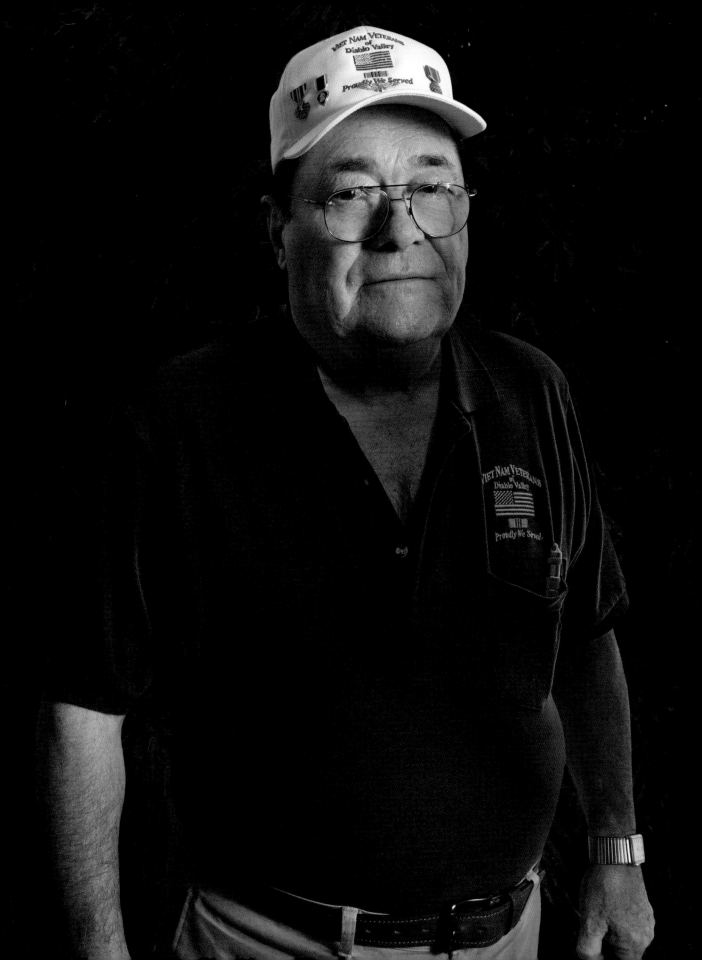

The pilot then tried but also had to wave off. I think we were both so shook up from the near-death experience that we were in no condition to make the very difficult night landing on the barge—something neither one of us had ever done before. Since we were now very low on fuel, we decided to return to Dong Tam. As we were landing at Dong Tam, approaching a hover, the aircraft started spinning to the left. The pilot put the aircraft on the deck to stop the spin. As we were trying to figure out what was wrong, the pilot looked down to find his kneeboard jammed behind the rudder pedal. This had prevented full throw of the rudder necessary for hover. It had apparently flown off his knee during the rough ride of the blade stall. Had we been able to get aboard the barge, we surely would have crashed as the aircraft spun. We had a good laugh for a few seconds, until enemy mortars started walking down the runway. Running on fumes, we had to hover over to the fuel pits—despite the mortars walking towards us. We took on about half a tank of fuel, as mortars were impacting around us, and got the hell out of there. As we had taken significant battle damage, we decided to head to our maintenance detachment at Vin Long. As we approached Vin Long, the tower advised us that they were under ground attack and to land at our own risk. We did land and the maintenance crew, in full battle gear, scampered over our aircraft to start on the repairs.

About 30 minutes into the repairs, the VC attacked again and we were told to get into the bunker, while the maintenance crew manned M60 machine guns in a fortified position atop the bunker. After about 20 minutes—it seemed much longer—the machine gunners from the maintenance crew beat off the attack and were able to complete the repairs. We left Vin Long and returned to Dong Tam at about 0200, where things were now quiet, and turned the aircraft over to the other crew. During our ordeal, our wing ship refueled at a different base and was waiting for us on our return to Dong Tam. They said that, when they saw us in that steep diving turn, they thought we were goners. The pilot and I then spent the next five hours filling out after-action reports from our notes, so didn't get much sleep before our next shift started at noon.

By the end of February 1968, I was promoted to Attack Helicopter Aircraft Commander. Since most of the pilots in the detachment were rotated back to Vung Tau and were replaced by new guys fresh in-country, I was the most experienced pilot in this combat unit. My co-pilot was a senior lieutenant, fresh in Nam but a fast learner.

On April 18, 1968 I was assigned to fly an aircraft to Vung Tau and replace it with one fresh out of maintenance. was about 15 minutes out of Dong Tam, flying at 2000 ft and 90 kts. when all of a sudden, the engine quit. I pu the aircraft into an autorotation and put out a "Mayday call, looking for a place to land. Fortunately, it was the dry season so the rice paddies were a hard surface. just managed to clear the last dike line and landed skidding about a plane length. I immediately turned to my crew and yelled "perimeter." My co-pilot, the fast learner was out of the aircraft with M-16 in hand and on his PRC90 emergency radio before I was even unstrapped. contacted the MACV compound at Go Cong and asked fo troops to guard the aircraft until it could be hooked out o there. Where we landed was not exactly friendly territory we had been shooting up an area about 3 km north only three days earlier. The troops arrived about 30 minutes later and rescue aircraft lifted us out of there. Later tha afternoon the aircraft was hooked out of there and flown to Vung Tau. It was flying three days later with a new engine. The tail number of this aircraft was 311. Prior to my engine failure there had been about 12 aircraft in ou squadron history that had suffered engine failure from battle damage or mechanical issues. All 12 had resulted in total loss or severe damage to the aircraft. I, as a lowly ensign, completed the first successful autorotation in the history of HA(L)-3. In 1975, I was a flight instructor in Pensacola, FL while completing my BS at the University of West Florida. My youngest sister came to visit and we went to the Naval Aviation Museum at the main Pensacola base. As we entered the museum, I spotted a picture o a Navy gunship on the far-left wall. As I walked over for a closer look, to my astonishment it was tail number 311— the same aircraft I put into a rice paddy back in 1968.

When I returned in late July 1968, the nation was in turmoil. Family and friends were welcoming but the genera mood of the country and the media was distinctly anti military. Since I was still in the Navy and spending most o my time on military bases, I was shielded from much of it but the prevailing mood and the bad press grated. Vietnam was the most reported-on war in American history and, maintain, the most inaccurately reported of any war in ou history.

RAYMOND F. LAROCHELLE

There was this Senegalese soldier named Bokassa, see, fighting with the French in Indo-China back in the early 1950s and he lives with this girl who presents him with a baby, two months before the French pack him and their whole Army off to France. Seventeen years later, the Senegalese soldier is the President of the Central African Republic and he remembers that little girl he left behind so he sends for her. She quit her job selling cigarettes on the streets of Saigon and joins him. Amidst much publicity, he presents his half-Vietnamese daughter to his people. Her name is Martine. Then a couple of months later, another Martine Bokassa turns up and the President is convinced this is the real one so he sends the first one back and brings the genuine daughter to Africa. There are at least 15 other mothers who claim their daughters are the real Martine Bokassa, but the President is satisfied he has the right one. It's a modern Cinderella

Look to the future, GI

story with a difference and it's been reported in all the papers and they'll probably base a movie on it one day, but that's not why we're mentioning it now.

There's a lesson here for all Americans, at least those who might have paternal responsibilities in Vietnam. Who can say with any certainty that one of the GI's who served in Vietnam during the US presence may not one day grow up to be President. Now suppose he remembers the daughter he left behind and wants to bring her to America. Now can he avoid the problem faced by President Bokassa. Easy. Put a little ink on that little daughter's fingers and have her smudge it on a piece of paper. Put the paper in a bank deposit vault and let it stay there until you become president. Then when it comes time to locate the girl, you have positive identification.

Conversation

MAJOR: That Bob Hope show was a winner. He updated those gags and had those blase young kids rolling in the aisles.

COLONEL: That's a pro. Knows how to bend with the changing times and changing audience.

MAJOR: A great trouper. Really with it. I always said, talk to these young kids in their language and they'll follow you anywhere.

COLONEL: Yeah. By the way, let's run through those parade arrangements.

MAJOR: Oh, yes, the parade. Let's see. Here's the manual. Presentation of colors. Para 3, Section 2, Appendix 12. The flag bearer steps forward four paces. The platoon leader executes about face, calls troops to attention. Then you step forward three paces and salute. Platoon leader calls "parade rest" and does about face. You deliver statement and then accept the colors.

COLONEL: Run through that again. I been doing it for 25 years but I still don't know the drill.

I HATE DOING PUSH-UPS ALL BY MY LONESOME.

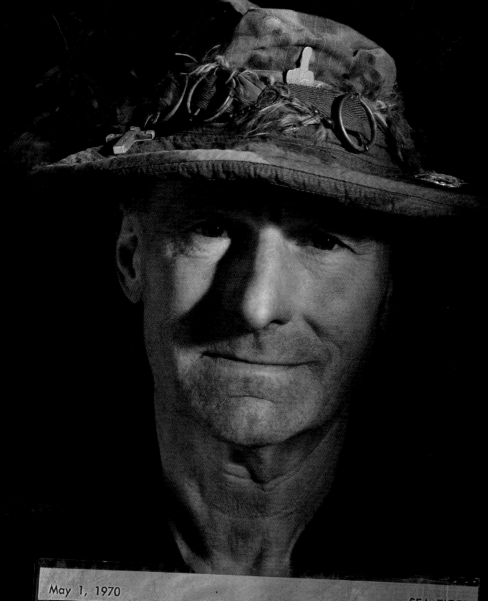

May 1, 1970 SEA TIGER

Vietnamese Capture Sports Festival As Thousands Cheer

Americans, Koreans and Vietnamese runners bolt from the starting point of the 5,000 meter run

I was born in San Francisco, California and was raised in nearby Novato, Marin County. My friends and I spent our childhoods surfing, scuba diving, and exploring. During this time, I also discovered my passion for running. After graduating from Novato High School in 1968, I started my first year in college but I wasn't motivated enough to keep my grades above the minimum level and I received an army draft notice. I did not want to go into the infantry so joined the Marine Corps instead and was sent to boot camp in San Diego, California. I can remember clearly how well the drill instructors turned "cocky" kids like me into soldiers. I was very humbled after nine weeks. They did a good job of making a Marine out of me.

I was "volunteered" for the Recon Force and began my advanced training, without ever being told exactly what the Force was. During my deployment my team completed 21 missions behind enemy lines including gathering intelligence data on enemy forces, carrying out ambushes, snatching high-ranking enemy officers, and calling in air strikes. I didn't think I would last 13 months but what kept me going was my love and respect for my team members. We were highly trained, highly motivated, came from all over the United States and, for the most part, believed in what we were fighting for. All I wanted to do was survive with my team and have us come home together.

Letters from home played a huge part in keeping our morale high. A letter from home—you really cherished it…. When someone got a letter… he would walk off into the bush someplace, and you wouldn't see him for hours. We never threw letters away and would eventually share them with each other. Through those notes, we learned a lot about each other's lives back home. The guys knew as much about my personal life as I did about theirs.

I carried a secret for many years, which only my family knew. The military decided to hold an Olympic style track meet in Danang to boost morale. Despite not being a member of the Marine track team, my running talents had apparently not gone unnoticed. A substitute point man was assigned to my squad and I was sent to compete in the 5,000-meter event. After barely qualifying, my lieutenant asked me what reward would motivate me to medal in the final race. I said I wanted to go to Hawaii. R&R on Hawaii was usually reserved for officers, but the lieutenant said he would see what he could do. That motivation was all it took, and I won the silver medal. I flew to Hawaii but what the Marine Corps didn't know was that family members had arranged to transport me to Canada where I could wait out the rest of the war in safety. When the time came, I realized I couldn't go through with it. I couldn't abandon my team. I got on the plane and flew back to Vietnam.

I remember the wildlife and beauty of Vietnam vividly. I can't even describe some of the beauty I saw—cascading waterfalls, orchids blooming, lush jungles and ponds and mountains. There were large swathes of jungle destroyed by bomb runs or napalm strikes, but the animals and plants were innocent—we have to take into consideration what we did to the environment.

My most memorable experience is probably to do with a village orphanage. The orphans had nothing; the nuns who cared for them were often forced to beg for or steal food. The team wanted to help. We had this grand plan to raise food and clothing for the village. After being turned away by both the military chaplain and my own church in Novato on the basis that the children were Buddhist, not Christian, I wrote home asking for help. There were many people in my town who did not support the war, but Mom encouraged them to give for the children. About ten days later, a truckload of food and clothing for the orphanage was delivered. I remember feeling overwhelmed by the support. It wasn't the government, it wasn't the politicians, it was the people.

I was discharged in 1970 and came home to a country that didn't believe in the war. I went to work, got married and started a family. Through the years I didn't discuss my service and many friends didn't even know I had gone to Vietnam.

As for my current perspective on the Vietnam War. I think we are not doing a great job of learning our lessons. There are just wars, I'm sure, but we can't keep getting into unjust wars. We can't have our children sacrificing for what I would call nothing but politics and greed. To any young people who wish to serve in America's military, I have one message—think about it. Military service is a sacrifice and if you are in combat and around so much death, you'll be living with it for the rest of your life. Today, I don't believe all the sacrifices I made during Vietnam were justified. While I would make those sacrifices again for the villagers, for the orphans, or for the cause, I now see that Vietnam was not a just war. There was corruption and greed on all sides of the war but I value the perspective I gained from being in Vietnam.

DARREN WALTON

Date 28 Nov 68
Place THU THUA, VIETNAM

Dear Family _____

I am ✓ fine ✓ missing you __ bored __ getting short ✓ making money __ eating well.

How are things ✓ in the world ✓ at work __ on the block __ at the hang-out __ on the farm?

The weather here is ✓ hot ✓ muddy ✓ wet ✓ humid ✓ dusty __ just like home.

My job is __ boring __ highly specialized ✓ classified __ exhausting ✓ unnecessary __ fun.

I'm thinking of ✓ home ✓ you, as usual ✓ home cooking ✓ girls __ sleep.

My future looks __ bright __ gloomy __ hopeful ✓ like more of same.

For R&R I plan to go to ✓ Sydney __ Hong Kong __ Singapore __ Hawaii __ Taipei __ Bangkok __ Manila __ Tokyo __ Penang __ Kuala Lumpur.

In my spare time I ✓ sleep __ drink __ play cards ✓ listen to music __ think of you.

My friends are __ few __ many __ interesting __ getting short ✓ groovy.

I'll be home by __ Thanksgiving __ Christmas __ Valentine's Day __ Easter ✓ Memorial Day __ 4th of July.

We need ✓ entertainment __ good food ✓ time off ✓ girls ✓ more girls.

Until I return please ✓ write often __ send care packages __ send money __ keep thinking of me!

Write __ soon ✓ today __ when you can __ because I'd like to hear from you!

__ Your son
__ Your loving husband
__ Affectionately
__ Your buddy
✓ Love

Signed Dick _____

* Two red cross girls visiting the American unit out here, dropped by today, Thanksgiving and dropped off a few of these, though you might get a kick out of it.

ALL YOU GRUNTS ARE THE SAME.
YOU ONLY HAVE ONE THING ON YOUR MIND.

Keep One Thing On
Your Mind

GRUNT
FREE PRESS

Just what I was thinking I swea[r]
for $5.00 (for 12 issues) won't bounce

Rank and Name ...

SS Number ...

Unit/Organization

..

APO/FPO ..

Scheduled Rotation Date

have a great grandfather who was in the Civil War. One uncle was a B-17 pilot during WWII. Another was in the Navy, so for me going into the military wasn't an "if," it was a "when." The military was just one part of growing up. So, in 1966, about a month before graduation from high school, I enlisted in the Navy with two school friends. We went in on the "buddy system" and thought we'd get

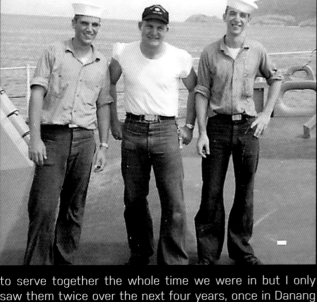

to serve together the whole time we were in but I only saw them twice over the next four years, once in Danang harbor in 1967, and once in Subic Bay in the Philippines in 1968. Going to war was never a factor in my decision to join. The whole idea of going into the service and seeing the world was very exciting.

April 3, 1967 rolled around, right after my 19th birthday, and I got orders to Danang for that very night. Now things are getting serious! We flew into the Danang airport at about 0100 the morning of April 4. The one thing I remember the most was when you first walk out the airplane door, even at that time, the heat just about knocks you to the floor. It's like walking into a brick wall. And then the smell, a combination of heat, jet fuel, human waste, charcoal, smoke, etc. What a rude awakening. They trucked us to Camp Tien Sha and we had to string our rack and try to get some sleep. Reveille was at 0600. Chow, quarters, and

then we were all assigned a job for the day. I was an ex-football player and pretty strong, so they told me to go over to this big truck and wait. Then a driver showed up and we lumbered over to a large receiving area at the Danang Hospital. It turns out, my very first day in Vietnam, I was to be a stretcher bearer for the hospital triage center. What a shock! I saw soldiers and Marines with all kinds of wounds and injuries, lost limbs, large wounds, lots of blood, lots of blood on my dungarees, lots of horror.

One guy I was carrying looked like he was on the wrong side of a claymore mine and had 1,000 little pockmarks all over his body, his face and uniform. Just before I put him down, he started shaking so I called the nurse over. I was looking directly into his face and he died right there. If anything, that first day in Vietnam probably had more emotional and mental effect on me than anything else I experienced in my 30 months overseas. I still have the image of this guy, the shape he was in, what he looked like, in my mind 51 years later. My sister passed away in January 2017. I was in the hospital intensive care unit, in her room, and holding her hand and looking directly at her face when she took her last breath. At that moment, my whole being was immediately back at the Danang Hospital triage center looking at that soldier as he died.

Most of my time in 1968 was with the Mobile Riverine Force in the Mekong Delta. We were part of a squad of seven ships. Typically, our rotation was every two or three months. We were relieved by the USS *Westchester County* (LST-1167) in the fall of 1968. She went on duty in the delta and we went to a local liberty port to take a needed break. On the night of November 1, 1968, as the crew slept, a team of VC frogmen evaded the picket boats and planted mines, each estimated to contain between 150 and 500 pounds of explosives. Compressed between the pontoons and the LST's hull, the force of the explosions was driven upward, shredding steel plating, rupturing fuel tanks and blasting into the berthing compartments. One of the berthing compartments that was hit was the Operations department NCOs, where I slept. If the Wesco hadn't relieved us, that would have been me on the KIA list. We lost 25 KIA, 17 of those KIA were from the ship's company, and 22 wounded. I knew four of the guys that were killed that night. That's when I stopped feeling so "bullet-proof."

ERNIE BERGMAN

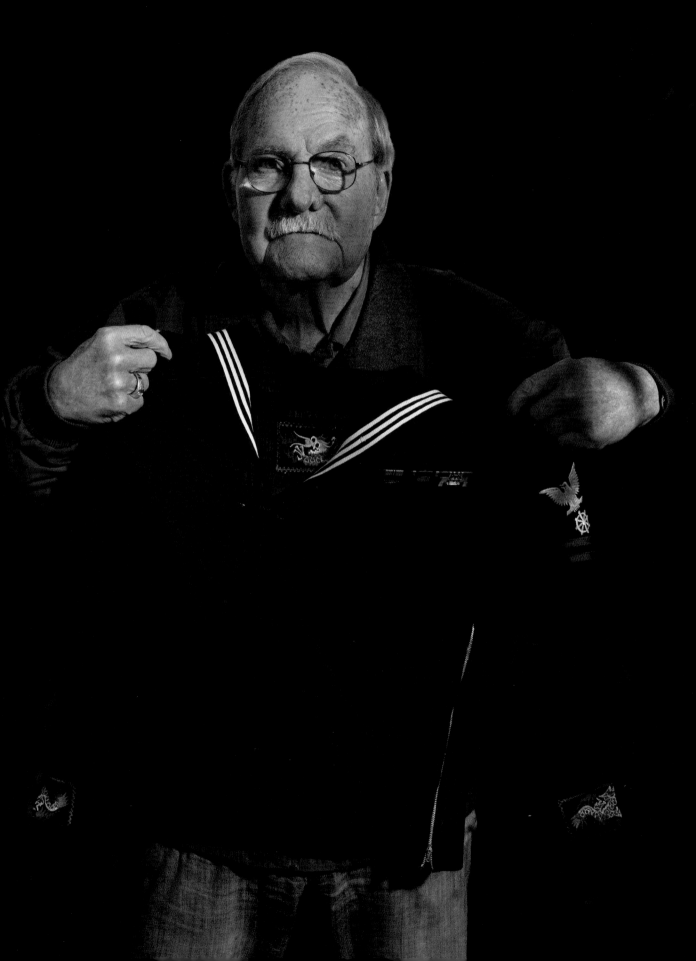

n July 1967 my brother Terry and I were drafted into the Army at the same time. At the induction center, I volunteered for Vietnam so that Terry would not have to go. He was four and a half years younger, newly married and I was single at the time due to divorce.

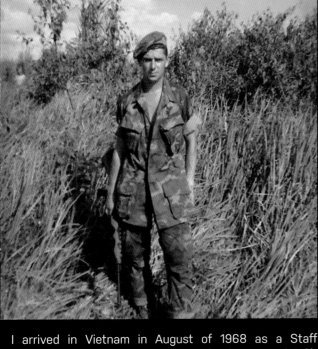

I arrived in Vietnam in August of 1968 as a Staff Sergeant E-6 and was assigned to Echo Company, 1st Air Cav., 2nd Battalion, Fifth Brigade. My first big battle was on LZ Jess. Sometime in late March or early April, on a really dark night, Chuck (NVA) tried to overrun the LZ by sneaking into Echo's sector. An alert young soldier named Glen Goss spotted the enemy with his Starlight scope and Echo's mortars were quickly pumping out rounds so fast that the tubes got hot and had to be cooled down—how, I will leave to your imagination. Come morning we counted 93 enemy KIA.

By early April I was the platoon sergeant of the recon platoon and we were running daily patrols. Echo was sent in to investigate a large bundle that an aircraft had spotted outside a heavily wooded area. Twenty-four of us were inserted around 1000 in the morning by chopper and humped about a klick to the pile. It turned out to be salt about the size of four bales of straw. We entered the woods and didn't go far before we came upon a camp with fresh food, weapons, ammo, and a freshly used latrine. We called it in but were told to keep going and came to a large bomb crater approximately 50 feet across and 15 to 20 feet deep. We went to the right of the bomb crater, which was luck or providence, because as the point man cleared the crater on the other side the enemy sprang a hastily prepared ambush. The point man was shot in the head but survived. The medic and I were called to the front of column. All hell had broken loose as the bulk of the platoon went into the crater and were returning fire. Our medic patched up Blue's head (his nickname) and, for whatever reason, went to pick him up. The medic took an AK round through the side of his chest, killing him instantly.

Amidst this chaos our lieutenant took a ricochet and was incapacitated, leaving me in charge. I had those in the crater form up on the opposite wall and start putting down some heavy fire to keep the enemy from overrunning us. The FO had started calling in the 105s, which was helping to keep the enemy's heads down but not for long. They wanted to rush us to get in the crater and do some real damage. I sent "Poncho" to the left with an M60 machine gun and another M60 with "Wash" to the right. I had picked up an M60 from a wounded soldier and together with the other two we got on top of the mound of dirt at the crater's rim. The threat of being overrun receded when the Cobra gunships came on station. They put on a display of sheer firepower, so low that the links from their mini-guns were dropping on our helmets like metal rain.

The enemy started falling back through the dense foliage. This gave us the opportunity to break contact and the guys picked up Blue and our medic and headed out of the woods into a large open area. We were about 200 yards from the tree line when the fast-movers came on station and requested we move away just a little further as they were going to drop some heavy ordinance on the woods. We replied we were a little tired and just go ahead and get it on. The first jet came in low and dropped what was probably a 500lb bomb and right behind him came another jet, again very low. We saw the canister of napalm flipping out end over end and then "swoosh," the jungle lit up like a Christmas tree. We felt the heat but we were really glad to see those flyboys. Shortly thereafter the choppers came in and picked us up.

A Medal of Honor, a Distinguished Service Cross, multiple Silver Stars, multiple Bronze Stars and multiple Purple Hearts were awarded due to the extraordinary bravery of the men of Echo in this firefight. I received the DSC for this firefight 49 years later, after it was upgraded from a Silver Star.

I came home in August of 1969 and it didn't take very long to realize that no one really cared where I had been or what I had done. I buried my medals, my stories and my memories down in the basement in a box where they stayed for 35 years. Then my wife read a book written by one of my peers and said to herself, "wait a minute girl, you need to go to the basement." She did and opened a large hole in my soul and has been dragging stuff out of it for 13 years.

MICHAEL L. DEHART

1968

Holiday Greetings

COMPANY C (S&S)

173rd ABN. BDE.

VIETNAM - 1969

Menu

Crackers

Shrimp Cocktail Giblet Gravy

Roast Turkey Cornbread Dressing

Bread Dressing

Cranberry Sauce

Glazed Sweet Potatoes

Mashed Potatoes

Buttered Green Beans and Mushrooms

Assorted Relish Tray

French Dressing

Chef's Salad Butter

Butter Flake Rolls

Fruit Cake

Mincemeat Pie or Pumpkin Pie with Whipped Cream

Assorted Nuts Assorted Candy

Assorted Fresh Fruit

Milk

Coffee

Tea

The morning of November 25, 1966 started like many mornings in Vietnam. This was now my eleventh month in Vietnam on this tour. We were alerted by the Control Tower at approximately 2345 that we had an inflight emergency inbound for a C-47 with a left engine out, ETA 10 minutes. We went into an orbit pattern north of the main runway. We flew the circular orbit pattern at about 300 feet above ground awaiting the inbound C-47 in distress. We would all fly with our flight helmets on and wired in place cable intercom radios and capable of monitoring the air traffic and control tower transmissions. We orbited for about 10 minutes and heard the C-47 aircraft repeat it's the single left engine out, 31 SOBs (Souls On Board), fuel load. As we circled, we heard a Vietnamese Air Force Control Tower Operator clear the plane to land VFR. On Final Approach, the VNAF Operator directed the C-47 Clear to Land R/W 07/R. Make a Left Turn and land on the active Runway 07.

Immediately my crew Pilot, Capt. Purviance and Co-Pilot Capt. Symmonds chimed in on intercom "Oh shit," "That is fuckin' stupid." "That is bad." To this day none of us understands why the C-47 pilot followed orders of the VNAF control tower operator and make a left turn on a left engine out. The time was a few minutes past midnight. Capt. Purviance announced over our intercom to be prepared for a crash landing. I was kneeling on the side door jump seat and saw the plane's perilous plunge to the ground. We went into a chase-like pursuit after the falling C-47 plane, which was at a point of no return and crashed right in front of us.

The explosion was spectacular and devastating, resulting in a large fire ball. The plane had impacted in a dry rice paddy mounding and, as we approached, another huge explosion occurred which was probably the tires or fuel cell of the wings exploding. The chopper deployed the Fire Suppression Kit (FSK) without incident and then dropped off me and the other two members of the team, rescue man/firefighter A1/C Ken Kaufmann and Flight Medic SSgt. Jerry Stanford. While we deployed the fire hose and nozzle, Jerry took off on foot and circled the crash site looking for any survivors or anybody who had been ejected.

The three of us were now on the ground in the "Badlands"—5.5 miles from Tan Son Nhut air base, unarmed, without portable radios, no SAR radios or flak vest. Ken Kaufmann and I were in aluminum fire pants, fire coat and crash hood that left us looking like space aliens. Flight Medic SSgt. Stanford carried a medical backpack but no weapon, no radio or SAR radio.

When Stanford returned, he signaled with a thumbs down that he found nobody. We had charged the FSK fire hose on the fire but the site was too large to dampen down the fire or contain the fuel load and materials burning in the destroyed aircraft. At no time did we see any bodies or remains; the impact basically incinerated the poor souls aboard that aircraft.

Suddenly, there were Vietnamese in black pajamas scouring the crash site picking up debris. At this point, without warning, our mission chopper departed for Tan Son Nhut, leaving the three of us on the ground.

In the hour that followed, some US Army Huey gunships crisscrossed above the crash site, which scared off some of the Vietnamese looters and spectators, while C-47 "Candlestick" and AC-47 "Spooky" gunships dropped flares. I ordered Kaufmann to remove his fire coat and crash hood. With Stanford, we hunkered down along a rice paddy dike. I remember a couple of the parachute flares dropping close to us and Vietnamese running up to pilfer the parachute fabric. At around 0100, our HH-43B returned, bringing a second FSK from Tan Son Nhut. The C-47 was still burning and Ken and I dressed again in our aluminum fire gear and deployed the firefighting foam from the second Fire Suppression Kit. It had little impact on the fire.

Another chopper brought in ten USAF Security Police "loaded for bear" with automatic weapons and they set up a perimeter and moved the Vietnamese onlookers away. I felt considerably safer after their arrival. Another USAF CH-3 Helicopter arrived later with 20 more security personnel followed by 40 fully armed soldiers from the 120th Assault Helicopter Battalion to back up the security personnel.

At about 0430, the three of us were finally flown back to Tan Son Nhut. My thoughts were of the tremendous loss of life and the experiences the three of us had been through. Ken, Jerry and I never slept that night and were awake until we changed shift at 0800. We crew debriefed at 1000 that morning and I had a private meeting with the Squadron Commander that afternoon. He guaranteed me that rescue crew would not be left on the ground, unarmed and unprotected, again. Two safety officers and members of the investigation questioned the aircrew involved in the deployment and rescue mission attempt. As a direct result, in future we were ordered to fly with our survival vest, loaded firearms and a SAR radio and flak vest.

I carry the experiences of that night with me to this day, some 50 years later.

Eight days after the fateful crash of the C-47 on November 25/26, 1966, the VC launched a major attack on Tan Son Nhut Air Base from Binh Ch'anh, the village near where the C-47 crashed. It makes me think how lucky we were to have survived the C-47 crash site.

HANK A. HOWARD

grew up in Marin County in Northern California—an ideal place for an Asian American to blend in. I received my draft notice in the summer of 1967 and made the decision to enlist in the Marines rather than be drafted by the Army. I quickly realized that we were at war with people that looked just like me. After a somewhat sheltered life, where I encountered little overt discrimination, I now found myself the center of attention for being Asian or a "gook." I was always volunteered by my peers to be the example in any hand-to-hand demonstration or to don black pajamas like a Viet Cong during mock battles. Marine boot camp is one of the most physically and mentally challenging experiences any sane person would ever care to endure. The fact that America was at war made the training that much tougher, as most of us expected to be shipped overseas at its conclusion. I often wondered if I would survive the 13 weeks of Marine training. I later learned that there were several bets within the ranks of the drill instructors that the "gook" in Platoon 3074 would never make it past the third week of training.

My resolve was that I was going to see this through. I was blessed with above average athletic skills and I had also completed one year of college when many of my peers had barely managed to complete high school. Marine boot camp did teach us to operate as a team and, as a team, any weak link could only result in failure. As the weeks passed, my ethnicity became less of a focus and our platoon developed a true sense of unity. We succeeded as a unit and we learned to watch each other's backs, attributes that, as we prepared for action overseas, would soon mean the difference between life and death.

Christmas 1967 was very special. I had just concluded advanced infantry training and scheduled for combat training in field artillery. I had also received orders for the WestPac theater, which meant I would be sent overseas. Timing was everything, and I was home for the holidays on a two-week leave during Christmas. Though the atmosphere had changed since my departure for boot camp, people were still patriotic and welcomed me home with open arms. I could feel that the perception of the war was changing, but I was home with family and still had that feeling of invincibility that all young people seem to possess. I didn't realize that I would never see the world this way again. I was able to make it home one last time, in February of 1968, just days before I was to be sent overseas. Even in that short time, the political climate had changed substantially. President Johnson was escalating the war and the nightly news continually brought the war home. The Tet Offensive had exploded in January and Americans finally realized we were in a real dogfight. A heavy sense of reality punctuated the weekend. Those that knew I was home came over to say their goodbyes in hushed tones like someone had just died. Others wished me well over the 'phone but I got the feeling that they could not bear to see me. This war had started to take its toll on all of us. Some of the invincibility from my last visit home wore off. I finally started to realize the important role we all had in the coming months, and the sense of responsibility was overwhelming during that flight back to Camp Pendleton.

Our staging battalion arrived in Danang and was quickly dispersed into other units according to individual Military Occupation Specialty (MOS). By the time I was finally processed, there were only two us left who were scheduled for transfer into an artillery unit about 15 miles northeast of Danang. Rather than deploying as a complete unit, we arrived as replacements. This meant earning the trust all over again of fellow Marines. Most of these guys had been in country for several months and had a rooted disdain for anyone Asian. I couldn't really blame them, given the horrors they must have endured fighting against people that looked exactly like me. Again, I faced challenges, except this time the stakes were much higher. The first few weeks were a blur that extended into months. All of a sudden, I was no longer a new guy and an oddity—I had become "just another Marine."

One day we had a chance to go into the Air Force Base in Danang for a meal after being out in the field for two weeks. We were unshaven, dirty, and exhausted and all we wanted was a meal and some rest before going back out again. I was in a truck with several other Marines when an Air Force MP stopped us at the gate. He had on pressed utilities, a spanking-clean white MP helmet and you could not help but notice the high gloss of his boots. He asked us to check our weapons at the gate because they were not allowed on base. He then looked at me and said I would not be permitted on base because non-documented Vietnamese could not enter for security purposes. One of my fellow Marines grabbed the MP by his shirt and said I was a United States Marine and, if he insulted any Marine again, he was going to shoot him on the spot.

Christmas 1968 came and I had less than three months to go before returning stateside. Passing the holiday season in hostile conditions brought a new meaning to being homesick. Having said that, being surrounded by people you could truly trust your life to is an experience that many non-combatants will never have. These fellow Americans only averaged 20 years of age, yet had a wisdom that only comes with facing life's uncertainties on a continual basis. That innocent and romantic glow of going off to war had become a distant memory. There was no more sense of invincibility and, as a young man of 20, I had already witnessed things that most people would never see in three lifetimes. Returning to the Bay Area after my tour was not as I expected. Returning veterans were not treated well and I never talked about my military service—I just wanted to get on with my life.

SELWYN LOUIS

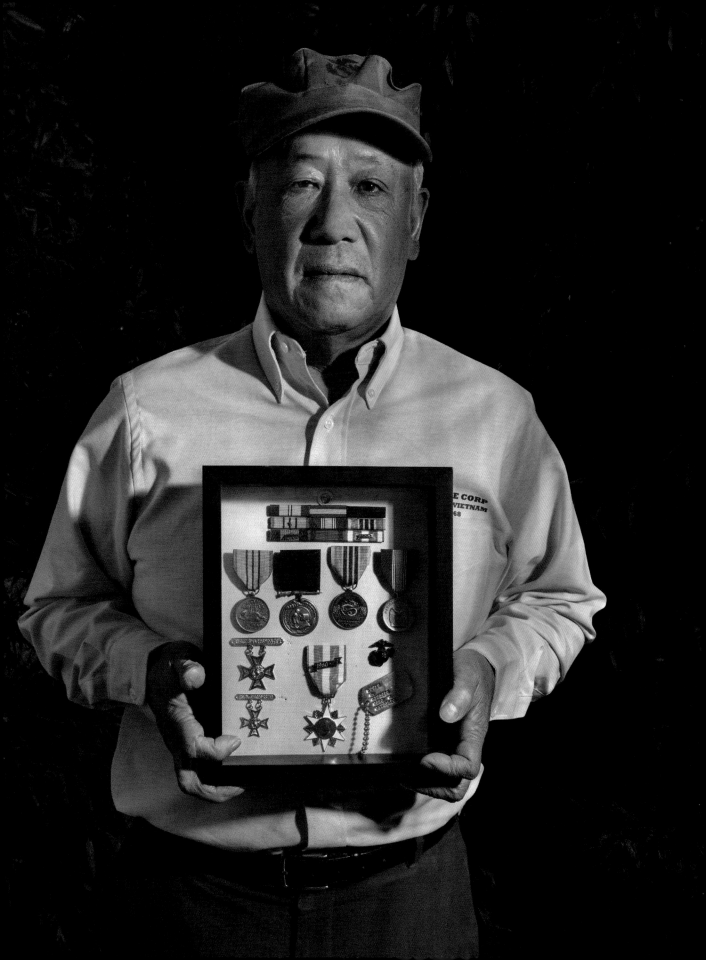

Company aidmen carried a large pack with a lot of life-saving equipment but were also, like other soldiers, armed with an M-16 rifle. As a medic, when trying to treat multiple casualties under fire in the heat of battle, I tended to concentrate on saving lives and forgot about the rifle. I did that several times, coming out of the battle area without my M-16. I got one written off as a battle loss, but they threatened to make me buy the next one out of my SP4's pay. After that, I started going into action carrying a D-handled shovel. That would be a lot cheaper if I lost it and besides, a shovel is always handy in the field.

RAYMOND DIAZ

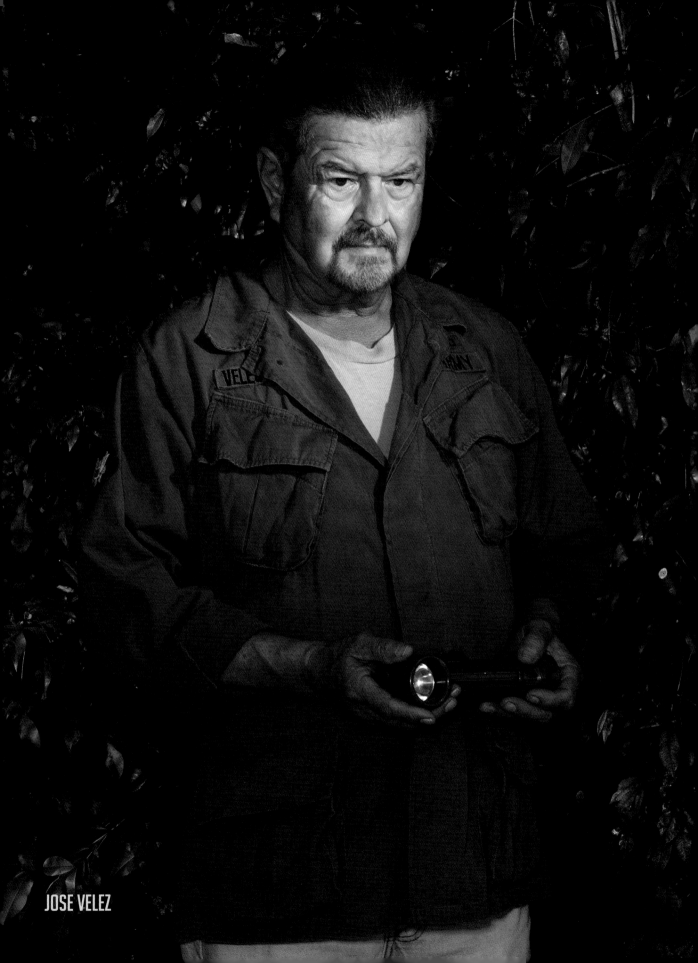

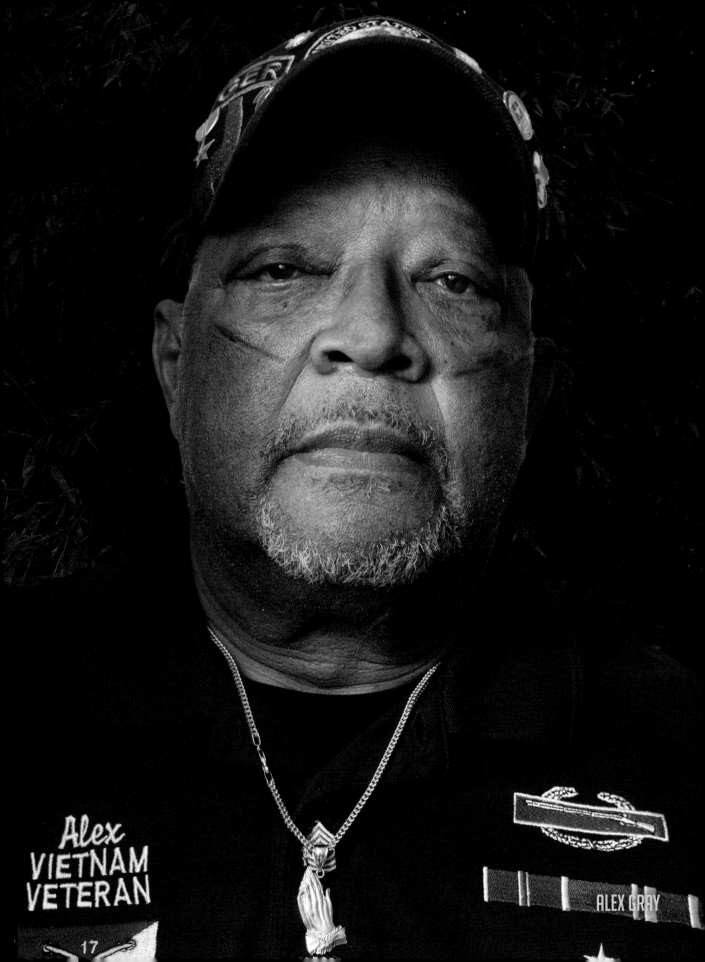

Alex
VIETNAM
VETERAN

17

ALEX GRAY

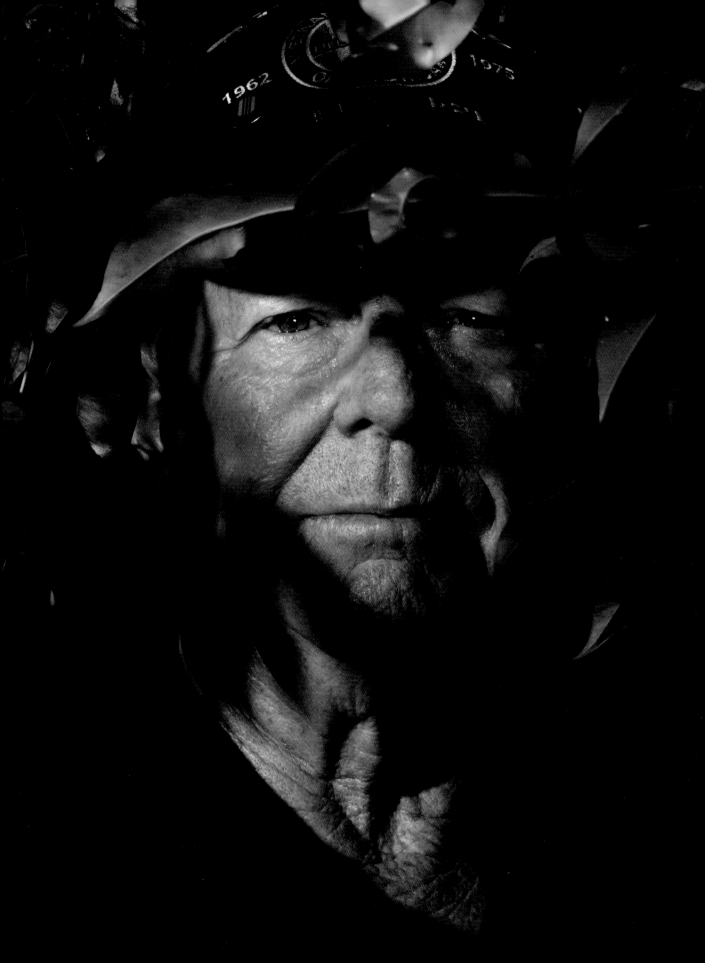

joined the US Army in 1962 at age 17 to get away from home and some things in life I was having trouble with. I felt that if I didn't get away, I would end up in jail. My mother kind of saw "the writing on the wall," as the old saying goes, and talked my dad into signing the papers. The country was not even talking about Vietnam at the time so we had no thoughts about being sent over to fight.

I spent three years as an engineer between the States, Okinawa and Korea, having reenlisted for six years in 1964. In 1966 I went to Okinawa and after a few months found out my old engineer company was there. I got reassigned to them with a cushy assignment. That cushy job lasted two weeks until we were notified that the outfit was shipping out to Vietnam in two weeks. I spent most of my year at a base just outside Pleiku on the road to Kontum but because my MOS as an engineer equipment repairman was in short supply, I was sent here, there and everywhere. That's the one thing about the Army, as an engineer you repair it all even if it's not your MOS. I spent several weeks in Kontum at the Special Forces base repairing their equipment and also at some of their posts. I had very little enemy contact most of the time. Once in Dakto I was at the Special Forces base when they got hit and it was pretty nasty for quite a few days before they were able to get me out. Just before I rotated out of country, my maintenance company got hit badly. Three sappers made it into the compound and blew a lot of our stuff up with satchel charges before one of the guys nailed them.

I spent '67–'68 back in Korea and, as my tour was ending, filled out the paperwork hoping to go back to Okinawa. A few days later they called me in and asked me if I would go back to Vietnam as my MOS was again in short supply. I said okay and figured I had time to have a little fun before I went to 'Nam. Wrong. They cut my tour short and shipped me out right away. They didn't even offer me the chance to go on leave.

In 1968 I was back in Qui Nhon. They had me shuttling trailers from place to place and I did have a few close calls.

A few times bullets came awful close to my head—you could feel them go by—I still have one armor-piercing slug that came on the passenger side, almost hit my neck and buried itself in the metal right next to me. The damn thing went through three pieces of steel on its way. I didn't know I could drive a truck the way I did until that happened. It was like the Indy 500, with all the shifting and putting the pedal to the metal.

I have continued to be involved in Veterans' affairs ever since my discharge in 1970. I am active in my Vietnam Veterans of America chapter and am post commander of my AMVETS post. For 41 of the last 43 years I have assisted in placing the flags on veterans' graves with the Boy Scouts of America. I chaired the program for around 12 years and have been the MC for some 23 years. I sit on the committee that plans the Memorial Day, Veterans Day and Wreaths Across America Day at Golden Gate National Cemetery in San Bruno. I have been doing Final Military Honors for our veterans who pass on and am a licensed chaplain. I work as a volunteer with the VA at the San Joaquin Valley National Cemetery a few days a month and at other venues all over the San Francisco Bay Area. I currently carry the brevet rank of colonel as a chaplain with the United States Volunteers–America.

If I had it to do all over again, would I? The answer is Yes. I had good times, bad times, boring times. I lost some friends in Vietnam and one in Korea. I had a few nightmares, but I have not had a bad one since 1984. I do find myself easily brought to tears when I talk about it and that has been getting worse. I may have to go into counseling one of these days but my therapy has been working with other Veterans and believe it or not the Final Military Honors help me a lot.

LEO MCARDLE

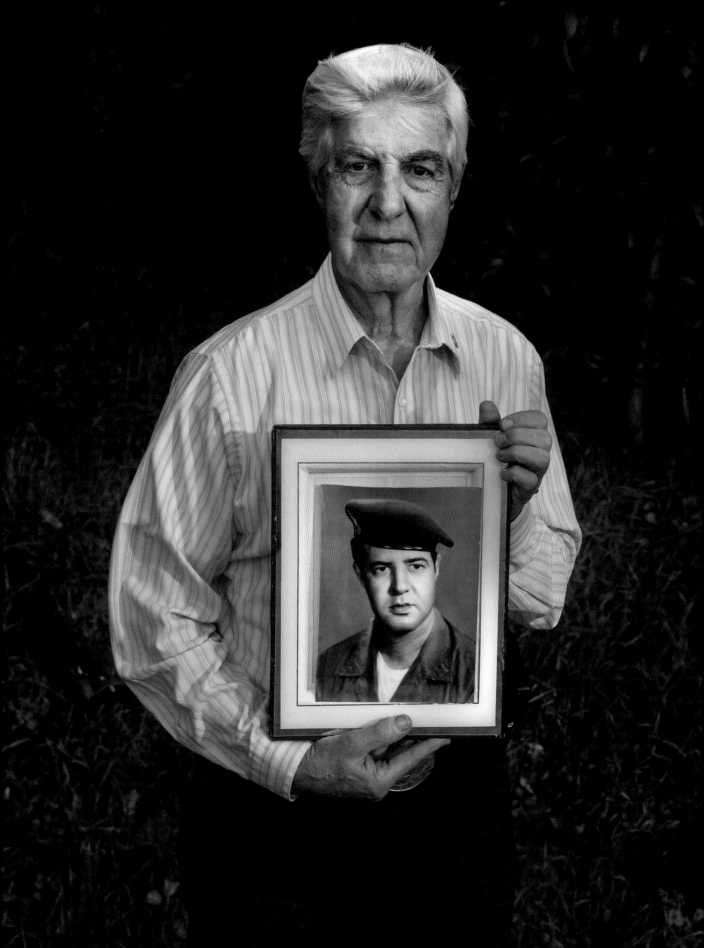

The barber across the street from our hotel turned out to be Viet Cong. He was collecting intelligence by cutting hair. It was unsettling to think about the fact that this guy had a straight razor in his hand the whole time while shaving my face, ears and neck. And he was the enemy.

 Two young Vietnamese sailors I was training wanted to take a picture with me. They had bought a Kodak Instamatic and got someone to take a picture of the three of us. Then the two sailors went into their room and I heard a boom! I went in and had to clean these two men off of the walls. There was a C-4 bomb planted in the camera and when they hit a certain point, the camera exploded instantly killing them both. I was just one picture away from what occurred, which affected me big time.

WILLIAM E. MCNICHOLAS

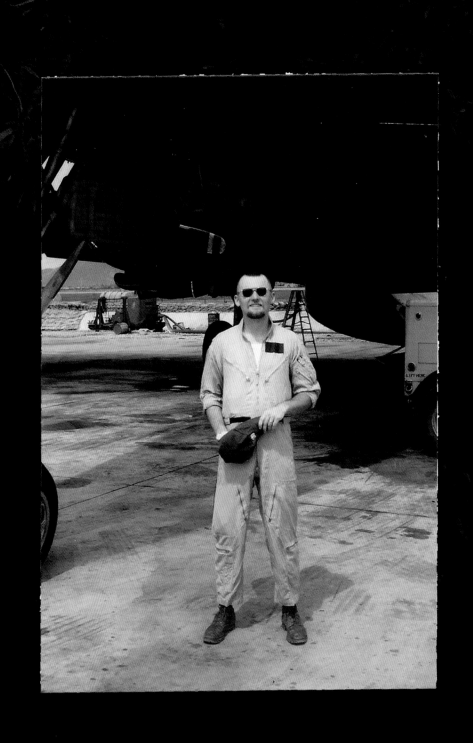

Between September 1965 and June 1967, I flew 213 missions against North Vietnam. There were a lot of guys in the squadron who flew many more. Most of the missions I flew were out of Danang, although about a half dozen were from Cubi Point, Philippines and another half dozen from the carriers USS *Midway* (CV41) and USS *Independence* (CV62).

Most missions were pretty uneventful, although a couple did get a bit dicey. For me, the most memorable was an early morning (around 0200) mission in September of 1965 when we were in an EA3B up around Haiphong and two MiGs came after us. Fortunately, we had equipment that allowed us to detect them before they reached us and we had a great pilot who got us out of there. We could not reach Mach 1 but we came as close as you can in the A3. We ultimately flew down to Yankee Station where the USS *Midway* launched two F4 Phantoms. We teamed up with them and went back north MiG hunting. The North Vietnamese were no fools and beat a retreat back home.

Every day we would get the results of our efforts in north via the Operations Reporting System. While apparently documenting our successes against the North Vietnamese, it also listed our losses. We lost so many young Navy, Air Force and Marine pilots and air crew, it was depressing. We attacked the same targets over and over. An excellent example is the Thanh Hoa bridge, originally built by the French, which we started hitting in 1965—we finally took it down in 1972!

While I never questioned the war on any moral or ethical level (it was only several years later that I realized how wrong this war was), I did question, as did many others, our overall tactical approach. It seemed to me that our air tactics were not proving successful but we were continuing to sacrifice good people with no positive national outcome in sight. I also felt this war would continue for years to come—and I turned out to be right. I can sum up my thoughts on the Vietnam war in two sentences—using the same five words.

WE FOUGHT THE WRONG WAR!

WE FOUGHT THE WAR WRONG!

PATRICK J. CONNOLLY

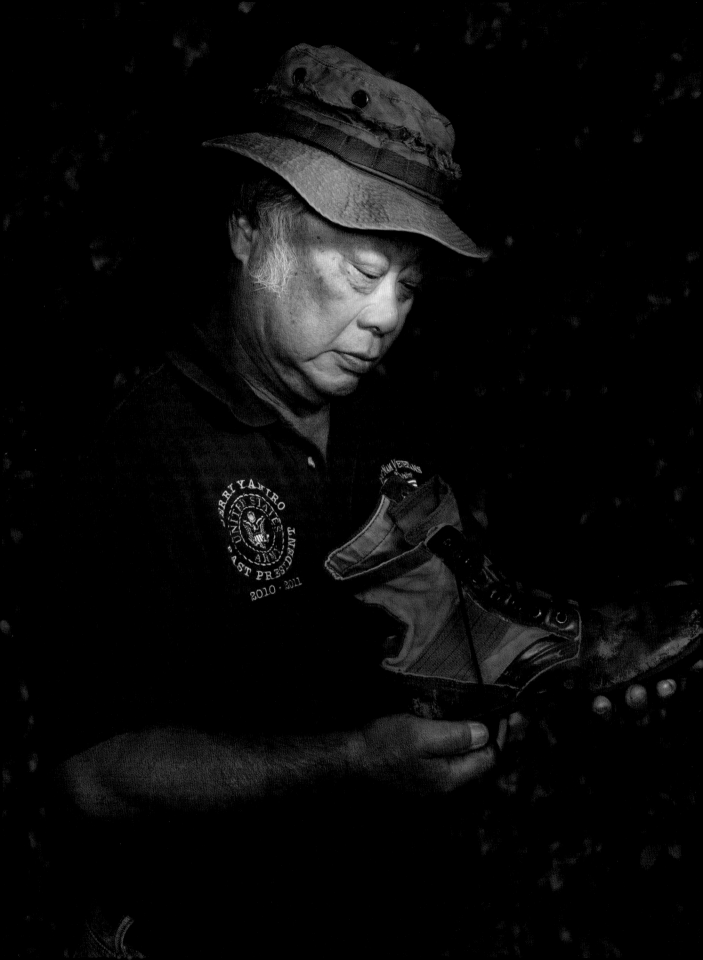

remember flying into Vietnam vividly. As the plane crossed the coast from the South China Sea, I had a window seat. I was looking out and, far below the aircraft, I noticed a white speck, a silver speck, flying just about the treetop level. As I watched it, all of a sudden, there was an eruption of flames, so evidently the aircraft had dropped a napalm bomb. As I watched it, I formed the realization that, yes there was truly a war going on here. That was probably my first impression of arriving in Vietnam. Sort of the "Welcome to Vietnam."

Some of the C-rations that we had when I first got there had been packaged in World War II—in the 1940s. I remember one of the boxes that I opened up, there was a pack of Lucky Strike cigarettes. Lucky Strike cigarettes during World War II were packaged in a green and white package, unlike the Lucky Strikes in the red and white package that you see today. Well, that gave you an idea how old the cigarettes were and the canned food was just as old as the cigarettes if not older.

I remember leaving Vietnam. In fact, it was probably my most poignant moment of the year that I was in Vietnam. I had made arrangements to fly back to Hawaii and take some leave. I was born in Hawaii. The flight left from Tan Son Nhut Air Force Base in South Vietnam and was heading to Hickam Air Force Base on the island of Oahu. The aircraft that we took wasn't a commercial aircraft, it was a huge military transport. They had some seating arrangements in front of the aircraft but it was generally used as a cargo aircraft. As we boarded the aircraft, I happened to notice that they were loading some kind of cargo in the back of the aircraft. I was going home, we were leaving Vietnam, so we weren't particularly interested in what was being loaded. We got inside the aircraft and I guess there was about ten or twelve of us that were taking the hop out of Vietnam. We introduced ourselves and were all jovial, chatting about where we are going and what we were going to be doing and that sort of stuff.

The aircraft took off and, as our eyes adjusted to the dim lighting inside the aircraft, we all noticed, pretty much simultaneously, what cargo they had been loading in the back. There were about 25 silver metal boxes which turned out to be caskets. The "cargo" that they were shipping home was our dead comrades. There was about a dozen of us in front of the aircraft that were leaving Vietnam and heading back to the rest of our lives. In the back of the aircraft were 25 of our comrades who were also going home, but this was their final journey.

That journey, my departure, was probably the most lasting impression that I have from Vietnam.

JERRY YAHIRO

GRUNT
FREE PRESS

35¢

Interview
with
a lifer·

....page 2

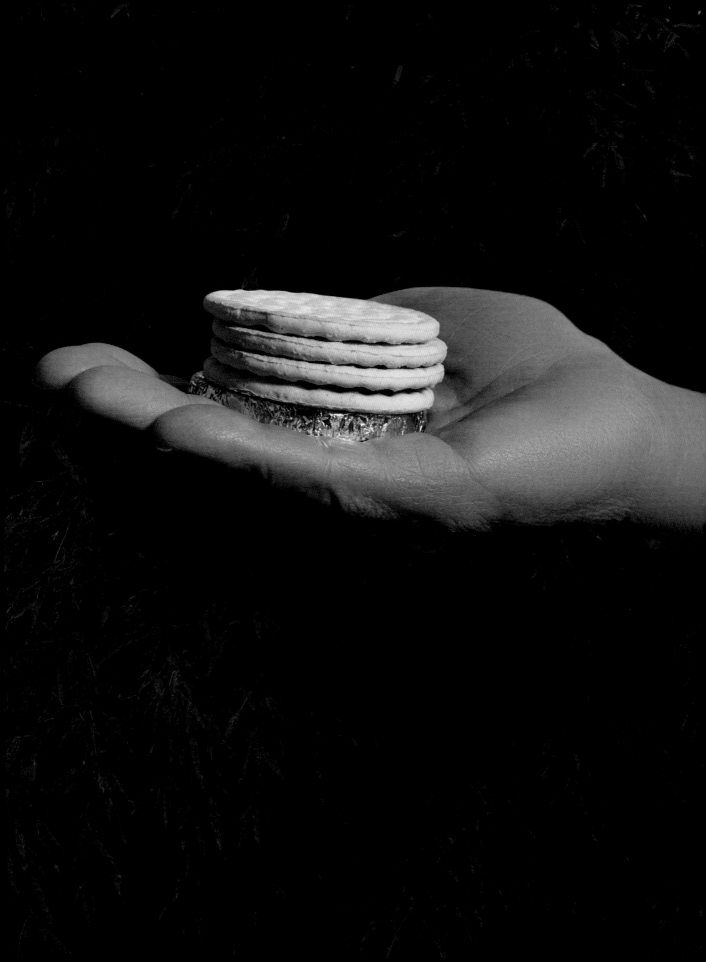

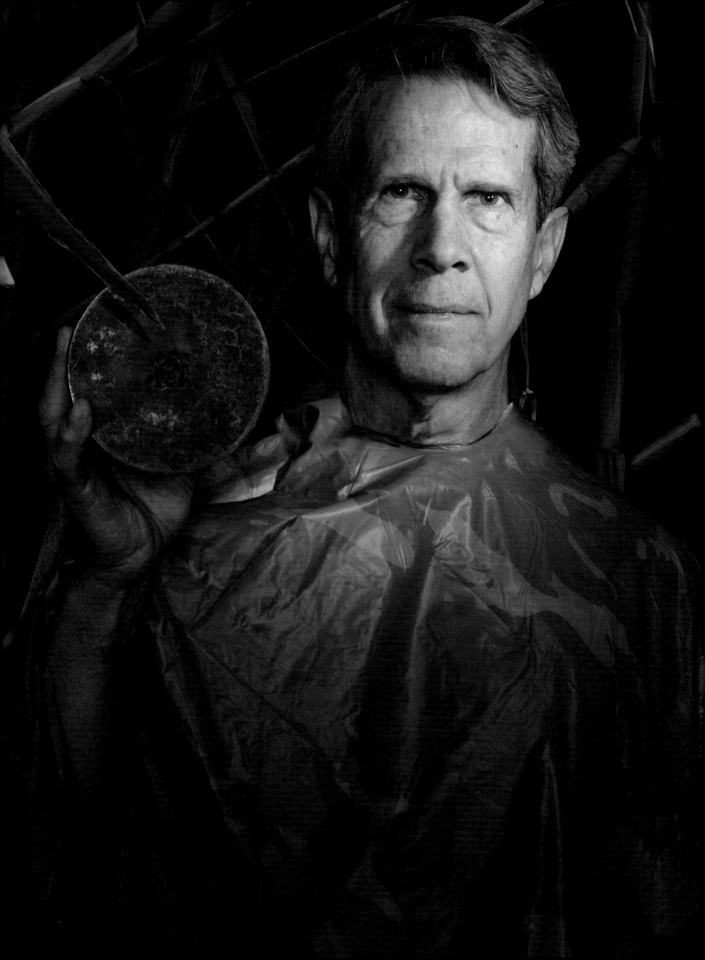

got my orders for Vietnam at the beginning of November 1969. I had gone through the Quartermaster Officer Basic Course and the Petroleum Officer Supply Course so I knew petroleum from the civilian side as well as the military side.

I knew in order to do any job that they asked me to do without hesitation or even thinking, I had to believe I was already dead. I broke down at that point and cried. I was completely willing to give everything I had for my country, but I did not want to die. The only way I could reconcile these two emotions was to consider myself to be dead. From that point forward I was willing to kill anyone, man, woman or child, including our own military, who I felt was trying to get me killed or kill me. I'm not sure if that was the attitude the Army wanted me to have. I do know that a lot of the military people who were in Vietnam hated the enemy and the Vietnamese in general. I guess by demonizing them it made it easier for some of the troops to kill them. I, on the other hand, didn't hate them at all. But, as I said, I was going to kill anything or anybody that tried to kill me. This difference in attitude is probably due to the fact that I didn't go through basic training either as an enlisted man or an officer and because I was an "old man"—26 years old—when I arrived in Vietnam. As a matter of fact, I thought the Vietnamese were very industrious, hard-working, family-oriented people. The enemy's job was to kill me and my job was to kill him. Pretty simple really. Life-and-death in war is strictly a matter of chance. There is nothing you can do to keep yourself absolutely safe and, if you are not going to die, there is nothing you do that will get you killed. To give you one example, I heard about a captain who had been in country a couple of weeks when he was stabbed to death in his hooch. I spoke to the MPs investigating the matter and they felt that he was killed as a result of mistaken identity. The officer who occupied that hooch before him was not well-liked by his men. The MPs surmised that someone had taken revenge. I was glad to leave Vietnam but I still had that "walking dead" feeling. At one point after I got back, my wife and I were driving in the car and something happened. I reacted violently and my wife yelled, "You're going to get us killed!" and I started laughing. I couldn't believe I had spent a whole year in a war zone and now I was supposed to worry about getting killed?

I didn't receive any kind of congratulations or best wishes from my parents or siblings or even close friends. No one ever talked about the war. I was kind of lucky I guess though. Nobody met me at the airport and tried to spit on me. I know what would've happened if that had

occurred—someone would've died. No one ever called me a "baby killer" either. Yes, we killed babies in Vietnam, but certainly fewer than in World War II when we firebombed 67 Japanese cities and killed somewhere between 246,000 and 900,000 Japanese men, women, and children. We did pretty much the same thing in Europe when we firebombed Dresden among other cities. I'm sure a few babies died in those incidents, but that of course was a "good war."

My values and outlook on life have certainly changed as a result of my experience in Vietnam. Let's say I'm a lot more cautious and a lot less willing to believe what other people say. I believe more than ever in the values General MacArthur spoke of in his address to the Corps of Cadets at West Point in 1962: Duty, Honor, Country.

CLIFFORD DECUIR

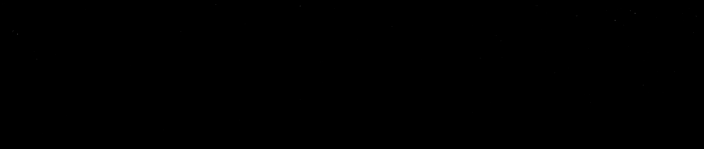

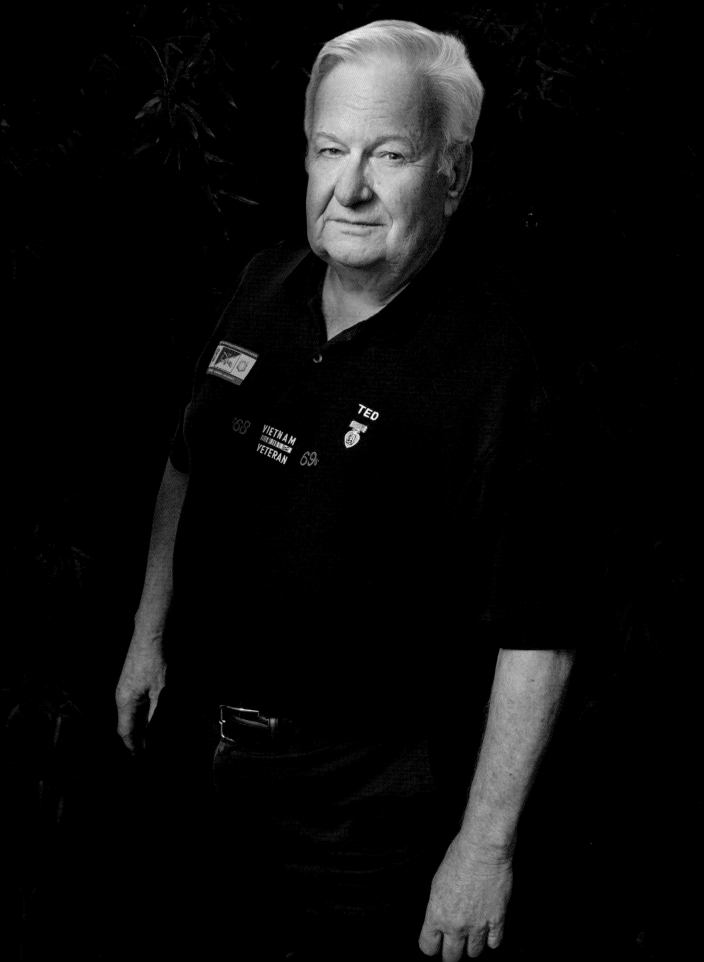

arrived in Saigon February 11, 1968 on my second 90-day Temporary Duty (TDY)—ideal timing for a new Combat Photographer. The 1968 Tet Offensive had begun only days earlier as desperate fighting erupted simultaneously practically everywhere in South Vietnam. DASPO photographers carried a Press Pass and functioned in the same way as civilian press news reporting teams; free to pursue their work, with a directive signed by General Westmoreland that granted them assistance and travel priority as they moved about to film at unit locations. I filmed successively at Khe Sanh and in the A Shau Valley, as the fighting continued. I was up near Hue city when "mini-Tet" broke out on May 5.

The following day, I was with a squad from B Troop, 2nd Squadron, 17th Cavalry, 101st Airborne Division as they were clearing the area in and around La Chu, a previously bombed-out and deserted village about 5 kilometers northwest of Hue. A North Vietnamese Army (NVA) battalion had strong defenses in and around the village and clearing them out was difficult, slow work. It was on this same day, just outside the village, that Sp4 Robert Patterson won his Medal of Honor.

I had been sticking really close to his squad all day; I wouldn't have been doing my job otherwise. A good motion picture shot requires the combat photographer to stand fully exposed to the action being recorded while holding the camera perfectly still for at least ten seconds, no matter what is happening.

I was filming near a temple building when a rocket-propelled grenade (RPG) detonated close by. I was blown about 20 feet by the blast but luckily had no visible wounds and I stayed with the men in the squad as they continued on for another two hours, clearing buildings and bunkers and starting forward, only to begin receiving fire from previously cleared locations, so progress was slow. Daylight was fading late in the afternoon when I was wounded. One of the troops threw a grenade into a bunker, only to have it immediately tossed back out into the middle of us. Six or seven of us were hit. I had grenade fragments in a leg and my buttocks. Several of the other wounded were in far worse condition than I was but we all remained together during the night because we were still in close contact with the NVA.

Early in the morning, about 0200, the enemy disengaged and withdrew. We walked out that next morning (May 7). The other wounded went to the Aid Station, but I caught a helicopter going to Phu Bai and my wounds were dressed at the 22nd Surgical Hospital there.

THEODORE "TED" ACHESON

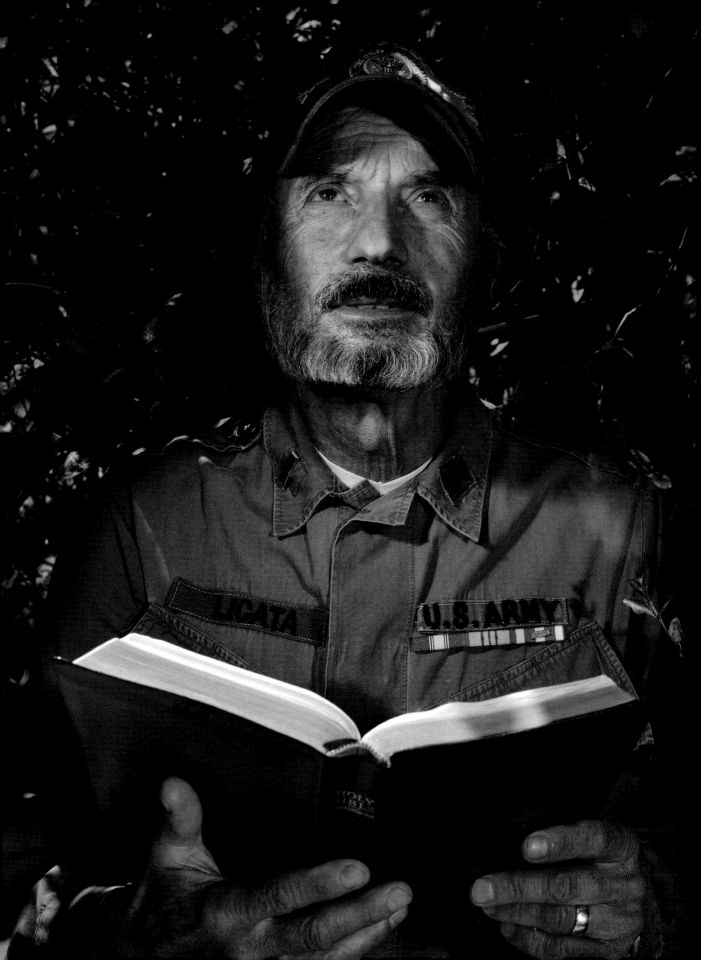

was not anxious to see combat, as some of my colleagues in ROTC were, because my dad had dispelled all thoughts that war is glamorous. On the other hand, I felt privileged to serve my country. My father—my hero—served his country well during World War II; now it was my turn and God gave me the calm assurance that my life was in his hands. My only regret was that I was newly married and I was not thrilled about leaving my soul mate.

I arrived in Vietnam at Bien Hoa Airbase and I recall a terrible odor and an uncomfortable sticky humidity that hardly ever left me for a year. My first night in Vietnam played like a horror movie. They put me up in a flea-pit hotel in the middle of Saigon with a guard and a machine gun surrounded by sand bags in front. They told me there was nothing to worry about. I had not been issued a weapon yet and I was up all night, hearing noises in the streets. I had been working out, was in good shape, high on adrenalin and ready for hand-to-hand combat but the bad guys never showed.

I was based at Nha Trang and, at one point, the enemy zeroed in on our position at about 0200. I was a young soldier and this was my first experience of enemy fire. The mortars marching closer and closer to my barracks were terrifying. It seemed like the next one would land right on top of us and we would be blown to dust. The choices were to run to a secure bunker or to get under my bunk. I chose to get under my bunk, where I had previously positioned sand bags and it proved to be a good choice as some soldiers were severely wounded on their way to the bunker. I heard soldiers screaming and thought I might die but, because Jesus is my Lord and Savior, I knew I was in His hands. It turns out that our Battalion Chapel, where I had attended a Bible Study the night before, had sustained a direct hit. It was around this time that we were inspected by four-star General, Ralph E. Haines, Jr., our Commander. Shortly thereafter, my wife got a surprise letter about me from General Haines in which he stated, "His senior officers tell me he is performing well and that he takes pride in his work and association with the officers and men of the 459th Signal Battalion. You can be proud of him, as we all are, for the job he is doing to further the cause of freedom." A short time later, I received a Bronze Star and the award letter states that the Bronze Star is awarded to First Lieutenant David S. Licata "For Meritorious Achievement in Ground Operations Against Hostile Forces in the Republic of Vietnam during the period 25 June 1969 to 10 June 1970."

I felt blessed to return home but we were not treated well. I witnessed sneering and anti-war protesting and American flag burning. There was no gratitude or recognition that we had risked our lives and fought communism for the cause of freedom. Having been a student at Cal, my wife and I drove to Berkeley and saw people wearing the flag that I fought for so proudly. The lack of respect for our flag was totally distasteful to me.

Although I never received a combat wound, because the area in which we operated and traveled was sprayed with the herbicide Agent Orange, I was exposed to this chemical. About 20 years after my return, my liver failed and I was very blessed to get a liver transplant. Agent Orange also affected my digestive system and I am currently 100% disabled as assessed by the VA.

DAVE LICATA

joined the Air Force in '63 when I was eighteen. After basic training I was sent to Air Intelligence School where I learned to read maps, charts, aerial photography, and radarscope photography. A month after my nineteenth birthday I arrived at a Strategic Air Command base outside a small city on the Great Plains where I worked on the war plan, the belligerent component of the Cold War. We had nuclear-armed B-47s and ICBMs aimed at the Soviet Union and ready to go on a moment's notice every day of the year. It should have been interesting but no matter how aware we were that civilization rested in our hands, the work grew dull. So when the United States began bombing North Vietnam all of us young airmen wanted to head right over. The men who had served in WWII told us we were nuts, but we young guys were full of war movies and wanted to play our part. I received orders for a base in Thailand. When I arrived, there wasn't much to the airbase. It was being carved out of a jungle, leaving loose red dirt that turned to mud when it rained or, when the weather was hot and dry, a dust that seeped into everything. Right off the top in the base orientation briefing we were told it was confidential that we had bases in Thailand so don't write home about it. Everyone who heard that was floored. Thailand was printed right on our orders. We had told everyone back home where we were going. That was nothing compared to what I learned the first time I reported to my new duty section, the Target Room in Base Operations. I expected to be shown the ropes and given a duty schedule. Instead I was thrown into an action already underway. Only minutes into serving in our war in Southeast Asia, I was told to work on something I knew our government denied we were doing. I had huge security clearance and I thought I knew what was going on. For example, I knew we were neutral in the civil war in Laos, in which the Pathet Lao were fighting the Royal Lao establishment. Then I reported to that target room in Thailand and was told to work on combat air support for a CIA base in Laos that was being overrun. I said to the sergeant in charge, "We're not supposed to be doing this." He looked at me like I was the most naïve kid in the military, then said he had only been there a week. It would all be explained. If it ever was, I missed that briefing.

The United States bombed Laos nearly every day for ten years. I've heard people say we were interdicting the Ho Chi Minh Trail. Well for a year of that time I was in the target room and we did bomb the trail, but we bombed just about everything else too. Every night a coded message came from Saigon with the coordinates of the next day's targets. In the Target Room a half dozen of us airmen built the target charts, marked them with the locations and range of enemy defenses, and with the Designated Ground Zero (a small yellow triangle with a red dot in the center). Along with that, an aerial photo, and a briefing the pilots climbed into their F-105s and crashed into the early dawn, bearing northeast. Many did not return. There were flights that had no Designated Ground Zero. Armed Reconnaissance flight was their designation. Armed Recce, we called them. These were mostly in southern Laos—a zone we called "Steel Tiger." The pilot's mission was to fly over the area and open fire on anything that moved. Everything that moved was a target. Those of us who worked in the Target Room kidded about it. We'd say a nun on a bicycle was a target or a boy on a water buffalo. We kidded but it was true. Near the southern Laos border with Vietnam where a country road twists along between farmland and hilly jungle stood two buildings that looked like old army barracks. I'd looked at them in aerial photography over and over but they were never targeted. Many sites in North Vietnam and Laos that looked like obvious targets were not to be attacked without direct orders from the Joint Chiefs of Staff. We called them JCS targets. The barracks were a JCS target so there they sat. There were two reasons why a pilot on an Armed Recce flight could strike those barracks: one, if he was briefed to strike them; two, he saw activity around the barracks. If he saw activity, it trumped JCS. Early one morning, around 0300, a pilot whose assignment that day was an Armed Reconnaissance flight came into the Target Room to study the maps and aerial photos of the area he would be flying over. He and I were the only people in the target room. He asked me if I knew of anything worth going after in the area. It excited me to be put in that position. I knew I was breaking an order but I showed him an aerial photo of the barracks, showed him on a map where they were, told him they were a JCS target. He thanked me. I felt like a big shot, felt more a part of the bombing than I'd felt in a while, my usual night in the target room sometimes being no more than an abstraction of the hell we caused. He blew up the barracks. It created an uproar because they were JCS but in his debriefing the pilot said he saw activity around them. That made them an Armed Reconnaissance target. Ultimately the chain of command accepted his story. The pilot never looked me in the eye again or acknowledged me in any way. Our bombing of Laos was covert and, like all of the work I did, Top Secret. The people I could tell about the barracks was reduced to the few airmen I worked beside in the target room (and bunked, ate, and drank beside the rest of the time). So much was going on, though, with multiple targets every day and our birds getting shot down and our pilots killed or captured, that what I'd done about those barracks quickly lost interest. Other targets stay in my mind, in fact won't go away. A railroad bridge northeast of Hanoi, Bac Ninh Rail Interdiction Point we called it.

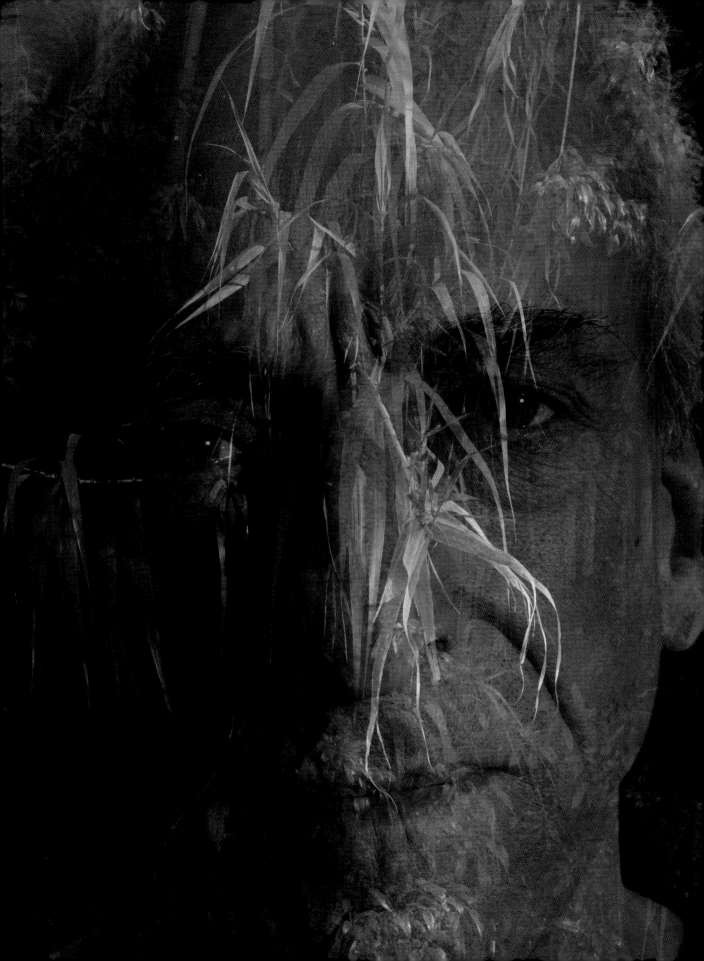

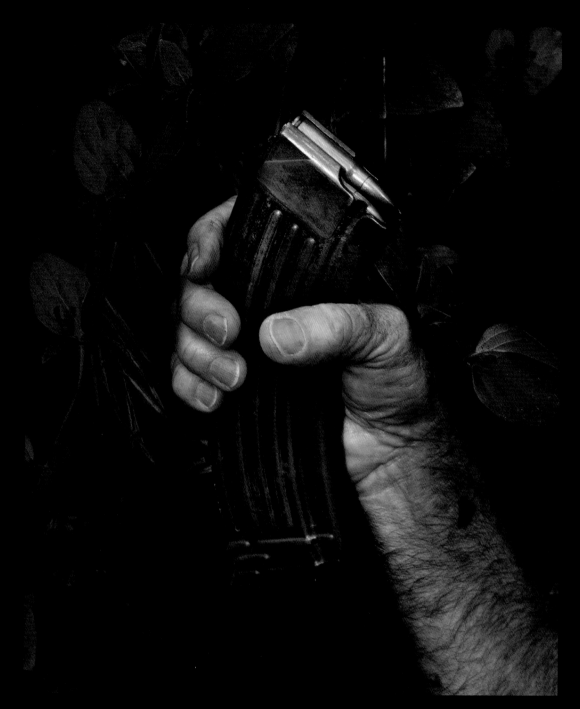

I remember it because we had to go after it three times before we took it out. All three times I built the target charts. A few weeks ago a friend of mine, an American veteran who lives in Hanoi and leads a project to educate people on how to handle unexploded ordnance, or UXO, sent me a news article that told of a bomb left over from the raids on Bac Ninh going off and killing a bunch of people and taking down a bunch of buildings. So even as I contemplate my war service I'm still destroying lives over there.

I feel bad writing about it. I feel I'm boasting about a single incident in a four-year chapter of my life during which everything I did was wrong. It stands, however, as one of a catalogue of reasons I rarely believe anything our government says, and one reason I do not want anyone to thank me for my service.

DENNY RILEY

Hi Honey

I love you. I have a very
short time to write, its getting
dark. I sorry that I is missed
writing the past two or three
days. We been
moving real hard the past
three days.
Hey, I've seen four
monkeys and one TIGER!
How about that.

We've been chasing
a mess of V.C. for the
past three days and the

another

HOLD RADIO WITH ANTENNA UP ↑

MORSE CODE

A · —
B — · · ·
C — · — ·
D — · ·
E ·
F · · — ·
G — — ·
H · · · ·
I · ·
J · — — —
K — · —
L · — · ·
M — —
N — ·
O — — —
P · — — ·
Q — — · —
R · — ·
S · · ·
T —
U · · —
V · · · —
W · — —
X — · · —
Y — · — —
Z — — · ·
1 · — — — —
2 · · — — —
3 · · · — —
4 · · · · —
5 · · · · ·
6 — · · · ·
7 — — · · ·
8 — — — · ·
9 — — — — ·
0 — — — — —

TURN ON-EXTEND ANTENNA FULLY. BLACK RING MUST SHOW. TURN MODE TO CW.
TRANSMIT-PRESS PUSH-TO-TALK PER CODE.
RECEIVE-HOLD SPKR/MIKE TO EAR.

OPERATING INSTRUCTIONS

TURN ON- EXTEND ANTENNA FULLY
BLACK RING MUST SHOW
SELECT CHAN-TURN CHAN TO CHANNEL
DESIRED. PRESS REL TO
RETURN TO GUARD.

SELECT MODE

VOICE-
RECEIVE-TURN MODE TO V
ADJUST VOL
HOLD SPKR/MIKE TO EAR
TRANSMIT-PRESS PUSH TO TALK
TALK INTO SPKR/MIKE
TONE-TRANSMIT-TURN MODE TO T
CW-SEE MOS MORSE CODE DECAL

VOL

MODE

REL CHAN

SPKR/MIKE

EUGENE GRAHAM

Next morning, we were marched out to an equally grimy "parade" field and addressed by a red-faced Catholic priest, who suggested we kill a commie for Christ. I knew I was in the WRONG place. We stopped at a grenade range. Before I was able to take my turn, a sergeant accidentally dropped his live grenade into the pit adjacent to his, occupied by another sergeant. He immediately jumped on the grenade to save his friend. I'll never forget the sight of his ruined body bouncing on a stretcher as he was taken to a helicopter.

AL MILBURN

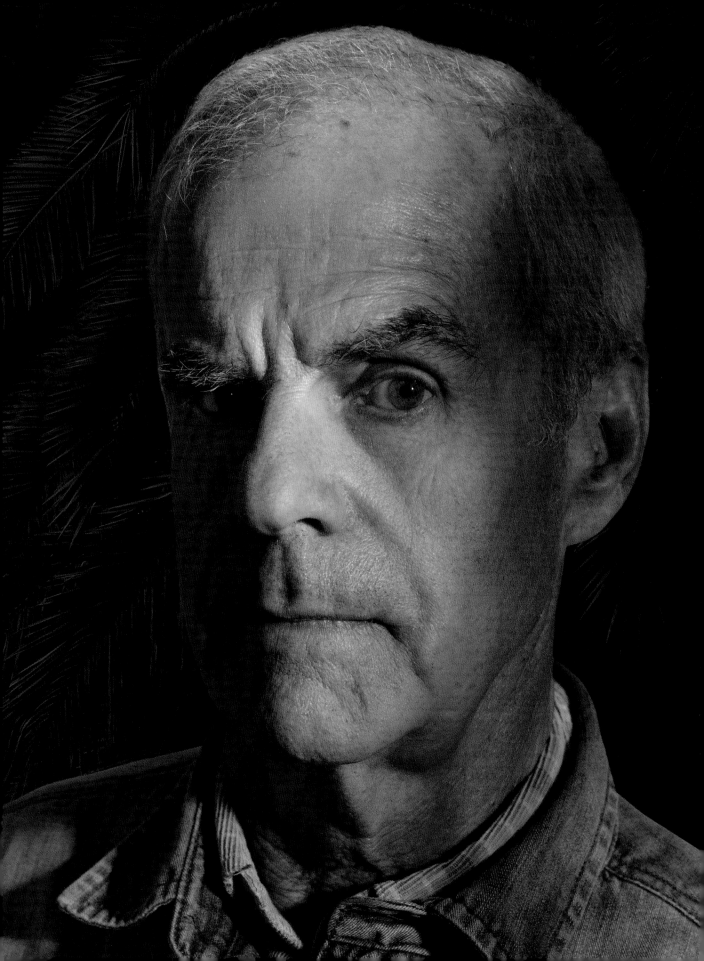

was drafted in August 1966 after flunking out of the University of Virginia in 1965 and becoming 1A. I seriously thought that a "probable ulcer" was going to keep me out of the army and was naive enough to think that I would show the X-rays to someone at the induction center who would pull me out of line, conclude that it was a mistake and send me home. I had band practice that night, August 4, 1966, and a date afterward. Instead, I found myself on a bus to Fort Bragg N.C, and 10 hours later watched as a "barber" skinned my head at 0400.

The most shocking thing I experienced in Vietnam (I remember the day) left permanent scars on at least two guys in my unit. An FNG, a new guy, was loading rockets into a Cobra gunship on the flight line when one of them went off. It torched a hole right through the guy and blew up a dumpster 200 yards beyond. Years later I spoke with the guy who was standing next to him at the time. He was later court-martialed over his changed behavior—the army denied any responsibility for the accident.

Later, I was medevac'd to a field hospital in Dong Tam with a suspected appendicitis. After my appendix was removed, I was placed in a Quonset hut. It was pretty much empty at the time but soon filled up as men from the 9th Infantry were brought in after surgery. A few hours later they wheeled this black guy in and moved him just across the aisle from me. I looked up and noticed that there was only one "tent" where his feet should be. I remember watching as the guy woke up, got up on his elbows, looked down at his missing foot and then lay back down staring

at the ceiling. I couldn't imagine what he must have felt. He was out of the war but his life had changed forever.

For years Vietnam was just something that I had done and I kind of forgot about it. I remember watching a program one evening about this older woman who was still trying to deal with the loss of her son. He was an MIA and he comment was "I just wish I knew for sure that he is gone." There was something so sad about that, it struck home. That could have been my mom. I decided that I wanted to start writing songs. So, for six months, I wrote tons of stuff and kept throwing it away because I knew it wasn't good enough. Early on in this process, I was watching a Memorial Day documentary about the nurses in Vietnam and the PTSD they had suffered. I was depressed after watching that and went downstairs and started playing my guitar. I had this guitar hook going and reached in a drawer to find some lyrics I had written about Vietnam. "We Just Did What We Were Told" became a song that day.

Fast forward to 2017. I decided I wanted to try and make a video of "We Just Did..." using a combination of my own pictures and some from the internet. Coincidentally, I also attended my first reunion in nearby Sacramento, partly because my interest was piqued at the mention that a "Huey" might be part of the weekend. It was, and we flew down the Feather River near Marysville at treetop level—I was screaming it was so cool. It was my first time back in a helicopter since Vietnam.

DON FORBES

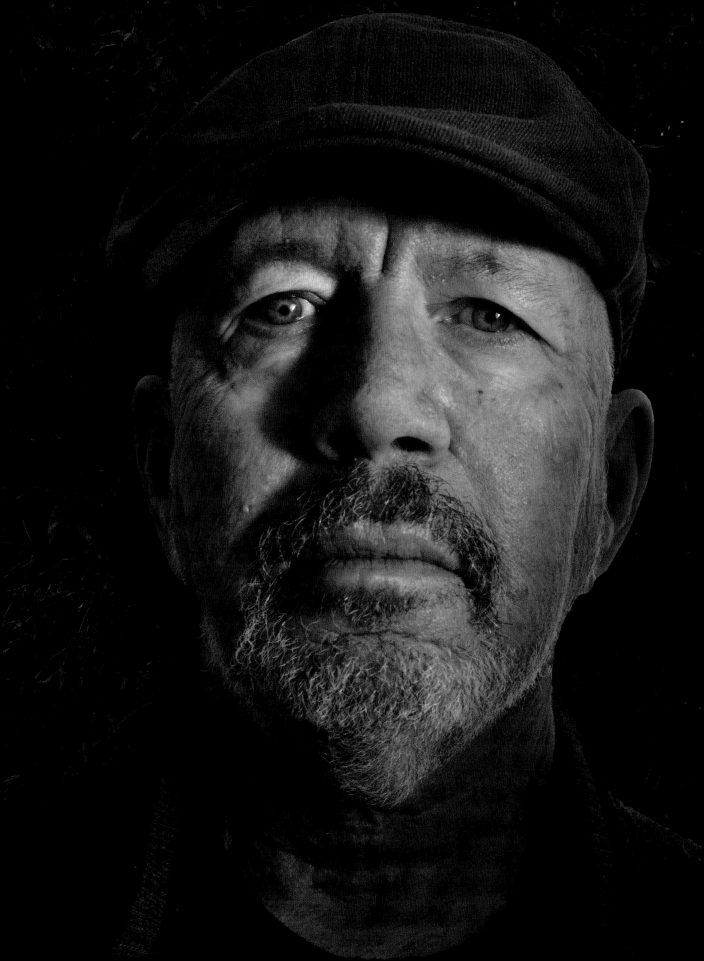

I flew helicopter gunships and, on this occasion, we were supporting a unit under some pretty heavy NVA attacks. We staged the mission so that there was constant coverage—as one flight team left, another took its place. That took a little bit of timing and management. I was first on the scene and I think I used up all the bullets in my mini-gun on the first pass. We still had some rockets left, but no bullets. The next flight wasn't due to relieve us for 10–15 minutes. By now, we were out of rockets too but helicopters make loud noises. You can make them louder with various movements of the flight controls. After we ran out of bullets and rockets, we made our gun runs making as much noise as we could, hoping that they would not know we were out of ammo and would keep their heads down. It seemed to work. The next flight relieved us and we had no bullet holes in our aircraft. We reloaded and did it right for the rest of the day.

PATRICK R. LEARY

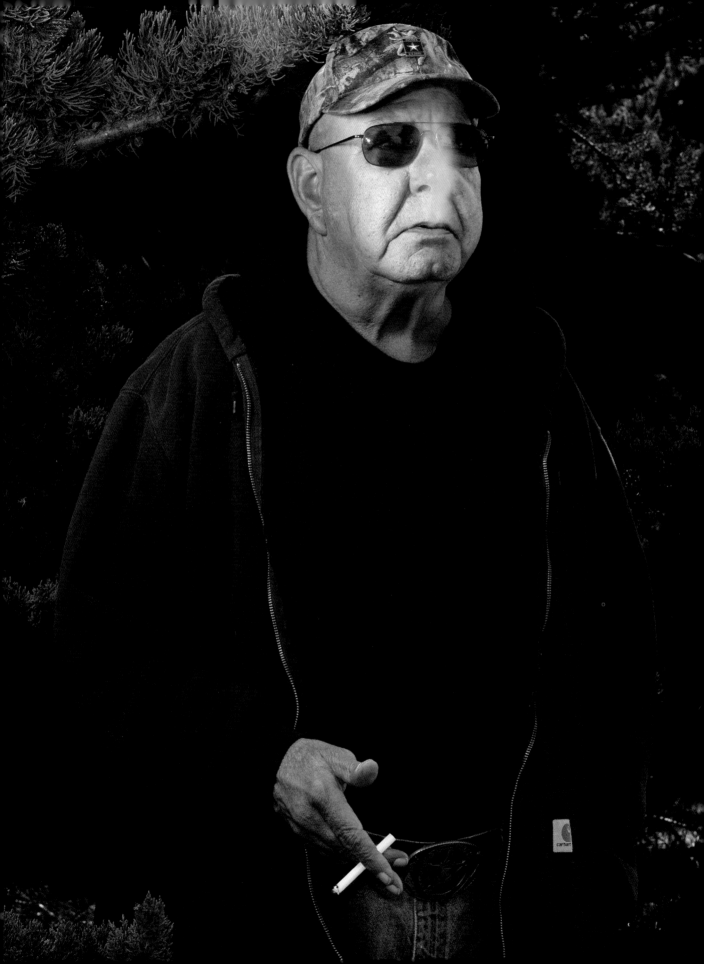

All dogs get 90% of their information from their nose. All humans leave a scent wherever we go and on everything we touch. This scent leaves the point of origin and carried by the wind in an ever-widening cone. This wind direction is important because with this info you know the direction that the dog is getting his input from and can react accordingly, also you know where the dog's blind side is and can take precautions accordingly. By watching the smoke from a cigarette you can determine all of the above.

JOHN LOCKE

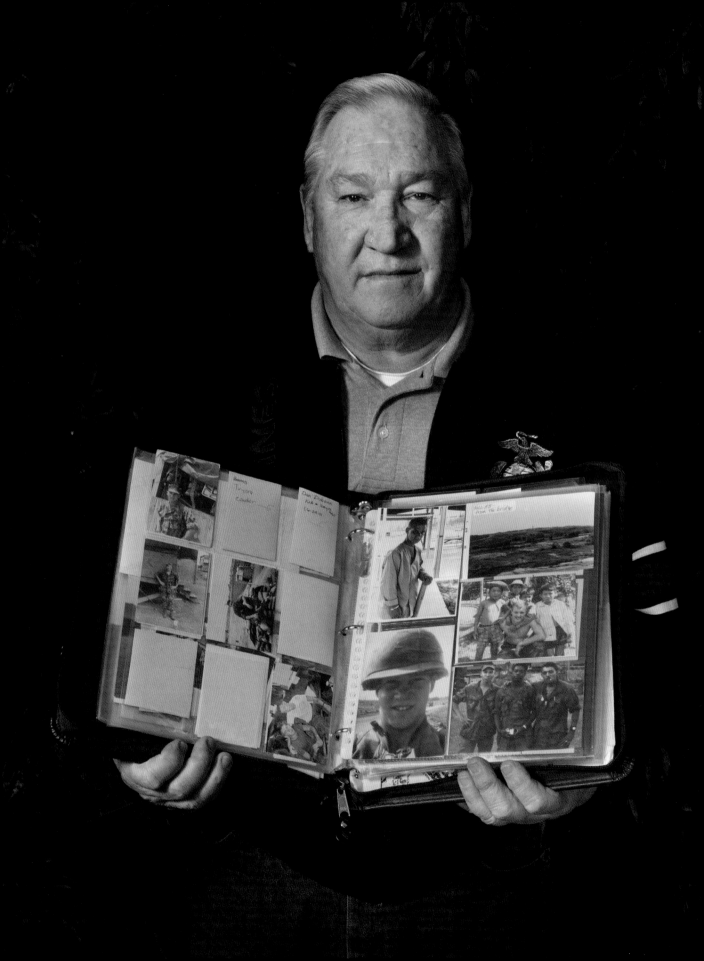

My toughest battle was Operation *Meade River*. It involved several weeks of Marine units pushing into a small area known as "Dodge City" and engaging VC and NVA formations. On the evening of December 5, 1968 during my watch, I thought I saw something out about 50 yards in front of me. It was difficult to see into the tree line, and I didn't open up with my M60 machine gun so as not to give away our position. I woke up my fellow Marines and our sergeant sent a small patrol to check it out. They did not make contact but found tracks in the dirt. The next morning, I went back to the same area with my pistol, a grenade and several Marines. We brought metal probes to check for tunnels but could not find anything except a big dirt mound. My unit was preparing to move out and, as we were called back, I threw my rod at the mound. The rod stuck in the dirt and a few seconds later it disappeared completely. I found this strange so I checked the area and found a small 12" x 12" board. I told the guys "I think I've found something" and as I looked into the hole, with the sun at my back, I saw a bare foot and a khaki pants leg. I moved back as the enemy fired several pistol rounds right past my head! Another Marine threw a grenade into the hole. When we went back to the hole, the remaining enemy, three men and three women, one of them a high-ranking officer, surrendered.

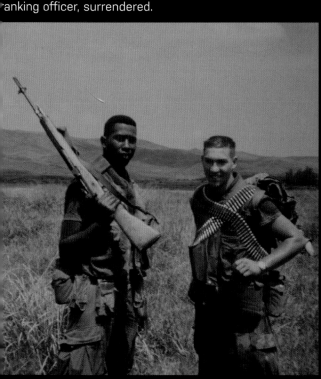

A couple of days later one of the platoons on our flank got ambushed. My sergeant and my gun team moved across an open field to assist. As we got closer, we saw about ten NVA trying to outflank the platoon on our right. They were in the open and I opened fire, saw them all being hit and observed no further movement. I then joined my sergeant and the lieutenant of that platoon and lay down 15 yards away from them. We had no cover and my A-gunner and I were just preparing to move when I saw enemy troops attacking some wounded Marines. I knew that if I opened fire both me and my A-gunner might die right then, but I had no choice. I had to protect them with the M60. Within seconds, an RPG and a machine gun opened up on us. The lieutenant and sergeant were both wounded. An RPG round exploded right in front of me, throwing me through the air onto my back. I was severely concussed and caught shrapnel around my eyes causing my vision to blur and go dark at times. I rolled back on the gun and fired at enemy positions whenever I could see. I don't remember how long this engagement lasted. Someone got me to a first aid area where I was medevac'd to the NSA hospital in Danang. I don't remember much after I got hit but was in the hospital for two weeks. My vision returned and I rejoined my unit.

One of the lighter moments occurred in the first few days of the operation. It was Thanksgiving Day and command flew out a hot dinner for the troops. While they were setting up, we had a call to saddle up—choppers were inbound. They told us it was going to be a hot LZ. We had no eating irons, so I took off my helmet and had the cooks fill it with dinner, including the gravy. In the chopper I shared my "helmet dinner" with my fellow Marines. We all dug into the helmet with our hands and ate as much as we could eat, gravy dripping through our fingers! Best Thanksgiving dinner ever, and I give thanks every year for this moment with my brothers.

The hardest thing I had to face in Vietnam was leaving my Marine buddies behind when my tour ended. When I returned to the States, I felt a bit bitter towards the American public for its attitude toward the war. I married my high school sweetheart within the first year back and started a whole new life. My family fought in the Philippines during WWII and they understood the horrors of combat. My wife had patience enough to help me through the adjustment and to put the war behind me. I've never met greater men than those I have served with. I hope that their lives have been as good as mine has been.

FRANK ARCHIBALD

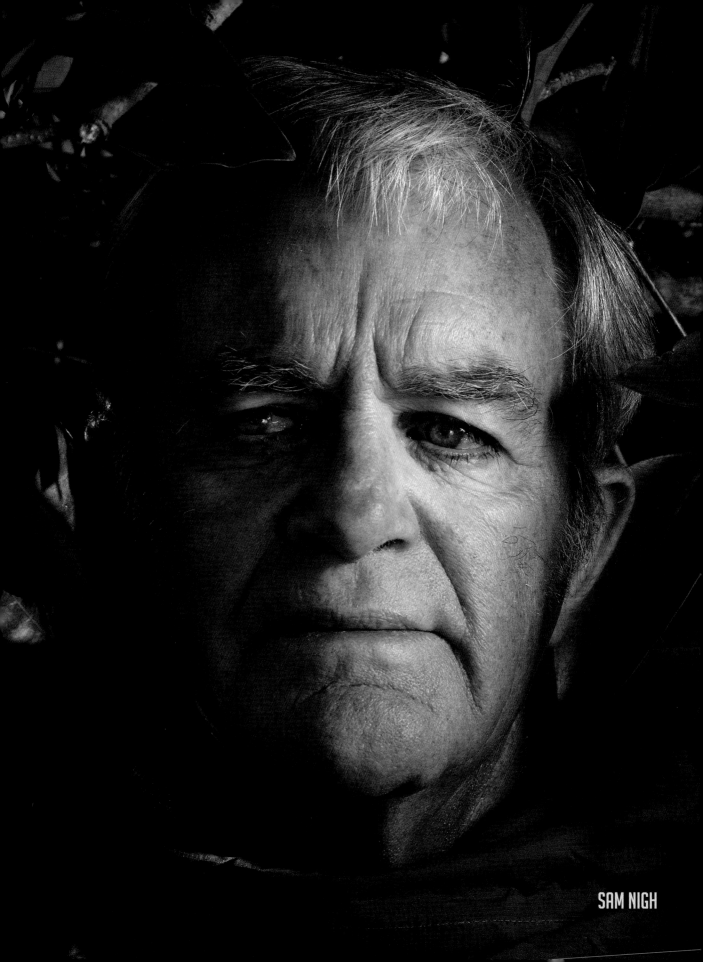

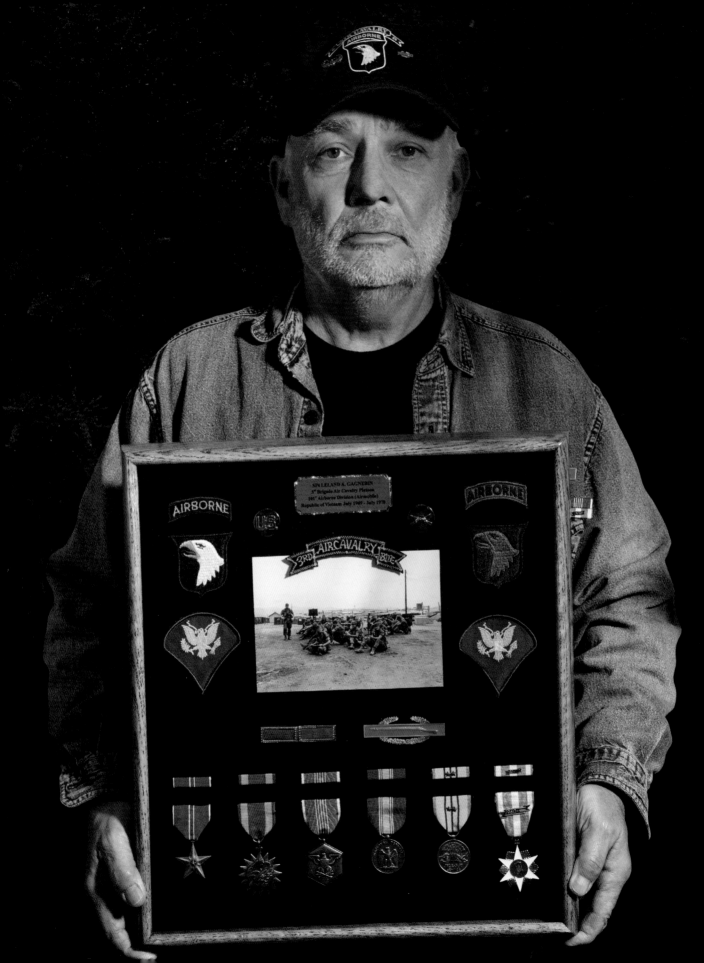

When the medevac arrived, the shooting had not subsided. We were pinned down. I was amazed that he was able to hover over us for as long as he did, lowering a line to sling out our wounded man, all the while taking rounds. He stayed for as long as he could just above the trees. There was no place to land and there was absolutely no place for us to move to aid in the extraction. He took round after round and when he began losing oil pressure the sling was raised, empty. He had to leave or lose his ship. I shared in the pilot's dismay. Jesus he was brave. I had never seen such an unselfish act in all my life. There were

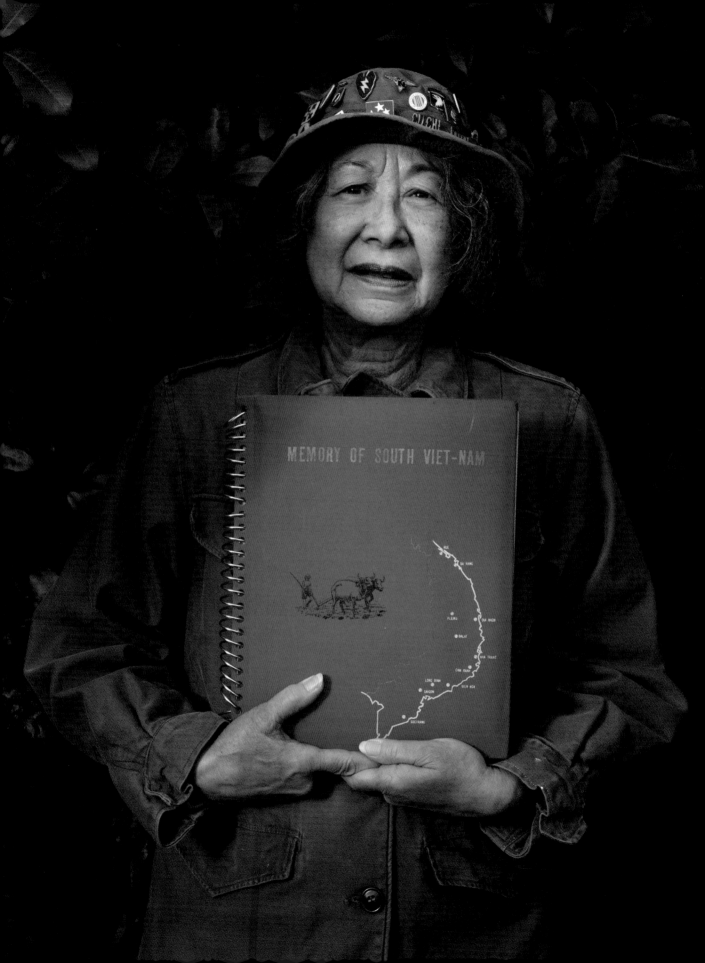

The other half of the ward was burns and on some of those phosphorus burns we used a chemical. Phosphorus grenades would be thrown and whoever was at the other end would get burned—badly burned. We would get some of those guys coming into triage and we would put copper sulfate all over them. Just soak them with copper sulfate to stop the burning because you can see the smoke coming out of their flesh. The phosphorus didn't stop burning, you had to neutralize it and those guys ended up in the ICU.
LILY ADAMS

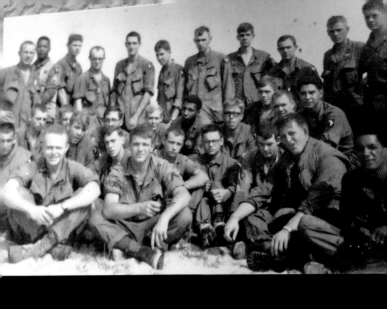

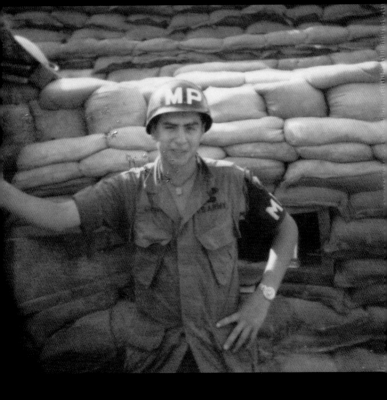

MIGUEL GUERRA

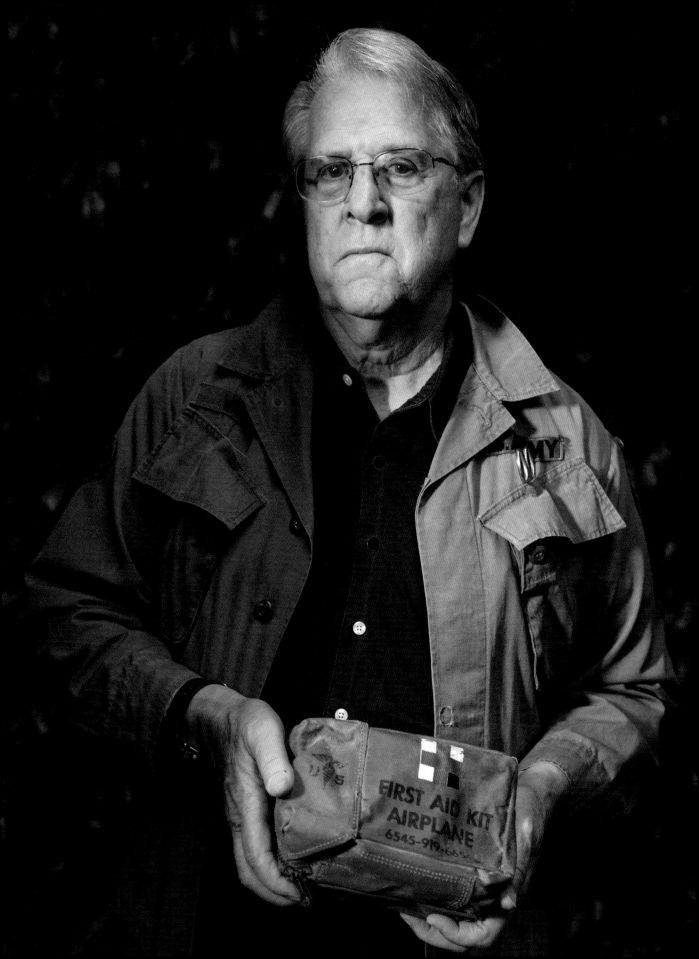

FIRST AID KIT
AIRPLANE
6545-919-665

There were no rear zones. You could get incoming anywhere. You could get incoming delivered very accurately anywhere, because there were what we refer to as PA&E workers—Pacific Architects and Engineers. Many of them were Philippino but there were Vietnamese that worked for them too. You might see somebody during the day walking off a distance. They were measuring the distance. They did not do this obviously but you could tell what was going on. They were Vietcong. They were Vietnamese workers in the day, and Vietcong at night. They would be stepping off distances. When they shot mortars or rockets, they were very accurate. At our new LZ (Thu Thiem), the motor-pool had PSP (Perforated Steel Planking), that's the interlocking metal sheets that are put down as road that you could drive on. Well, on our first night, there was a 10,000-gallon JB4 jet fuel tanker sitting in the motor-pool. They put a rocket right into that thing. It was a huge explosion. In fact, it blew a huge crater right through the PSP.

JAMES VALINOTI

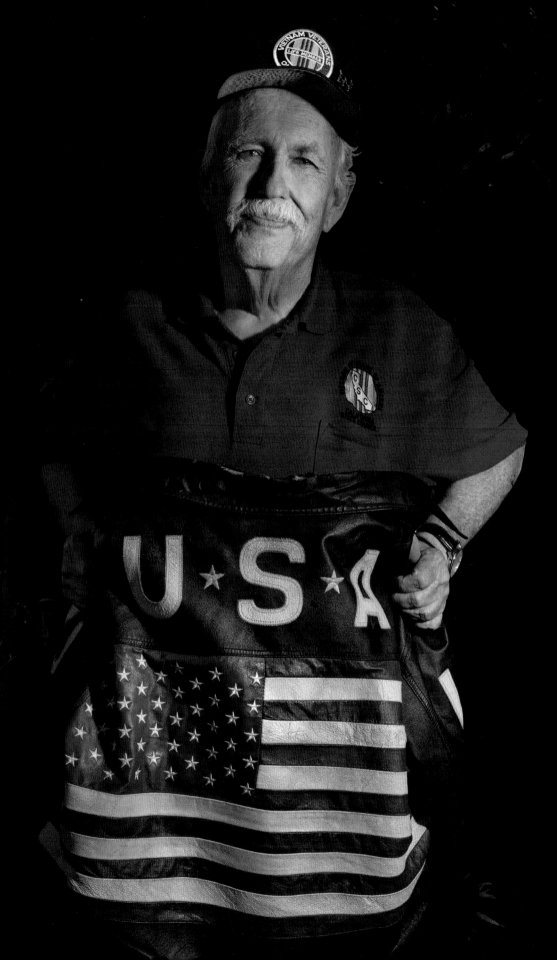

At the beginning of 1968, we moved to a base just above Hue, Camp Evans. Hue was a city that seemed untouched by the war at that time. Within weeks of arriving at Camp Evans, however, the VC launched their Tet Offensive, attacked Hue and took most of city. By February, Camp Evans was cut off by road, the only way to get supplies in being by air. There were huge parachute drops of explosives and supplies. The artillery was firing around the clock. My job was to deliver supplies by truck to just outside of Hue to support those recapturing the city. Lots of my friends who were also driving trucks survived but a lot of people didn't make it. It was a stand-up war for weeks.

I didn't see the city until I was leaving Vietnam in May '68 and it was destroyed. Buildings that had been standing for centuries were just hollowed-out shells. The bridge over the Perfume River was down but we were still crossing over it as best we could.

A few months ago I was lucky enough go back to Hue with my wife. It was wonderful to see that it was rebuilt, I didn't see hungry kids and everyone seemed happy. I was able to sit next to the Citadel temple near the Perfume River and said my goodbyes to all those who died during Tet, be they friend or enemy.

JOHN CHENEY

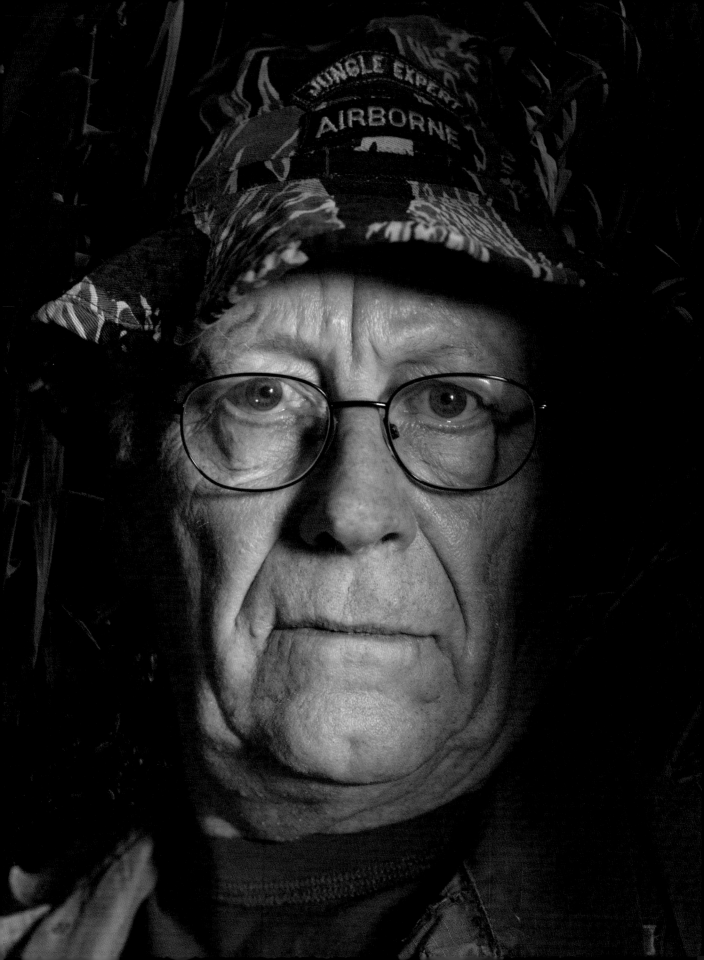

When we were on patrol, we knew it was just a matter of time before we engaged in a skirmish or full-on firefight and our senses of sight, hearing and our reflexes were always heightened. It's strange, but I always found some level of relief when shooting started because then I had an outlet for the tension and anxiety that builds over time. I always had to fire a couple of rounds, even into the air, to release the tension. After that I always remained cool and in control during the firefight. I suppose it was adrenalin that allowed me to remain calm, but I often found myself almost shaking from nervousness and emotional release after when things settled down.

I returned from Vietnam and got out of the Army on the same day, Thanksgiving Day 1969. Service in Vietnam was characterized by individual, one year, rotations. Even in small units, like the 13-man Special Forces team I served with, it wasn't unusual to have individuals with only days to go before they rotated back to the United States and others with a year to go. For that reason, you didn't see the cohesiveness and camaraderie you see when units rotate together.

We certainly did not come back to parades, receptions and news coverage. It is significant that today, forty years after the War ended, Vietnam veterans say "welcome home" to one another when they meet. We are older and greyer—and some of us have a lot less hair—but we look back with pride now on what we did "once upon a time, a long time ago in a land far, far away."

DENNIS DRENNAN

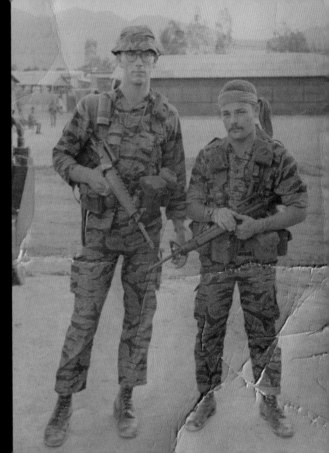

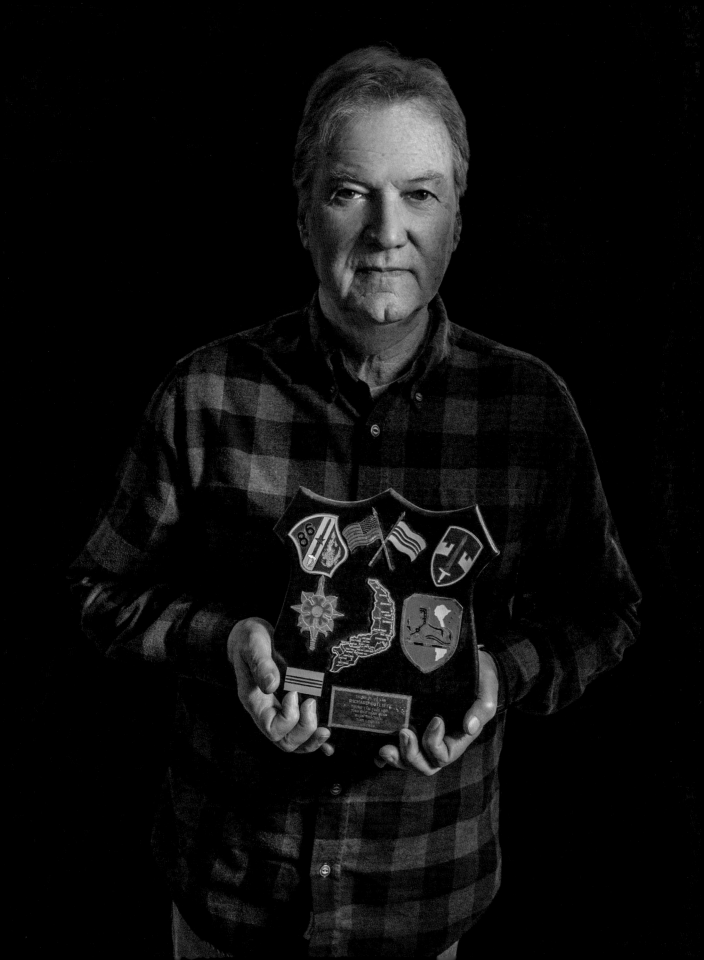

A group of high-ranking US military officers and South Vietnamese officials were to visit a base camp close to a settlement of Montagnard villagers. An advance party arrived a few days before the visit and, seeing the Montagnard women were topless, returned with Army t-shirts to pass out to the villagers. The villagers were told to wear the t-shirts when the dignitaries visited. The helicopters duly arrived with the senior officers and were greeted by the local men and women clad in the pre-supplied t-shirts. The Montagnard women had, thoughtfully, cut holes in theirs in order that they should appear traditionally bare-breasted in honor of their guests.

BOB GULLETT

I landed the ultimate "dream" assignment as a lifeguard at one of the twelve above-ground swimming pools scattered throughout the base. My duty uniform consisted of a red pair of swimming trunks and a tank-top. Basically, I spent my days at the place where other guys went on their time off. I am one of the few veterans, who, for the most part, had a lot of fun in 'Nam.

 I must admit, I do feel a little guilty sometimes when talking to Vietnam combat vets. One of the first questions is, "What did you do in 'Nam?" When the fact that I was a lifeguard comes up, it can get a little dicey and weird. At first, it doesn't make sense—Vietnam War, working at a swimming pool. I totally understand the various reactions and confusion. I explain it as "hitting the Vietnam War's jackpot!"
PETE WHALON

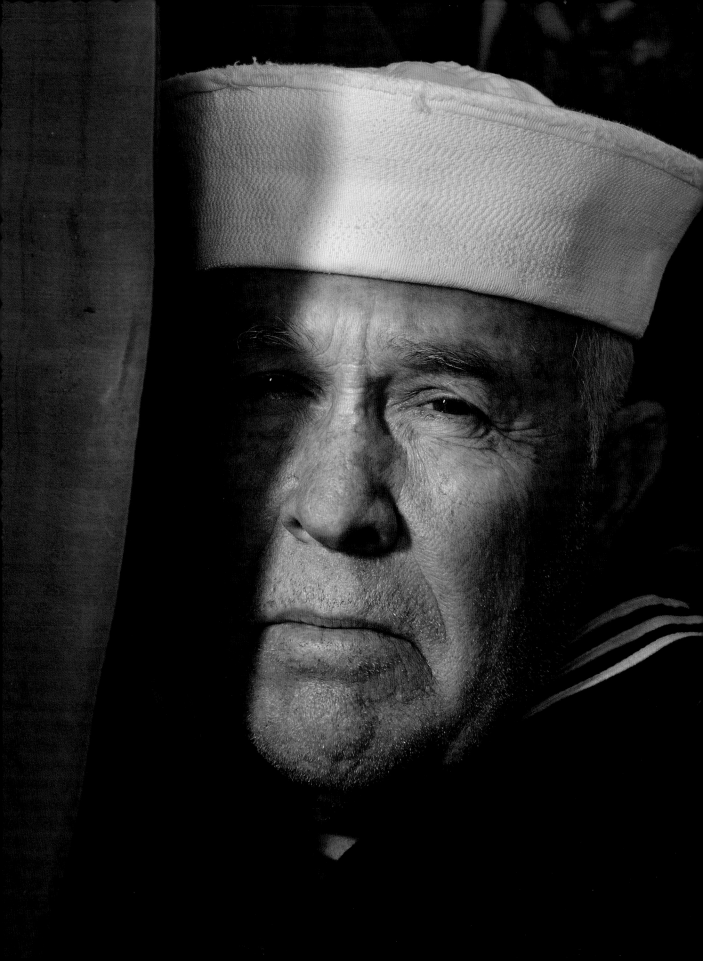

got married and then reported to the USS *Bradley* out of San Diego. The *Bradley* and several other war ships were ordered to break from the squadron and shadow a Soviet naval exercise further out to sea. On a number of occasions, several Soviet ships stopped to pick up bags of trash we had thrown off the fantail. They were always looking for any possible sensitive material that might be accidentally tossed over the side by us. A number of us had the idea of making them a present. We filled several bags up with nasty-smelling garbage from the mess decks, used toilet paper and a lot of human poop. It only took a day to fill the bags. We then double-bagged them and tossed them off the fantail when we saw a Soviet ship following us. Sure enough, within minutes the Soviet ship grabbed both bags and brought them up on their decks. I would have given a thousand bucks to see their faces when they opened those bags. They seemed less eager about picking up our trash after that.

In May of 1970 I missed the birth of my first daughter while I was in Vietnam. That hurt a lot. My wife tried to tell me all about it, but it still hurt a lot not being there. In June of 1970 I spent my 21st birthday standing a phone-talker's watch on the bridge of the *Bradley*. We were in close, barely a mile offshore. I was standing on the starboard bridge wing watching the gunfire from *Bradley* and several other ships. We were just below the DMZ and there were some furious firefights taking place ashore. Although we couldn't hear it, there was a lot of tracer flying around. With all the fighting going on we could well be fired upon and I remember "I want to see my wife and new daughter" went through my mind so many times. In 1972 I went to Vietnam again on the USS *Lockwood*. There was a huge "fake" offensive put together near the DMZ designed to draw as many NVA troops south as possible. As a result, many North Vietnamese ports were relatively lightly protected and US special forces were able to mine many of the harbors. We were then assigned to patrol the coast of North Vietnam near Haiphong harbor and warn commercial shipping that the harbors were mined.

In April 1969, before the *Bradley* left for Vietnam, we did a lot of training off the West Coast and at one point, made a stop in Vancouver. While walking through a park in my dress whites, I saw a group of around a dozen young men. As they saw me, they began to walk my way. I then spotted another group of six or maybe seven approaching from another direction. I confess I was a little anxious as they got closer but they all came up to me with smiles. One of them asked where I was from and what ship I was on. After a few minutes' conversation, I found out that all these men were draft dodgers. They tried to convince me to join them but I declined. They tried to tell me all the bad things I was doing and that Vietnam was a complete mistake—it was wrong and I should not go. I never left the ship again and we left Vancouver several days later. I was surprised and a bit confused with the many reasons they gave for deserting. I think my impression was that they were not very together on their reasons for deserting and that they were really full of crap.

KEN COWING

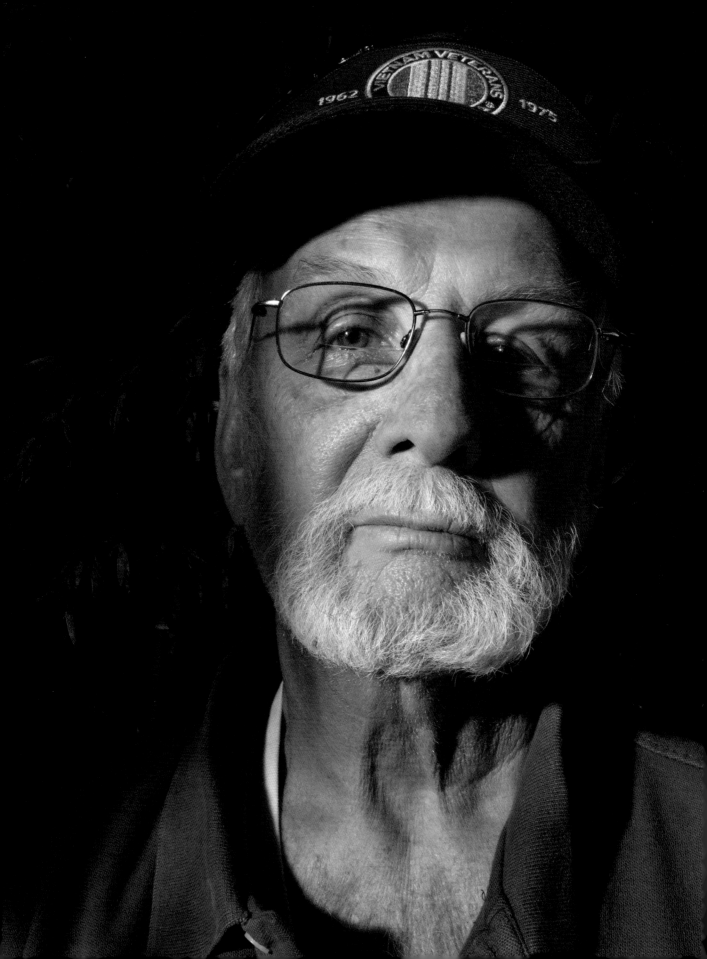

As a cargo pilot, I mostly flew around any action and we, generally, only landed in areas where we knew there were friendlies waiting to off-load our cargo and passengers. Still, we were often shot at, as when we flew airdrops near the DMZ (de-militarized zone). I also landed several times at Khe Sanh during the '68 Tet siege. On one of those occasions, a mortar landed about 40 yards from us—the plane shook but was not damaged.

I had the opportunity to see the entire country of Vietnam from high above. Most of our flying was in I Corps, in and around Danang. I also flew sorties out of Phan Rang, in southern II Corps, and then several trips down into IV Corps—it is a beautiful country and I could just imagine all the great resorts that could be built there—if the war ever ended.

Regarding the protestors; I was originally against them—they were not supporting our government's mission—but then the Pentagon Papers surfaced and I became convinced that it was the bravery of the protestors that eventually got us out of the quagmire.

MIKE GAROUTTE

Well, the war was wrong, with a capital W. All the values that I associated with the United States of America were being walked over and ignored. We were behaving like a bunch of Nazis. We ended up killing more than 2,000,000 people for no good reason. At some point, to go along with it, or to accept it, or to stand back and watch it, is to degrade yourself, not to mention the way it was degrading the country. I did my little bit. If it was going to happen, it was going to happen over my objections. I threw my body on the cogs of the machine and tried to slow it down. I tried to reach out to my fellow citizens to get their senses back. I wasn't the first to be arrested for resisting the draft. There were people before and after me. I was very visible because I was the student body president at Stanford when I first committed civil disobedience against the conscription system. I not only refused but I set out to organize other people to refuse. In the beginning, there weren't a lot of people doing that.

It was my country, right or wrong. What made us stand out was we were addressing what to do when it is wrong. I think that's something all Americans need to learn. We're not always the guys in the white hats. We've done some bad things and we need to make up for them. Right at the top of my list of bad things is more than 10 years of war in Southeast Asia. You can't just walk away from killing 2,000,000 people for no good reason. That's going to haunt you. I think it haunts the country today. Until we're willing to face up to it and take responsibility for it, it's going to continue to haunt us. Look at how we keep repeating it, the same mistake. My feeling about the people who were in the war was, we wanted them to join us. We wanted them to refuse their orders. They didn't have to do that. People went in Induction Centers, we leafletted troop ships, we leafletted military bases, we tried to reach out. We helped deserters flee to Canada if that's what they wanted to do. We helped them get legal representation if they wanted to resist inside the military. Ultimately, by 1971, from when the Vietnam veterans became a major part of the peace movement, I spent a lot of time organizing these veterans. We're the only draft resisters that I knew who were actually on the board of the Veterans Organization.

My dad wasn't a fan of the war. He had been a captain in the Army Reserve for 20 years after serving the duration during World War II. He thought "the war sucks," but he just was worried about his son. He told me, "Don't ruin your life," and begged me not to do what I was doing. I said, "Well, it's my life dad." There was never acrimony between us. He showed up every day in my trial. He used to drive down to Arizona when I was there to visit me. In a way, he thought that I was throwing my life away and that was the nature of our disagreement. It wasn't about the war per se.

I had a trial and I was convicted. I was out on bond while I appealed the conviction. The appeal was basically just to grab a little more time. I didn't expect my case to be overturned, nor did I want it to be, clearly. I was living up on Page Mill Road in the hills above Palo Alto. The federal marshal's office called me. They wanted me to come down to San Francisco and turn myself in at the jail. I said, "Shit. If you're going to take me away for three years, the least you can do is give me a ride. You know where I am. Come and get me when you want me." They did. They came along the same day that the first moon shot lifted off. It was weird. The morning I spent watching these Americans heading to outer space, and then I went off to outer space myself. It was certainly a heavy time. Two marshals showed up at my house and put me in the back seat of their car, handcuffed me, and drove me off to San Francisco County Jail.

I did a month in San Francisco County Jail. I did seven months in a prison camp in Arizona, and 12 months in a Federal Correctional Institution in West Texas. Then, I was paroled. I know what it feels like to have time stacked up on top of you, which most people don't have the experience of. Time is certainly an intangible commodity for anybody that's been in prison. It's called doing time and time becomes a kind of verb in that situation.

Prison's got no shortage of people with "death before dishonor" tattooed on their chest, but the etiquette in prison is, if you don't like somebody then don't sit at their table and chat along. Don't take a bunk next to them. In prison, if you start objecting to people for what they're in there for, that's a pretty open-ended proposition. It's not like there are a lot of prisoners who are in there for doing good stuff. Frankly, we draft resisters didn't have much problem with the rest of the inmates. We had more problem with the guards. I mean to the rest of the inmates we were convicts. When the time came to get down with the other convicts we were there. There weren't any snitches amongst the draft resister population. We organized to try and give everybody in the prison better conditions. It was never an issue for me or for hardly any of the people that I knew.

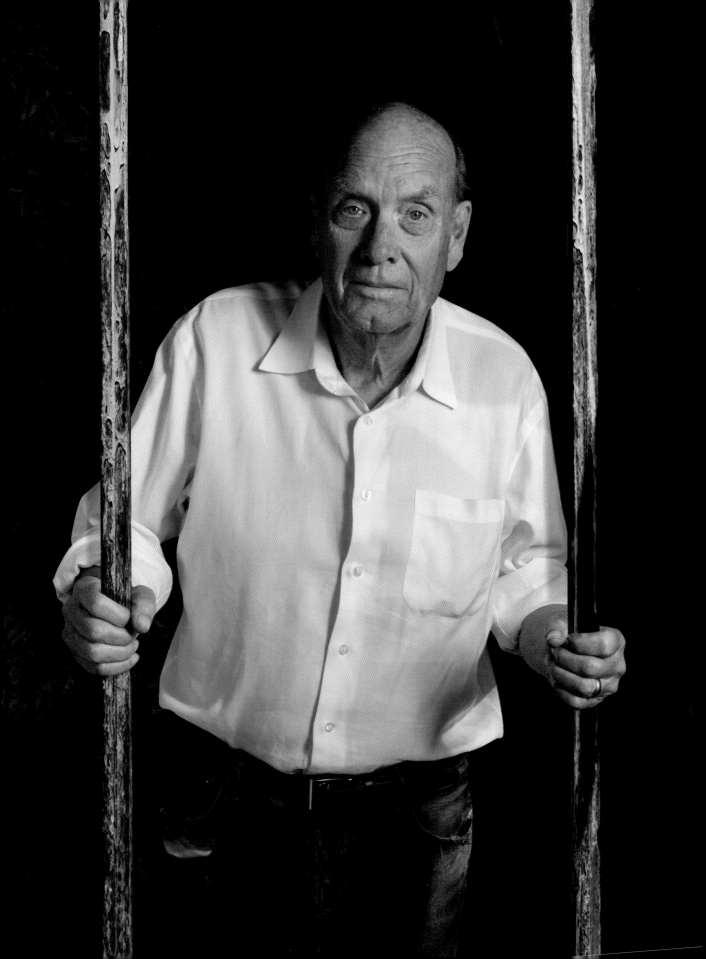

My son was born five months after I went to jail. For the first 15 months of his life I got to see him in the visiting yard once a month. I basically didn't exist for the first 15 months of his life. I'd see him in the visiting room once a month but I'm sure for him it was like, "Who is this guy?" Children's most formative time is those first 18 months of their lives, so I missed out on all that. I think that definitely affected our relationship; not making it bad, just making it different. It was certainly impactful. My family lived in California. They were keeping me in Texas. Certainly, in many ways, prison was a hardship for me and for my family. They took 20 months of my life and made me spend it in a cage. In that sense, I lost time, but I don't think in the larger measure... I don't think you lose by doing what you consider to be right.

I think Joan wrote some songs about me being in jail. There was some song called David's Song because it was written while I was in jail. I can't even—I can't even remember it now. The day I was released, when my plane landed at San Francisco, there were a bunch of reporters there and there was a little news conference. It was part of a totally disorienting experience just walking out of prison and into another life. It's strange. It's harder coming out of prison than just going in, in terms of adjustment. Suddenly, you're out and then you got home and family. I spent hours turning the light switches on and off. Hadn't done that for a while. It was part of a generally disorienting experience. My wife and my son came out to Texas and flew in to San Francisco with me. They were there with a rent-a-car when I stepped out of the front door of the Federal Correctional Institution. My parents weren't there. I had expected that they would be.

I continued to organize against the war until peace agreements were signed in 1973. Organizing draft resistance and other kinds of opposition to the war. I was in for the duration. I think the rise of Vietnam Veterans in the anti-war movement is really a key development, providing a lot of energy to carry the movement in the last few years. Our role is "hate the war, not the warrior," but the war was wrong and everybody who was touched by it has got to come to terms with that. I'm sure that there are a lot of veterans out there who don't want to hear that. They don't want to hear that their buddies died for nothing—for worse than nothing. It's easy, in that circumstance, to blame those of us delivering the message. It is what it is, whatever their reaction.

I've certainly been heckled but I have a lot of close relationships with veterans. Guys that I organized with and became good friends with. For me, I never did have an issue with them. People do what they do and, whatever point they were at, we wanted them to come from there and join us.

I can remember, shortly after I got out of prison, the "Vietnam Veterans Against the War" staged a demonstration in Washington, which became very famous. They threw their medals on to the capitol steps and renounced the war. I guess I was listening to that on the radio and I just had to pull over. I just start crying because, for a long time, this was what we have been looking for, in terms of those guys making that kind of statement.

My view of the war is unchanged. The passage of time has, if anything, only made me feel more right. I'm certain that I've never had second thoughts about what I did and would do it all over again in the same circumstance. It was the time. I used to tell myself part of the reason I was doing this was so when I got to be 70 years old, I wanted to able to look back and feel good about what I did. I'm 72 and I still feel really good about what I did. I think it was the right thing to do and I'm proud that I did it.

DAVID HARRIS

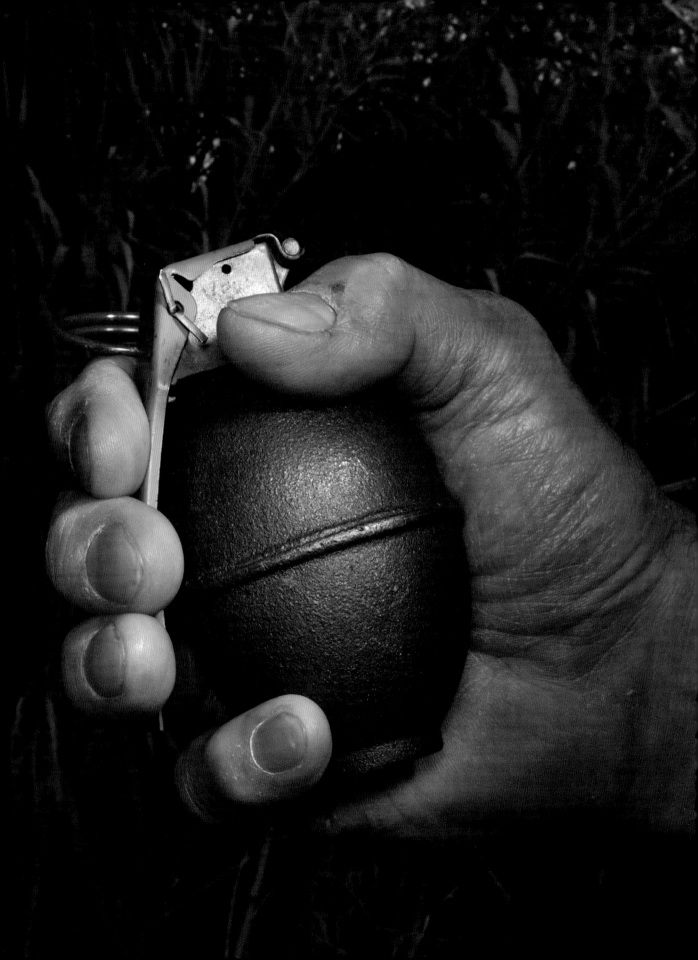

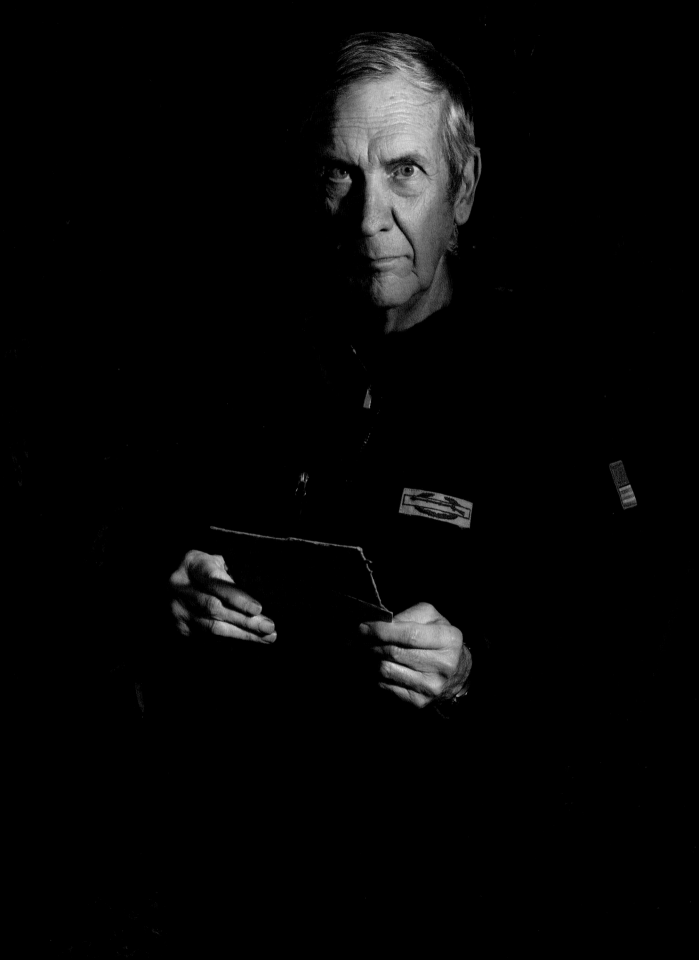

For over a year, July 1969 to September 1970 I was a grunt, an 11B light weapons infantryman, in the Republic of Vietnam. Fifty years later, I am still trying to explain and learn lessons from American involvement in Vietnam. I identify myself as an old infantry squad leader and so am most comfortable around friends like my old Vietnam veteran bartender. I can talk to him about the war and he remembers the time he was late and another guy got assigned in his place and got sent to that hill that was overrun.

Graduating from college in 1968, I was 1-A and headed for a war. In my small town of Janesville, Wisconsin, patriotism and service were accepted and expected. There were already kids I knew who had been killed or wounded. I decided to go to Wisconsin Law School in Madison in fall 1968, to be close to home, and it was there I got my draft notice for February 1969. At the Milwaukee induction center, even the Marines were taking draftees. "One, two, three, four, you're in the Marine Corps." Buses took us to Fort Campbell, Kentucky for basic. After tests, they wanted me to be a computer operator. I said I wanted to be a combat engineer. The intake processor said, if we disagree, you'll go infantry. I said, if we're going to have a war, let's have a war so I got MOS 11B.

I was assigned to Alpha Co., 1/18th Infantry, 1st Infantry Division operating in the "Iron Triangle" between Saigon and the Cambodian border. Most of our operations were to interdict VC movement toward Saigon and the populated areas of South Vietnam. We did patrols, night ambushes, and village seals. I got my Combat Infantryman's Badge on a patrol when we engaged a bunch of VC moving at twilight in late July. I also learned about friendly fire, when helicopter gunships, called for support, began their gun run too early and shot up lead elements of the platoon.

We did night ambushes most nights. I ended up doing over 200 ambushes. Most didn't produce anything, but the ones that did were hairy. We were inserted by chopper for week-long jungle patrols. I did 84 combat assaults in Hueys. Hearing that "whop, whop, whop" still makes me nervous.

In November, our Mike platoon stayed behind in a fake extraction near the Song Be river, when the rest of the company got picked up. I was the RTO for the platoon leader. We set up one ambush and, on November 10, 1969, from a hidden trail, four VC came out directly toward us. We had grenades ready to throw. We shot three but one got away. One guy drew back and hit another guy in the mouth with a grenade with the pin pulled, dropping the grenade on the ground. Luckily, someone picked it up and threw it.

The next day, November 11, we moved to another trail and, as I was putting up the big whip antenna to arrange for pickup, a group of 30 VC came "diddy-bopping" past us on the trail about five feet away. We had three squads 100 yards apart, on the trail and blew claymores on the group of VC, killing 21 and capturing seven.

Later in November, our new battalion commander, a former Special Forces officer, decided we would do shotgun ambushes. We would be dropped in small groups to saturate a broad area with ambushes. Unfortunately, the company command group inserted next to a VC base camp, and my CO, Harvey Kelley, went out to investigate and was shot and KIA.

Meanwhile, my little group set up claymores on a trail and, on the second day, killed a single VC. We dragged him into bushes and then reset our ambush. The battalion got on the horn and said what was he wearing? So, I had to drag this dead body out of the bushes. He was wearing a belt with a North Vietnam star so I took it. The next thing we knew the battalion commander was wearing the belt.

I had been crazy enough early in my tour to extend. So, when the 1st Division pulled out in February 1970, I went to the 11th ACR, and then up to the Americal Division out of Chu Lai as an infantry squad leader. We were up against NVA in the north. One squad leader was killed by a "bouncing betty" mine and another squad got blown to bits hitting daisy-chained artillery rounds going through a village. But I survived until they finally pulled me out of the field. To this day I have regrets because I took good care of my men and one guy, who had been a point man for me, was killed a month after I left Vietnam.

In 1970 I applied to law school again. My company commander's recommendation said, "this is the only soldier I have met who can call in artillery without using a map." I arrived at Harvard Law School with a CIB and five Bronze Stars a week after leaving Vietnam, and three days late for the start of classes. Whenever I went to Washington DC for work, I would run down to the mall early every morning and then walk past The Wall and say hello to my friends who never made it back. In 2007, I rescued a 15-year-old girl from a mistakenly released San Quentin convict with a knife, getting a sucking chest wound and punctured lung and showing you still need an old infantry squad leader once in a while.

KERMIT KUBITZ

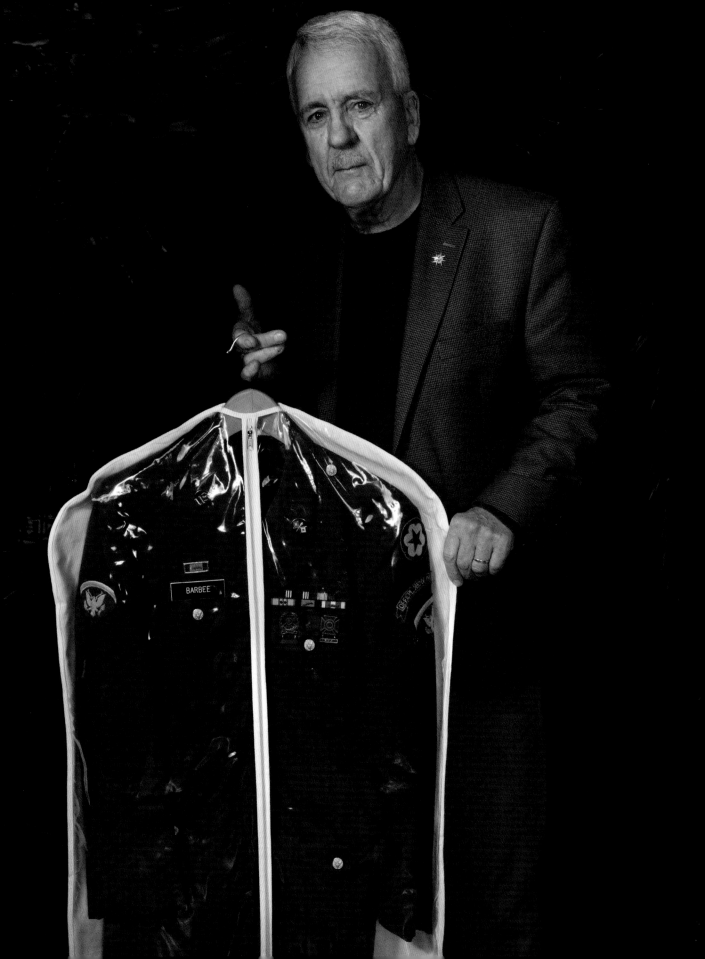

I went to Phuoc Vinh to do filming with the 101st Cavalry. I flew in on a Huey just at dusk and was chatting with a few troops out in the base when the klaxon went off and rockets started to rain down. As the shooting began, I ran with about six troops. They split up and I followed the three who ran to the left. The three troops split again and I followed the one to the right and dived into a bunker after him, after all it was night, I couldn't film and carried no weapon. I landed in the red mud inside the bunker in a sprawl. As I pushed myself up and my eyes adjusted, I noticed two soldiers sitting at the far end of the bunker on ammo cans. There were a few beer cans at their feet and they were intently watching a little 13-in. black and white tv set, which was sitting on a piece of wood jammed between the sand bags. They had rigged a wire running to a generator outside to power it and were watching Armed Forces Television broadcast out of Saigon. The ground was shaking, men were yelling and screaming outside and dust and dirt were dropping from the ceiling. As the artillery, rockets, machine-gun and small-arm fire continued outside, we watched as Neil Armstrong descended the lunar lander and took his first steps on the moon. It was July 21, 1969. One small step for mankind ... I thought my brain was going to f'cking explode. The whole world was watching the moon landing while we were getting blown up and it felt like nobody cared.

STEWART BARBEE

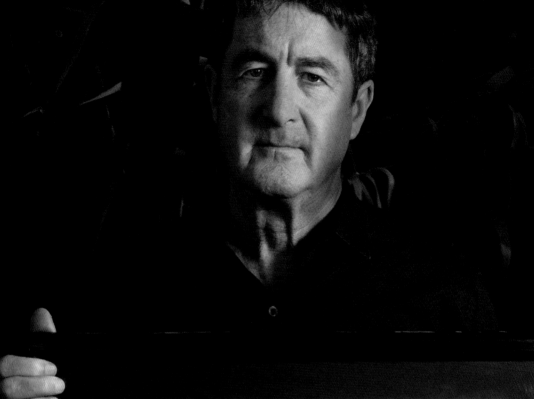

"If we do not speak of it others will surely rewrite the script. Each of the body bags all of the mass graves will be reopened and their contents abracadabraed into a noble cause."

GEORGE SWIERS, VIETNAM VETERAN

I was a member of the 101st Airborne Division and part of what was known as the "No Slack" battalion. As an infantryman I spent much of my 12-month tour of duty in the field in I Corps searching out enemy. We operated mostly as a squad of ten riflemen or as a larger platoon of 35 soldiers. Like bait, we humped up and down mountains through thick vegetation seeking contact and once engaged we'd use a field radio to call in enormous artillery and air firepower.

At a recent reunion I had in Branston, MO this past September, I learned that I had missed a couple of bad days in the field that led to some of my comrades being wounded and killed. In one case my squad was in the lead chopper to a supposedly secure firebase that turned out to be booby-trapped. The chopper crashed and one buddy was killed and several severely injured. I also lucked out after 10 months when I was reassigned to a Headquarters Company in Nha Trang. I don't feel any guilt for missing some bad days, just sad for the others and gratitude that I endured and escaped.

MICHAEL BLECKER

153

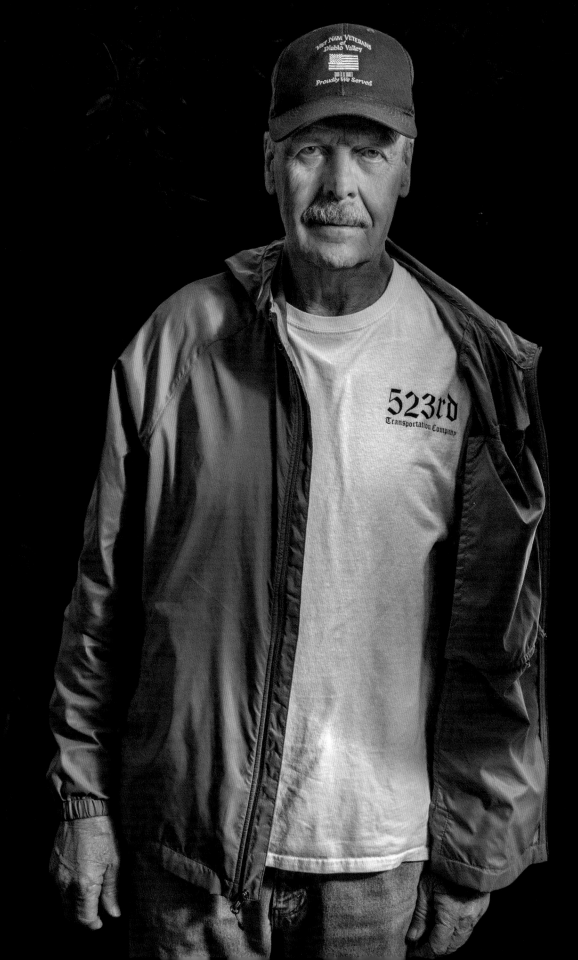

I had only one experience with protesters after returning. I chose to attend a Moratorium march in Boston in October, 1969. Since I was a civilian I remained an observer and left with the feeling that that the drivers I knew in Vietnam exhibited far more self-control and responsibility than the sorry-looking mob of protesters.

JONATHAN "JON" ROBBINS

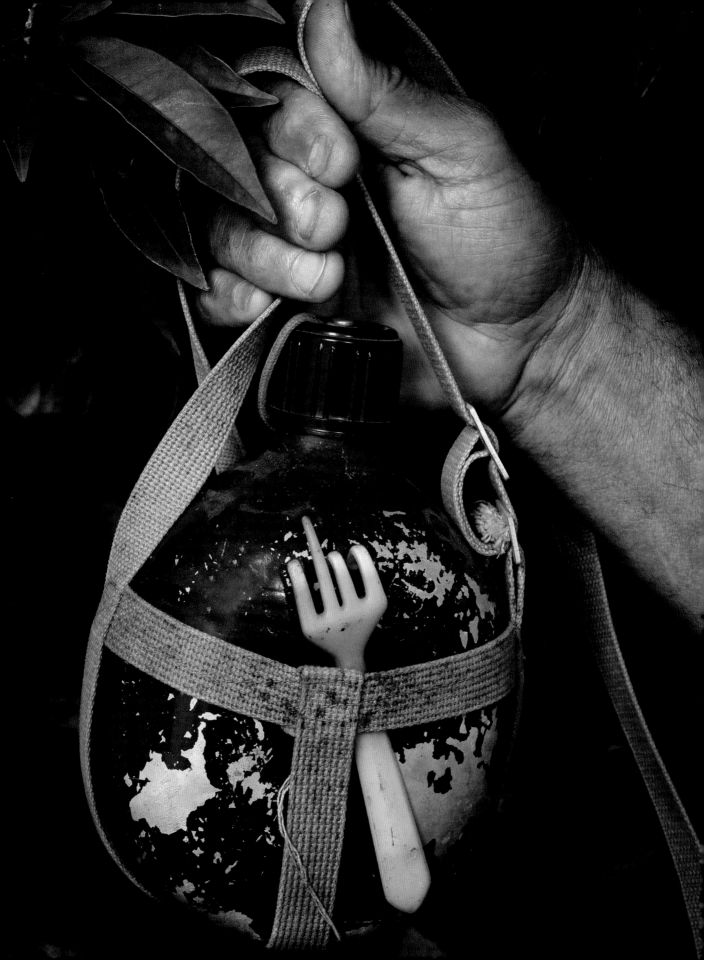

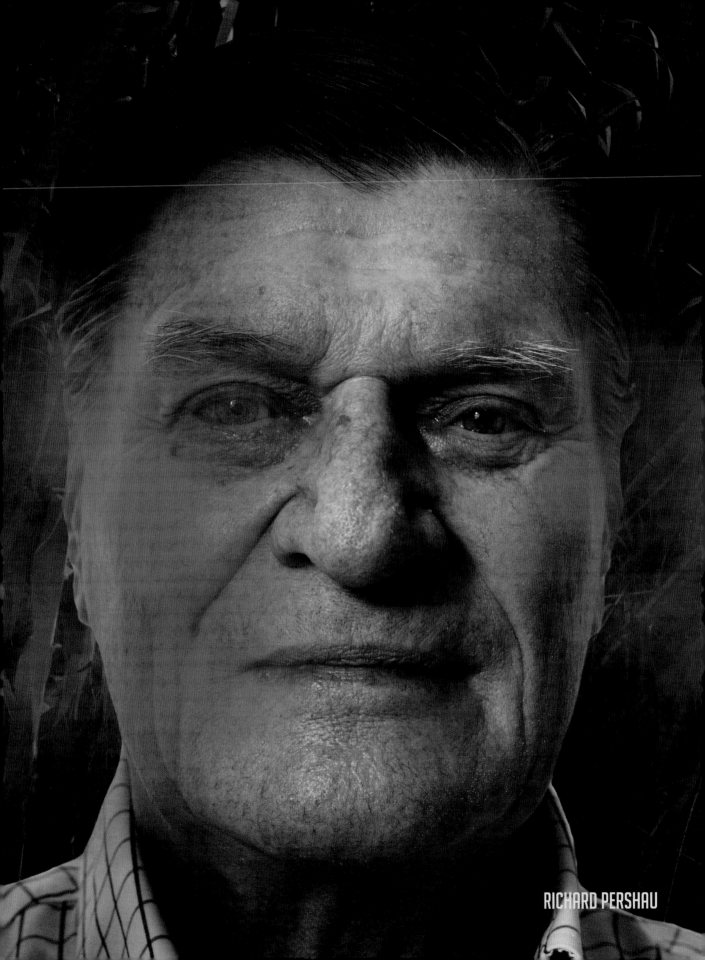

RICHARD PERSHAU

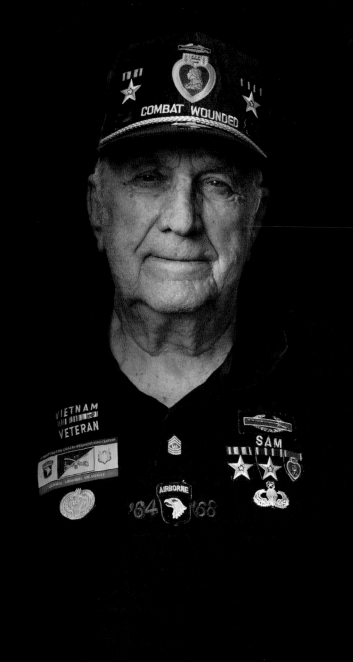

Agent Orange got the best of me.

Agent Orange has been in control of my body for 20 years and it's hell. Open heart surgery, skin cancer, prostate surgery, colon surgery and other colon-related surgeries, diabetes with five shots daily in my stomach.

My body has taken a beating from Agent Orange, but, it keeps on ticking, like a Timex watch.

SAM BERNDT

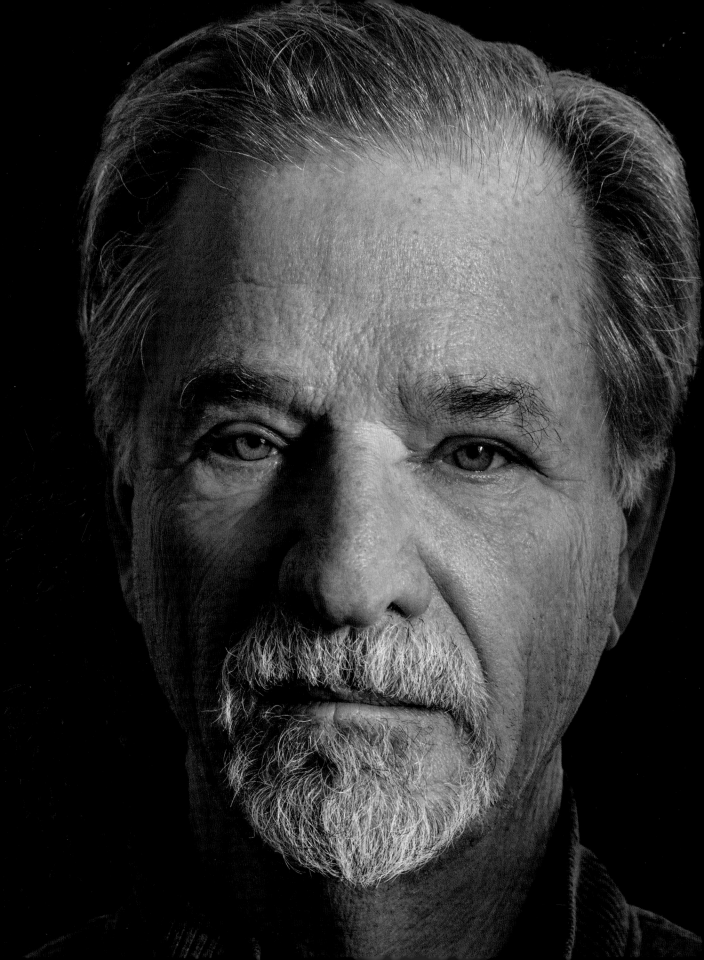

It was late 1967. I was stationed with an Army medical ambulance company near Pleiku. Our task was to move wounded soldiers from the battlefield into medical units. Our primary medical unit in Pleiku was the Army 71st Evacuation Hospital.

When the Martha Rae USO show came to Pleiku, it was a secret. I'm sure all USO shows were targets for the enemy and closely guarded. We picked up wounded soldiers out of the 71st Evac Hospital to take them to the show. The wounded soldiers were actually the least willing to go. The war had taken an awful toll on all of them. They had lost buddies, others they knew were still in the fight. These soldiers would often say, "just leave me here I want to die." These young men could see no future. We took them to the show, despite their objections, and it was marvelous. Great music, comedy, speeches, and girls! The Dallas Cowboy Cheerleaders, or at least a troupe made to look like them, were wonderful. Just the most beautiful things these guys had seen—ever!

It was a different group of men we took back to the 71st Evac Hospital after the show. They could now see a glimmer of hope beyond their present horror and sadness. The change in these men was perhaps the most rewarding thing I have ever seen. I am not a religious person. I'm not sure what praying does to help suffering people. I do know that joy, laughter, happiness and a vision of a positive future helps to heal the wounds of war. I will thank God for the recovery of these young men—God had the wisdom to send Martha Rae and a bunch of hot chicks to re-light their fire.

MICHAEL WEBER

came from a working-class family with two brothers and two sisters. Mom was from Oklahoma and Dad from Michigan. They met in the shipyards building Liberty ships. Mom was a tacker on the steel plate sheets that Dad had fitted in place. I was born in 1946 in California. We moved when I was a baby and lived on the prairies of Colorado until 1957 and then moved back to the Bay Area. We were a pretty normal family for the day. Mom stayed home mostly and never drove. We walked a lot. I got out of high school in '66 at 19 years old—we lost one fellow in the war right before I got out. His photo was displayed in the glass case in front of the school. I knew him. I had been raised in the Baptist church since early childhood, and "Thou Shall Not Kill" was part of my psyche. By then I was working at my father's gas station on the coast, in Pacifica, not far from San Bruno, California, my home town. I had a 1962 Corvair and a 1952 Triumph motorcycle. My long-time girlfriend had just left for Honolulu for college. I was going to small venues like the Avalon Ballroom, the Matrix, then the Fillmore and the Winterland Ballroom. I felt the energy from San Francisco and the things that were developing, the civil rights movement, burning of draft cards. I followed Moby Grape and Jefferson Airplane, The Quick and the Dead. I was in altered states for periods of time absorbed in thoughts surrounding the draft, the war, what to do? Canada? Jail? Underground? My personal anti-war sentiment and my rebellious, nature precluded my involvement in the war or serving in any capacity in the military. There were mixed feelings all around preceding the "Summer of Love." My folks hated the war. Dad did not serve in WWII as he was an inactive reservist because of his job as a ship fitter. He hoped I could "just" be a truck driver and not shoot people. He had two other sons watching this play out, so he was guarded but understanding. I was also watching my younger brothers react to what was going on with me. My family always supported my choice, even if it was not what they wanted, but at least I was not in the war. My friends were mostly not into going to the war. Some got out medically, a few psychologically; most had no way out that they could see. Some, once in, applied for jobs that would keep them in training for as long as possible to avoid the war.

So, in the summer of '67, a buddy and I took a "drive away" car, from LA to NYC. We made it to Ohio, where I rear-ended a car (no one was injured). That ended our ride. Then we took a bus to Niagara Falls and on to Toronto. We headed for Yorkville, the hip area of Toronto, looking for drugs and information on how we would fit in Canada. We had very little luck in Toronto, unsophisticated as we were. My buddy bailed and flew home. I hitchhiked from Toronto back to the Bay Area by way of Chicago, Illinois, Haiti, Missouri, New Orleans and then to Texas, Las Vegas and right to my front door. I arrived home just three days before I was drafted. I did not see a clear choice that day, my day of induction, September 17, 1967, at Oakland,

California during the summer of love.

I had been locked up as a teen, only for a few days in Juvenile Hall, for Grand Theft Auto—joy riding—and years later, while still in high school, a few friends and I were in a fight with some sailors. Another one of our friends jumped in and hit one of the sailors with a crescent wrench, so I went to jail. I was 18, no one else was. It turned out OK. The sailor was OK and did not press charges but I knew what it felt like to be locked up as a teen.

Nothing, however, prepared me for the harassment we underwent during Basic and Advanced Infantry Training at Fort Lewis, WA. For me it was hard to put up with the pompous drill sergeants and their handlers. I had to fight to go to school after 6th grade, so I was bored with the "Bad Ass" attitudes.

I intuitively knew the war was wrong and everything going on in the Bay Area and the people around me reinforced that belief. I saw the misguided leading us to slaughter, with their shiny bars, starched and pressed uniforms. Sold-out MFs with their "High and Tight." Just tools, all of us tools of war. I saw right through it. I was drafted during the summer of love. I wasn't going to kill anyone. How did I feel about the guys that went? I had different feelings and thoughts all during my resistance, prison time and 12-year exile in Canada. I spent two years underground in Canada and, a decade later, four years underground in California. Early on, I was busy trying to figure my way out of the military. Seeing guys shipping out for 'Nam made it hyper-real. I felt sad for the guys that appeared to be buying into the whole "Gung Ho" bullshit— kill a Cong for Christ shitheads. Also sad for the helpless, confused young men all around me. I figured the best example I could set was to talk it up and go AWOL. I felt I would have been foolish to do otherwise. It was hard to watch people sell out to the man. I saw friends back home that had been wounded, sent home with casts and braces and I could see the eyes of the guys I had known. Now they seemed like strangers. I felt we were on different sides. I could understand the marching and marksmanship etc. It was the lies and abhorrent behavior of the people charged with training us and caring for us. It convinced me it was all a lie. Then, while home on Christmas leave, sitting in a room with Persian carpets and candlelight, after hours of contemplating, I found I was released! I would not go to Vietnam no matter what. I had decided. Days later, my mother gave me the phone number and address of the War Resisters League. After a few weeks back at training, I saw the company was set for Vietnam. My MOS—Infantryman. Enough! So I left for good. Civilian clothes under my uniform, I went on sick call to hospital, went into a phone booth, dropped the uniform minus the name tag and got a cab to Seattle. From there a bus home. After four months, I called the War Resisters League. Then I met the seven other AWOLs that were ready to make a statement with their act of resistance. It ended up being

a total of nine men resigning and protesting the war. All while in sanctuary. Come and get us! I went AWOL from Company A, 2nd Bn. 4th Bde, Ft Lewis on March 20, 1968. I went into sanctuary, in July of 1968, in San Francisco. "The Nine for Peace" were all arrested July 17, 1968 (on camera) at the communion table of Saint Andrew's Church, Marin County, CA surrounded by hundreds of supporters. We were taken to our respective brigs or stockades. I was taken to San Francisco and confined at Presidio Stockade Building 1213 and charged with "Desertion and Refusing to Wear the Uniform."

While in pre-trial confinement, on October 11, 1968, 19-year-old Richard Bunch was shot and killed while on a work detail by a shotgun-armed guard. On October 14, after deliberation, 27 prisoners broke formation and formed a circle on the grassy area of the yard to protest the unnecessary killing/murder of a fellow prisoner. This became known as the "Presidio mutiny." We had a list of demands read by Walter Pawlowski. We sang "We Shall Overcome" until we were hauled back into cells. Then all 27 were charged with mutiny.

For me, it was hard in solitary confinement, even though I was prepared to resist and not cooperate, I had seen it all before. I could predict when they would come while in the box—sick-call, meals, meds and lights out. However, many of the prisoners were kind and concerned enough to give an extra dessert or cigarettes. There was "Solidarity in Solitary" among prisoners. Once out of "segregation," I saw the hard times guys were having, trapped inside the military jail where they didn't know any one and were far from home. I had daily visits from clergy. They protested at the gates for daily visits to ensure our safety and spiritual support. I was home.

I went to work with others, finding lawyers for incoming prisoners, getting letters out and money and information in —all with the support of my family and the movement. Jail was worse than we could have conceived of at the time. We knew no better but when I watch *The Great Escape* I connect with the characters and their desperation. It becomes an internal struggle to contain one's anger until you can do something that counts. And deal with it we did, from the moment we opened your eyes until sleep comforted us and briefly took mercy. And then more the next morning and so it went on.

Escape seemed like a drastic solution—leaving the country, home town, family, San Francisco during the halcyon days of the '60s. I wept during those days of struggle, to release the pain of the box/situation I was in, but I knew I was right no matter what. My court martial for desertion and refusing a direct order (to wear the uniform) took place in November 1968. I was sentenced to 4 years hard labor and a dishonorable discharge. The mutiny trials were around the corner, I had 4 years to do and the thought of spending my youth in prison repulsed me. These mutiny trials brought sentences of 14, 15, and

16 years in 1969. So I pulled the pin and said goodbye. On December 24, 1968, I escaped confinement along with Walter Pawlowski and fled to Canada. I arrived in Grand Forks, British Columbia, New Year's Eve 1968, and Walter and I wished each other Happy New Year while on the bus to Vancouver. I think we ate some nutmeg.

I like to say I was stationed in Vancouver during the Vietnam War. I came back to the States in 1980 because of family. I went back to prison in 1984, after four years living and working in the Bay Area, which still fucks with my mind. I dropped my ID, which was picked up by a sheriff then passed to San Bruno police. I went down to pick it up, knowing I would be arrested, but my rope was at its end. December 9, 1984, I was arrested and, same drill, sent to solitary confinement at the Presidio stockade after they found my 201 file (my military personnel file). Then to Fort Ord. After a fall I was in hospital for 3 days, taken back to the solitary confinement cell, then given a direct order to put on my class A uniform. I was walked to a waiting car, with a driver by two MPs, one on each side, and guarded until I got into the stockade at Fort Riley, Kansas. I worked as a carpenter in confinement, now at 38 years old.

I was dishonorably discharged on May 10, 1985. My DD 214 (Certificate of Release or Discharge from Active Duty) states time in service as 17 years, 2 months; Sharpshooter; service medal; Dishonorable Discharge. If I have any regrets, they are for what my Mom and Dad went through, what my two sisters and two brothers went through, without me. I missed that part of their lives from 1967 to 1980. Visits from family and friends were wonderful but there many aspects of loss involved, not simple or tragic just the distance war puts between us. My feelings about the people who went were and are mixed but are mostly reconciled for me. The experience of those who went to Vietnam serves as a striking testimony of why I did not. My heart would not allow it. I was saddened by the war and those who had to fight it, on all sides. We still suffer. I lived in an anti-war area of the world and feel lucky to have been there in those days. These were epic, pivotal days of my life. I give the "movement" huge credit for creating a space for GIs to find a platform from which we could speak. The impact on my family was spread over 50 years of resistance prison, escape, exile, reimprisonment in 1984 and my final discharge in 1985. And I'm always going to be recovering from some aspect of it. I wish I did not have to experience all that I have—it's a shame. At the same time, it's all made me who I am. I can't think that I could have done it better. Some critics think I should have been willing to "do the time." I however am fine with my choice to spare myself war and prison and raise a family in the country.

I'm still here after it all, proud to have been among them. My generation made me proud then and still does.

KEITH MATHER

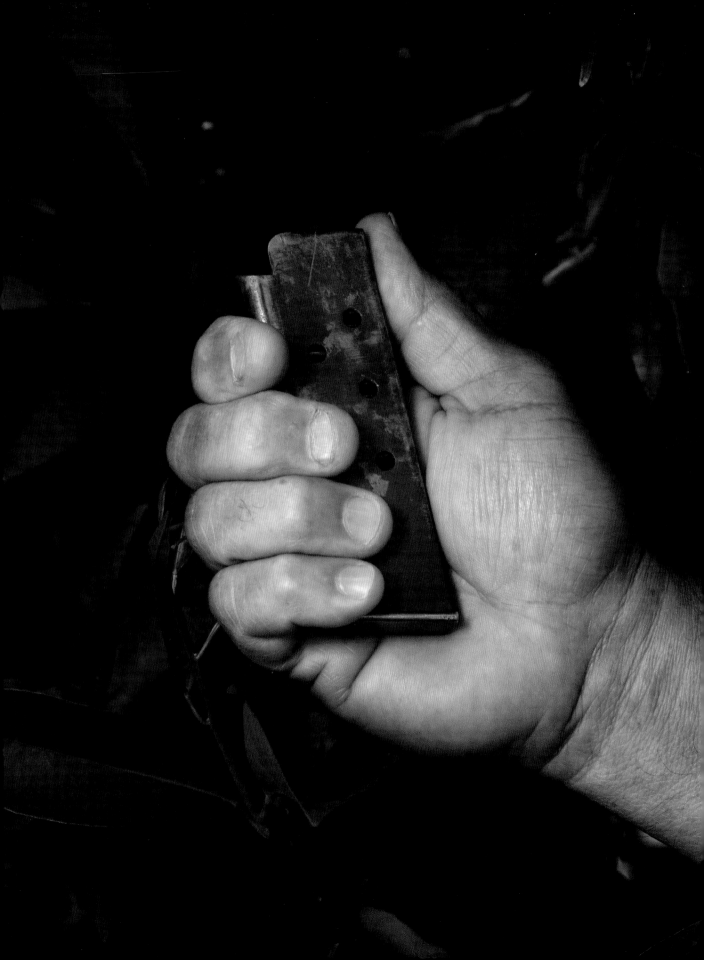

We started the day going north on Route 606, heading toward the Ben Hai River. All the "salts" were scared shitless. We knew this was Charlie's home turf and that we would probably be in deep shit sometime in the near future. We hardly made any enemy contact on the way up to the Ben Hai River. The terrain was thick and very hard to move through and that made us move more toward the road—just what Charlie wanted. The enemy knew that we had to leave by the same road we came in on. When we had almost reached the river, A-4s laid down a smokescreen to the west between the high ground and us. Hotel Company was then Helo-lifted into a zone at the river. My battalion commander said it looked like something from Quantico it was so perfect. We set up defensive positions and dug in the best we could. I had my machine gun facing south, the way we would be leaving.

A couple of hours after dark a few other Marines and I began hearing talking and digging. We didn't sleep a wink all night. Our battalion CO received a radio message from the 9th Marines Regimental CO stating that five NVA battalions were en route to engage us and to get the hell out of there. Our CO told him we had gotten in here—we would sure as hell get out.

We made a break for it around 1000 and started south on Route 606. After we had been moving for about an hour or so, we heard a loud explosion. Marines screamed in pain, and every corpsman in the area was there. The NVA had buried a 250lb B-52 dud in the road and an NVA soldier leaning up against a tree had detonated it. He was killed by the blast and he took a squad of Marines with him. That must have been the digging we heard!

Corporal Bill Underwood, a squad leader in 3rd Platoon, Echo Co., said he heard a loud explosion and turned around and the Marine he had been talking to was gone. He was damn near vaporized. He said all that was left of that Marine he put in a poncho and put the poncho on the tank. We walked past the place where the bomb went off. There were entrails in trees. There were heads and legs and arms, and feet still in boots! There were Marines all over the place, picking up body parts. It was not something a young man who had just turned 20 years old wanted to see. The history books say five Marines wounded. That is bull! I was there. There were dead Marines all over.

Just a short distance from the first explosion the engineers found another bomb, also command detonated. Our engineers detonated this one. The moment the second bomb went off, the NVA hit us with machine guns, rifles and mortars. They dropped the mortars right on the road, making us dive into roadside ditches to avoid being hit with shrapnel. A lot of Marines were stabbed by punji stakes placed by the NVA. Some other Marines were killed or wounded by booby traps rigged on the roadside.

From then on it became a running battle south with them trying to break us up and close their ambush. There were NVA on both sides of the road. I said to my A-gunner, "I saw a bush move." He said, "You're scared, and you're seeing things." I shot the bush; it fell over dead!

We started to notice troops off to our right and left. I recall someone saying, "Friendlies on the right, Friendlies on the left" and someone else saying, "There are no Friendlies on the right or left." We had no flankers out. At least a company of our men opened up on the NVA, who were wearing US flak jackets, jungle utilities, and helmets, and carrying M-16 rifles. I think we killed between eight and ten NVA.

I really believe that if we had not had the spotter plane calling in air strikes, I wouldn't be here today writing this. The NVA were smart and they knew the only way to survive our supporting arms was to stay as close to us as possible. That meant that when the spotter plane called in the Phantom Jets, the napalm was dropped so close to us we could have roasted hot dogs. The Phantom pilots were good; they came so close to the tops of the trees that we could see the pilots waving at us. We saw NVA on fire, running out of their bunkers. That was a hell of a way to die. I will never forget two smells—the smell of burning flesh, and the smell of death.

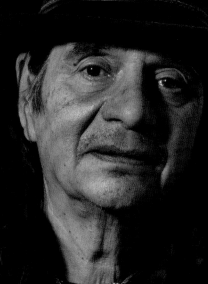

We started to round a bend in the road, and an NVA let loose with an RPG and disabled the lead tank. Soon after an Ontos was also hit with an RPG. Another Ontos came up to aid the first Ontos and tank. It opened up with its machine gun, and suppressed the NVA fire long enough to get the wounded loaded and to get the hell out of there.

I remember that after that, tracked vehicles were flying down that road. They almost ran over my A-gunner and I just as we hit the dirt from another mortar barrage. Instead of the tanks supporting us they turned into a liability. We had to protect them from the RPG crews and we used them as ambulances to transport dead and wounded. We lost two tanks and two Ontos. In the official history of the operation, there is only mention of three crewmen in each tank crew being wounded. That, too, is bull. I personally pulled a dead Marine out of his tank. He was blown nearly in half. An RPG round went through the tank, through the Marine, and bounced around inside the tank. It made a really nasty mess! I remember that well, because it was 100 degrees or better, and he had been in the tank for about eight hours. He had swollen up to double his size, rigor mortis had begun, and he had turned black.

Most of my company got out of the ambush, but we left two squads in there. That night, our Colonel informed us that in the morning we would be going back in and getting our guys. We liked hearing that; Marines don't leave anybody behind. Being the kind of CO he was, he decided to try to link up with Hotel Company and the rest of the battalion that night. He took control of a company from 3rd Battalion, 4th Marines, and a section of tanks. The NVA realized they could not defeat us in detail and broke contact and ran. They had already done enough damage as it was

The linkup was delayed until daybreak to avoid any mistakes. We could hear an Echo Company platoon leader, a lieutenant, on his radio who was caught inside the ambush telling us not to resupply them anymore. His Marines were fighting so fierce he said, "They'll go to Hanoi." They were just doing what they had to do to survive. The next morning at daylight we moved out heading north. When we finally rejoined the rest of our battalion the NVA had vacated the area. The lieutenant whom we had heard on the radio and several of his men had been caught in the open and were captured. The NVA hog-tied them with communication wire, bayoneted them and eventually murdered them in their attempt to draw Corpsmen and Marines into their killing zone. We had heard their screams the night before but passed them off as an NVA trick. All the time it was our own men being tortured to death. We medevac'd the rest of the dead and wounded and were out of the DMZ by around 1200. This "Show of Force" cost the lives of 23 Marines and 251 others wounded. I believe Marines died and were wounded because of poor planning and reconnaissance and overzealous commanders at 3rd Marines HQ. If it had not been for our supporting arms and their pinpoint accuracy, I believe my unit might have been annihilated. The NVA had everything in place to achieve that end. Someone was watching over us that day!

LARRY YEPEZ

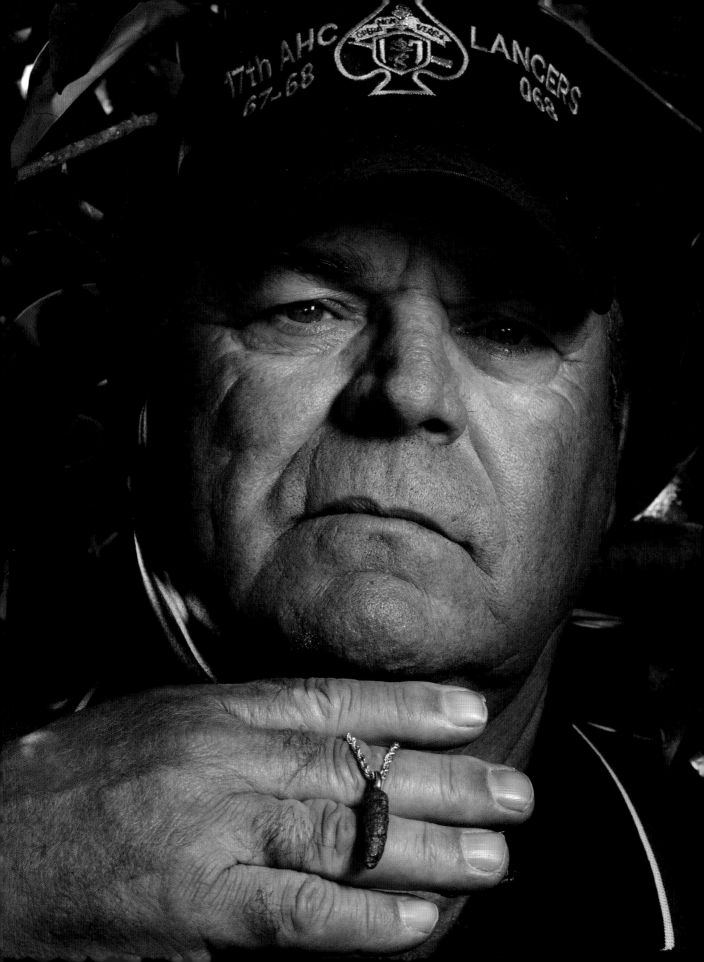

I was a crew chief and door gunner on a UH-1C. We were very busy over there. Our helicopter could fire 8,500 rounds per minute so anybody in trouble on the ground would be glad to see us coming.

 I pulled this bullet from our helicopter and I wear it around my neck as a reminder that I am alive and in memory of my comrades that lost their lives.

RON PETTY

W̱e had just returned from an evening assembly where we were told three medics would be leaving for the field to join Bravo Company, 2nd Bn., 60th Infantry. They had been overrun the previous night and suffered 14 killed and 47 wounded. The 14 killed included three medics. This is when Ron Johnson, a buddy of mine, made a split-second decision to volunteer.

He marched off to see "Top," our first sergeant, and was back in minutes saying, "I leave at 0700 hrs." I didn't hesitate and a few minutes later returned and said "I'm going with you." Tom Bradley, overheard us talking and asked what was up? We said we were both leaving in the morning for the delta. Tom volunteered as well. We were going to experience what the real men in the Army were all about. For me, it was about doing something that was of real value. All I wanted was a job where I could earn something and be a productive troop. I was in the heartbeat of the action of the 9th Infantry Division. Now I wanted to get a feel of what the pulse was like.

My MOS was 91 E-20 (Dental Lab Tech). With the stroke of a pencil, and zero training, I became a 91 A-20 (Combat Medic). As a fully fledged combat medic, I was about to become the biggest fraud in the field. "Top" was irresponsible letting me go. He knew I wasn't trained to perform as a medic. It proved I was just an expendable number on the company roster.

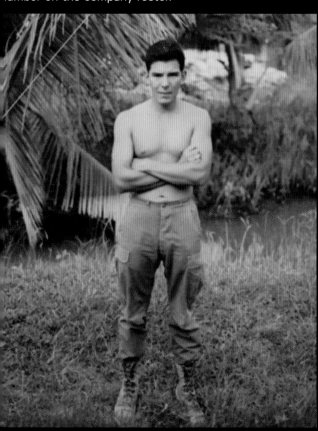

The feelings of being in combat was one of constant fear of the unknown. This is where, without realizing it, you became hyper vigilant, always on guard and all of your senses became acute, your sight, smell, hearing—your nerve center was always on high alert. You became a good scout, always looking for signs of the enemy. Hidden in a one-man spider hole waiting and watching for a GI so he could chop you off at the legs. Good tactics because the wounds would not kill you and he knew that a wounded soldier would need the assistance of two to four more. Then the gook had a chance to really do some damage. As a medic, I learned this first hand—I was usually the one going to tend to a wounded grunt under fire. To this day I still hear the call of "Medic!" in the movies that begin about 0200 as the reels play as I struggle to sleep. They're memories you cannot erase or escape. Thrashing, kicking and waking yourself up in a sweat or some uncontrolled scream.

There was a limit to what I could do in the field. I could apply a bandage to control the bleeding, apply a tourniquet, maybe even inject morphine to control the pain. I was so poorly prepared to care for the men but somehow, between me and God, we were saving lives. Now I had a job and was becoming useful.

I was assigned to the second platoon. The platoon was under strength with only 19 men including myself. Replacements at this time were hard to come by. Bravo Company was rebuilding due to the heavy losses they had suffered, which gave me a couple of weeks to get to know the men in my platoon. All I ever heard from them was, " I hope you're as good as Danny." They had no idea their new medic was completely untrained. I spent any free time at the Battalion Aid Station learning as much as I could.

There were so many ambush patrols, major search-and-destroy missions trying to root out the enemy. Gunships would go in first and pepper the landing zone with rockets, .50 caliber machine-gun and grenade fire. Then it would be our turn to be set down in the Landing Zone. We would gain real estate and lose it and then have to go and fight for it again. Some of my guys got banged up pretty bad and I would put them in for a Purple Heart. There were no pussy wounds in my platoon, these guys gave a lot of blood. You poured, you scored and deserved a ribbon. The men developed confidence in me and we were there for each other. I carried a rifle and became the 19th rifleman. We weren't fighting a war for our country we were fighting together to keep one another alive.

I had some pretty big shoes to fill. Danny, I took good care of your men. I must say these men admired how you cared for them and, as I understand it, you were there for them when the chips were down. I didn't let you down or the men.

FREDERICK LOUIS GRANADOS

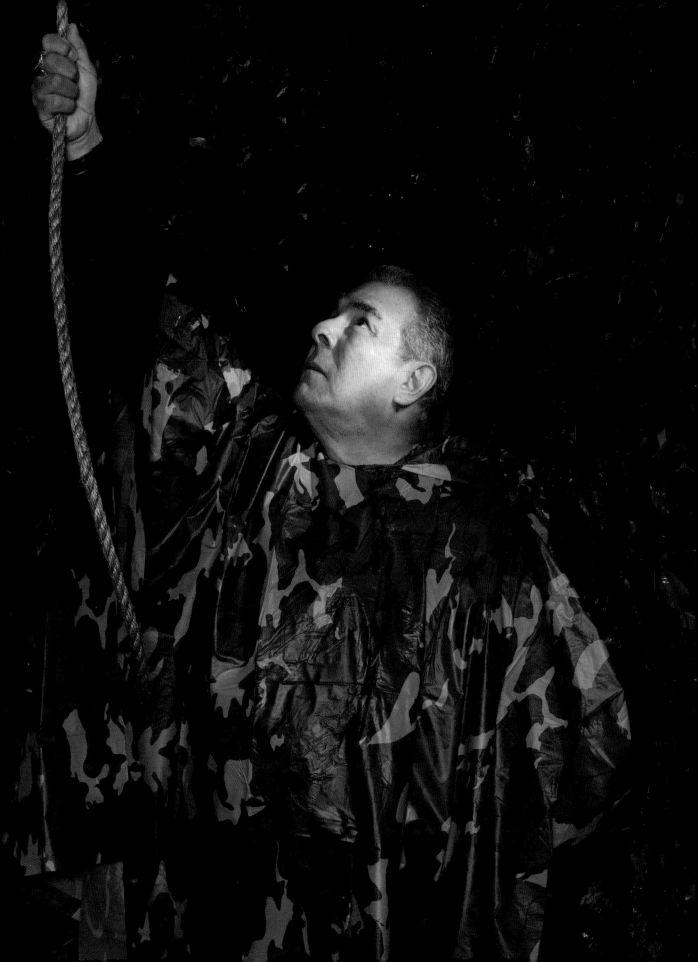

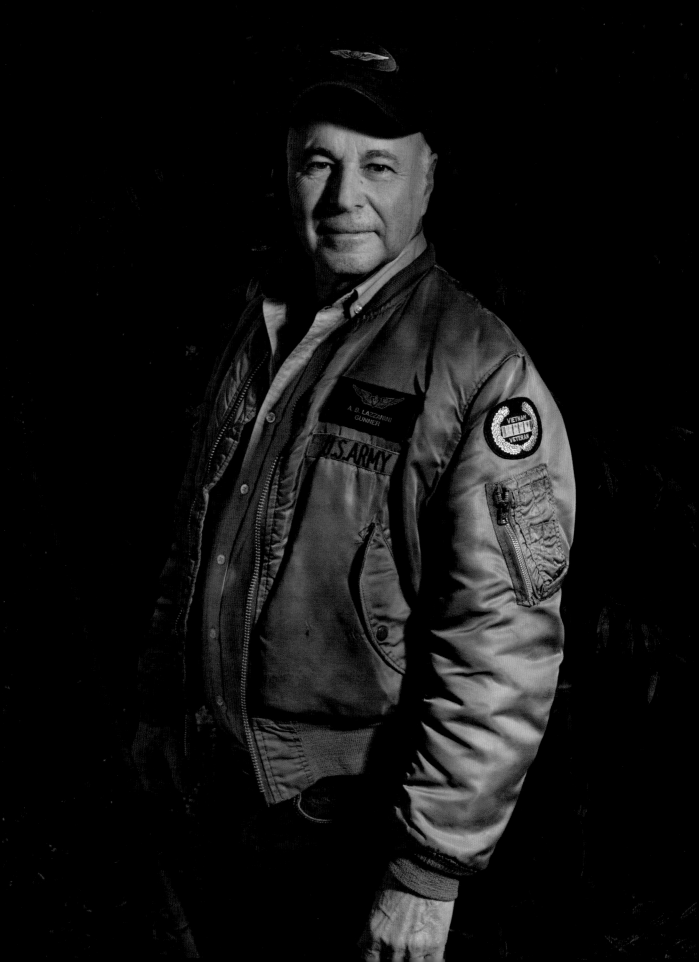

As a helicopter door gunner, the important thing to me was to protect my ship and crew and to see what kind of enemy body count I could ring up. I never gave a thought to being killed. My fear would always turn to anger.

In the final days of October 1967, an armored personnel carrier with numerous troops on board rolled on top of a powerful anti-tank mine. The ensuing explosion killed four men and severely injured several others on and around the vehicle. Vulnerable and alone, their distress call for a dust-off (medical evacuation) was responded to by the closest helicopter in the area. The UH-1D Huey Little Bear 714 was returning back to base from its lone previous mission. Two round trips were needed to deliver the wounded to a base hospital. It would take a perilous third trip in darkness to retrieve the bodies of the dead.

Hastily we loaded the last of the dead into the helicopter. Above me the rotor blades were spinning; frantically grasping for enough air to remove us from the engulfing jungle. A voice in my flight helmet cried out, "We're taking hits!" The crew chief's machine gun responded with a burst of yellowish orange tracers that disappeared into the night-shrouded jungle.

"I'm in," I shouted and squeezed into the small space behind my own machine gun. We started to lift off when flashes of white appeared from the shrinking earth below. I could hear the splats as the bullets searched the ship for another host. I yanked back on the triggers of my weapon and fired and fired. The burning armored personnel carrier remained as a marker, to soon fade and be forgotten like its unfortunate crew. In the real world, grieving parents would be left with only tears and memories.

"Where are you hit?" "What?" I replied. "Where are you hit?" again questioned the medic. We were back at the landing pad of the base hospital. The last body was being carried away on an olive-green-colored stretcher. The medic pointed to my blood-drenched arm. "It's not mine," I informed him coldly and turned back to re-enter my ship. Light from the well-lit pad revealed a palette of blood left by our passengers. The rotor blades fan effect had spray painted the inside of the Huey with a red sticky coating. Three bullet holes ventilated the area around my perch.

Jerry, the crew chief, was staring down at a puddle of reddish-black fluid growing under the tail boom. The pilot was shutting down the engine to examine a strange whistling sound coming from one of the rotor blades. I would soon reveal a .30 caliber incision.

Once again, in my seat behind the machine gun, I leaned back against the bulkhead and closed my eyes. "I'll be back in the States in ten more days and all of this will be forgotten," I said to myself.

I was wrong. I have never forgotten.

TONY LAZZARINI

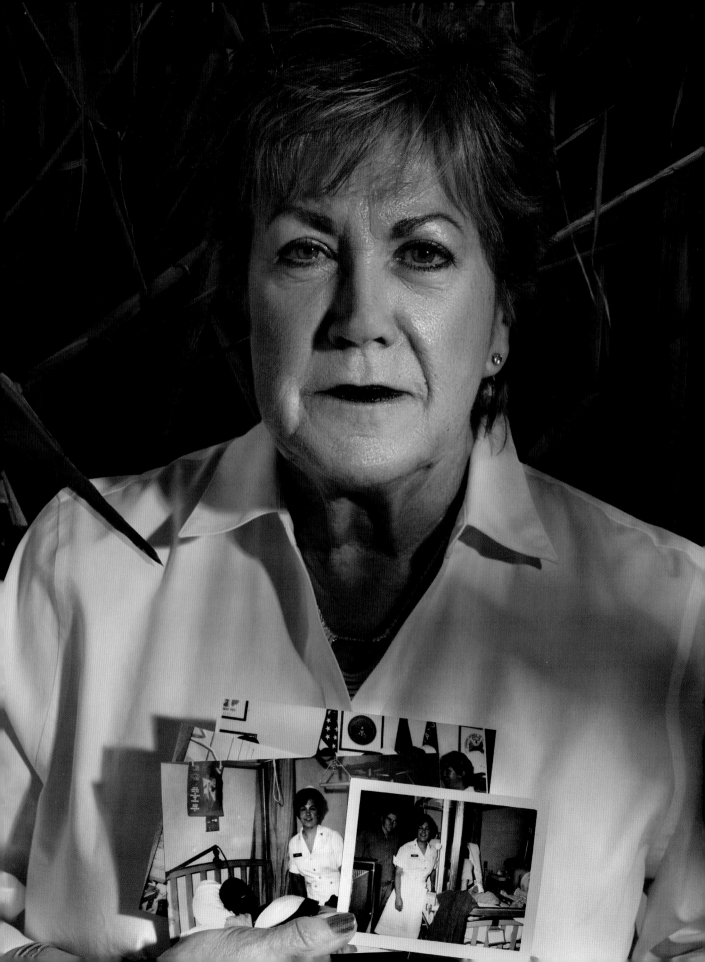

I served as a medical surgical nurse at Letterman General Hospital during the Vietnam War conflict. With only a pull-around curtain for privacy, the night and darkness were difficult times. The loneliness of being away from loved ones, confined to a steel-framed bed, in a body cast or the immense trauma of becoming a paraplegic could be overwhelming. I remember one night, as I made my rounds checking on the patients, touching the remaining hand of a very brave young man and looking into his eyes—such despair. Someone always had the radio on and, inevitably, Kenny Rogers' song *Ruby, Don't Take Your Love to Town* would play. A story often shared was how the fact that they had "come home different" had fractured a relationship.

Night did not bring peace to these young men, locked into traumatic dreams and nightmares. My corpsman and I had to be very careful to stand at the foot of the bed when waking someone as their reaction to this possible "danger" was often extreme. I did have a scare or two trying to wake a patient out of a sound sleep.

These young Americans who had fought in this terrible war received, I feel, little recognition for their sacrifice while in the hospital. Rarely did dignitaries walk the unit to thank them for their service. Perhaps worse still, because the war was unpopular, there were times when embarrassed families would not show up. When they went on pass, men who had paid a huge price in the service of their country would encounter an often uncaring and sometimes an unsympathetic public.

At times I think about and pray for the young patients that I took care of in my early nursing career. I learned invaluable lessons about humanity and about mankind's inhumanity. My Army career gave me one of the most important jobs of my life and nursing career—taking care of our troops.

PATRICIA LAPERA HENDRICKS

One night we were alerted that a patient was going to surgery with an unexploded grenade in his mouth. At his base camp, another GI had neglected to clear his grenade launcher. It accidently discharged and passed through one bystander (killed) and lodged in the mouth of another bystander. Since it had not traveled far enough to arm itself, it had not exploded. The surgeons operating on him were able to carefully remove the cartridge without detonating it, saving both their lives and the patient's life.
GEORGE EDMOND GRANDEMANGE

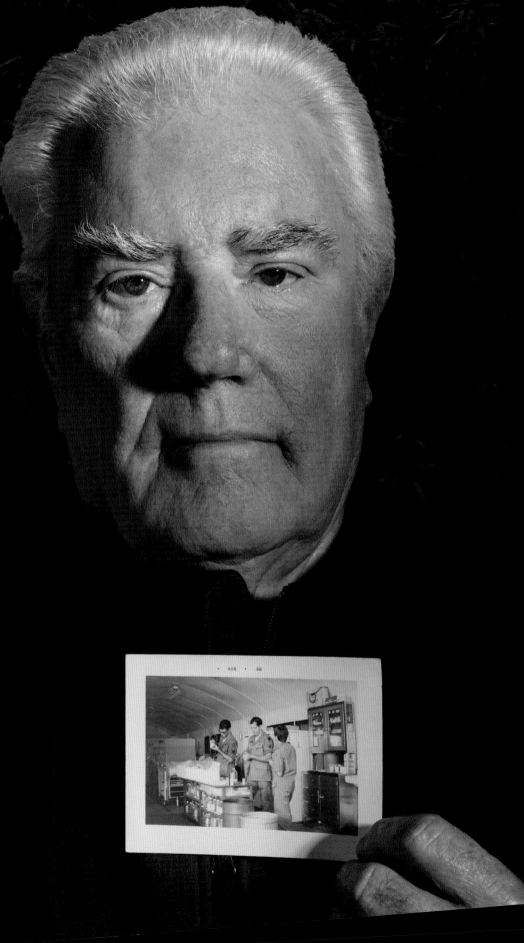

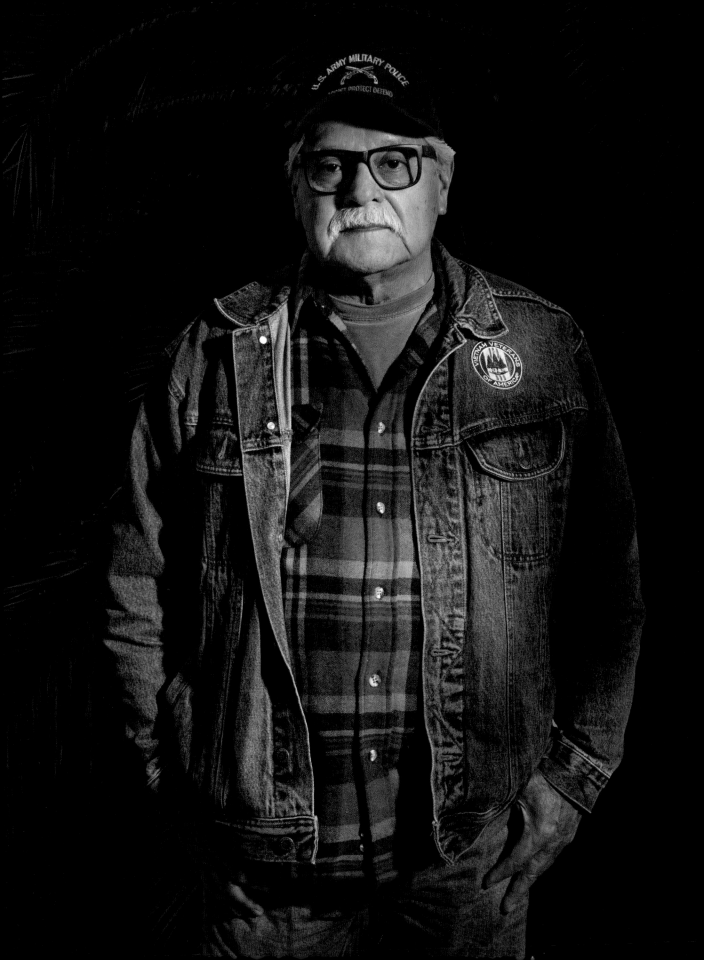

In 1968 Randy Cain, who went to Santiago High School with me and was a few years my junior, and I were inducted into the US Army on the same day. Although many veterans had signed up to go into the service together, Randy and I had not. Yet we ended up doing our entire tour of service together. From the time we left the induction service on the bus to Fort Ord to the time we stepped off the plane home, we were always together. Same company, same periods of leave, same unit, same assignments, same free-time activities. That is all I am willing to relive—the rest is too painful.

GABRIEL AREVALO

My older brother, Tom, had been in 'Nam in 1965–66 as a mechanic and then helicopter door gunner. He showed me a pic of the "tent hospital" he was in when he had malaria. I thought that I could help if I joined. I joined the Army with three other nurse friends from school. We went in on the buddy system and drove off in my red and white rambler station wagon for our big adventure to Texas. We were separated immediately after our basic training at Fort Sam Houston, San Antonio in September 1967. So much for the buddy system.

My younger brother, Steve, was killed in a motorcycle accident while I was in basic training and I went home to Seal Beach for a week for his funeral. Some parts of basic after I came back were a blur. We did get some great training for triage and dealing with mass casualties. I started to realize the severity of injuries I would see and signed up for the operating-room course—an eight-month program.

My roommate, Marylou, and I flew to 'Nam on the same Continental flight out of Travis AFB. We were 22. It was right after the assassination of Robert Kennedy and the country was in turmoil. When we landed at Tan Son Nhut Airbase, a wall of heat and stench hit us as we came down the stairs from the plane in our summer uniforms with nylons and heels. I saw a long line of men in dirty fatigues lying in a row waiting to board the plane. Their eyes looked haunted and they were so tired. I was assigned to 44th Medical Btn. 68th Medical Group, 2nd Surgical Hospital, Chu Lai in I Corps. This was the beginning of all the stares. There were so few women that, everywhere I went, the men would salute as they passed and then you would hear, "Wow, that was a roundeye." During the helicopter ride from Danang to Chu Lai, the pilot got an emergency call, so he dropped me off on top of a deserted mountain with the words "Wait here and someone will come pick you up." Great! I had no weapon, no map, had no clue where I was. So I pulled my duffle bag into the tree line and waited. It felt like forever and I was scared sh......! Welcome to Vietnam! I was so glad to see that chopper flying in to pick me up. I never found out if it was a joke. In only a few hours, someone was at the door yelling for me to get over to the OR ... ASAP. My first case was so rushed—a blown-out aorta from a frag wound and I didn't even have time to get my gloves on. I was throwing my instruments up on the mayo stand with my hands just in my gown sleeves. Everyone was yelling. It was a Vietnamese woman and she had a compression suit on to stop the bleeding but when we deflated it, we still couldn't get the bleeder and she

died. I was covered in blood. It went straight through the cloth gown onto my skin. I didn't have time to process her death because I had to scrub right away for the next case. We worked 12-hour shifts six days a week and more if needed. By the time three weeks had passed, I had so many casualties that I didn't think I could do it. I had seen men come in at night with their legs chopped off with a machete and then, 15 minutes later, the North Vietnamese that did it came in and we had to treat them because our security wanted to interrogate them. One night another "push" of wounded came in and I was with a guy that had half of his face blown off and he was asking me for a mirror so he could look. I told him I didn't have a mirror. It was all I could do not to cry.

Most of the fighting occurred at night and I was on night duty as the junior officer. We had a Vietnamese husband and wife come in and he had a gunshot in the anus with exit in the belly and his wife had been scalped. These were my first torture cases. I couldn't understand how people could be so cruel. By then I had thrown away my bible, cursed at God, and went into survival mode. A few months later, I broke down in the break room crying saying that I just couldn't do this anymore. Sergeant Edwards slapped me and told me to get back in there. I wasn't going anywhere. Welcome to Hell!

I was able to go on some Medcaps—medical missions to villages near the base. This helped go some way to balance all the negative that I was seeing. We operated on children at the hospital for hairlip and cleft palate repairs, club feet and webbed hands and feet. Then I flew with them up to Danang to transfer them and their family to the Vietnamese civilian hospital. It wasn't until years later that I realized that those defects were related to the Agent Orange defoliant that was being used in the jungle. Specialist doctors were rotated in to do eye, neuro, and vascular surgery, so we didn't have to transport many patients out to the Sanctuary navy hospital ship operating off the coast. A reserve unit from North Carolina came in to take over and the 2nd Surgical went up to Phu Bai. I stayed back to help orient the reserve unit. They were petrified. We were getting rocketed at night—the sound of incoming rockets is seared into my brain. If we were in the OR, the nurse anesthetist and I would put the patient on the floor, I would cover the surgical area with towels and my body and the anesthetist would bag breathe him. The doctors would go to the bunkers because their lives were more valuable. We didn't even have flak jackets.

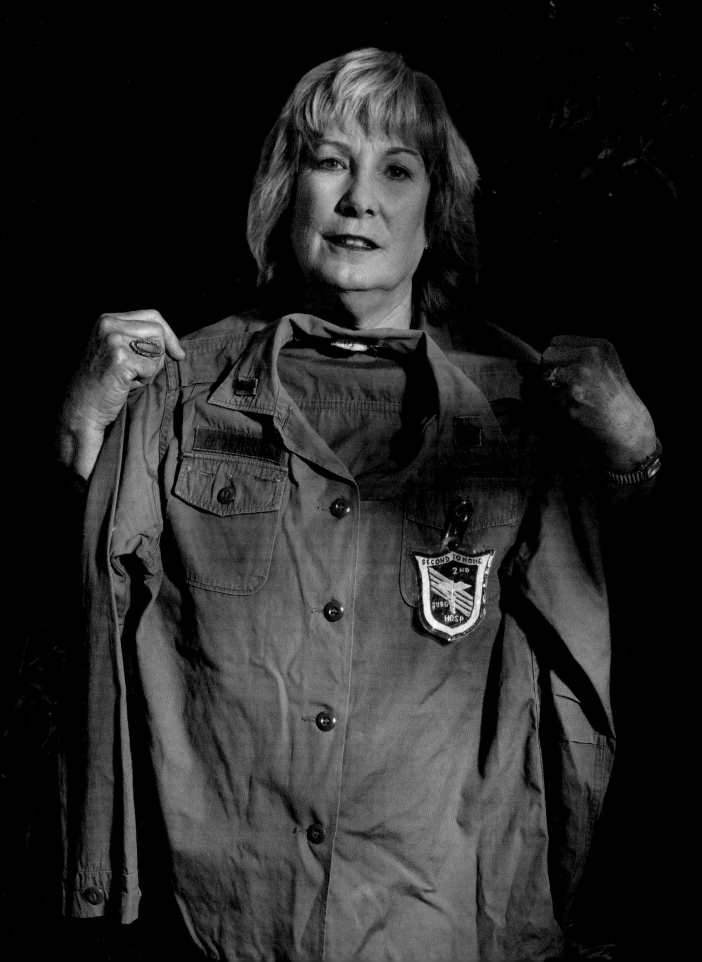

I cried for all the people we lost, Americans and Vietnamese, until I couldn't cry any more. It was so hard to lie, telling a soldier he was going to be OK, when I knew he wouldn't make it. We would put "expectants" on a gurney over to the side wall of the emergency area with morphine to die so that we could work on those that had a better chance of living. I transferred back to 2nd Surgical in January 1969, getting a chopper ride to Lai Khe. They were setting up in a new MUST unit (Mobile Unit Surgical Transport) in the Iron Triangle to support "Big Red One"— 1st Infantry Division. In the spring, we received POWs that the LRRPs brought back over from Cambodia. They came in wearing black pajamas and barely alive. All were suffering from torture wounds; some had had their penis cut off. One of them asked me to let him die; he didn't want to go home. I was silent. The robot Kate kept working but I was angry—so angry. My hands continued to work, my compassion being drained, and my soul was ripping apart. I didn't want to work on any enemy soldiers. One day in the A&E, we had a lot of casualties and one guy came over and put a gun to my head and told me, "work on my buddy first." By then, I was in such a mood, I turned and told him, "go ahead and shoot me … there will be two less hands to help all of you." The corpsmen came over and grabbed him … he broke down. I kept moving.

 The helicopter pilot that had taken me to Lai Khe sought me out and we finally started dating. It took a while because I didn't trust anyone by then. One night we were walking back from his unit and a rocket thudded down within a hundred yards of us. We had heard the "thwaccck" sound of incoming but then it just hit the ground without exploding. We looked at each other and started running—it never went off. Another night, the compound was overrun as the VC came through the perimeter wire. We had a warning siren alert and moved the patients into the containers to hide them … and sat and waited. Satchel charges were put in our tents. There were two Vietnamese children shot that night when they were found to be the ones that had hidden the charges. I was sick to my stomach when I saw them. So young and yet able to do that. The K-9 unit next to us started coming over to sniff out any satchel charges after that. Security on the compound for those coming in and out got a little tighter. The OR was always working if we had casualties and, at night, we would suit up with flak jackets before gowning up. One night, we had a young guy with frag wounds on the pericardium of his heart. The surgeon was able to sew up the tears on his beating heart

while we pumped in so many bags of plasma. He lived! I can't tell you how many times I would hold my breath during some of these parts of surgery. If we got an NVA in to work on, I didn't want to be in on the case. They were the enemy and I didn't want them to live.

 We had two nurses there that were married to infantry officers. I sat with Patty and Russell having a beer some evenings when the guys came in from the field. Two days after Russell went out, he was airlifted into our emergency room DOA with his head almost severed from his neck. I was there with another nurse, Barbara, and I had to yell at her to hold Patty back when she came running through the door trying to see if it was Russell. We didn't want her to see him like that. The robot Kate took over again. Patty was loaded up with tranquilizers and flown out of there the next day. She went home with his casket to bury him. We barely had time to cry before more casualties came in. It wasn't until years later, when I saw her at a reunion, that I found out that she had served another tour in Vietnam. Because we hadn't let her see Russell, she thought we had made a mistake and she was still looking for him because she secretly thought he was still alive. God, that was horrible. Flying home to Travis AFB, we were bussed to the Oakland Depot with protestors throwing rotten vegetables at us. It was shocking. I already felt 105 years old, had been up for 30 hours, had lost 35 pounds and was exhausted. We were not prepared for this. How could this be? We had left one war zone to arrive in another. They told us to take off our uniforms. What, like we should hide it?

I went back to Seal Beach and waited until my future husband—the helicopter pilot—came back six months later. I was somewhat shielded from the political demonstrations in the early '70s by being at Ft Stewart, Georgia with my husband. The war was, however, following me in my dreams and then started to intrude with "daymares of blood." I would see blood all over me or dripping down our ceiling and walls at night. I couldn't wash it off, no matter how many showers I took. I didn't know they were flashbacks. I was grinding my teeth so loud it would wake my husband. He was having his own problems from his tour. He was in the middle of an investigation surrounding his photo of an NVA prisoner being thrown out of a helicopter during one of his missions. We couldn't talk about it. I felt weak and didn't want to reveal what I was going through to my husband after all we had lived through. Our marriage became another casualty of war. I called my brother to come get me and I came home to San Francisco Bay Area. I studied Nutrition and Dietetics at Berkeley, graduating with a degree but gravitated back into nursing because the pay was better. I worked at the VA Medical Center for many years. One night in the late '80s, I was covering a night shift for one of my nurses and I admitted a veteran to the ward. I had to ask him to remove his .45 from his attaché case. Later that night, he came out of his room and stared at me while pacing up and down, then returned

to his room. I was starting to get nervous, when he rushed out again and said, "Put your hand over your face like you are wearing a mask and say, 'it's alright, we've got you now, you are safe.'" I did what he asked and he replied, with tears in his eyes, "It's you ... you were my nurse when I got to the field hospital in Lai Khe. I'll never forget your blue eyes and your voice when they took me to surgery. I believed you; I was safe." It was stunning! He called me his masked angel. This was the only patient that I had worked on that I knew made it home.

I worked at the VA until the '90s. I had remarried and moved up to Sonoma County and had two daughters that brought true joy back into my life. I learned how to laugh and play again. When the Gulf War began, my life came unglued. I would sit in the rocker with my babies watching the news as the war ramped up. I started having nightmares again—"daymares"—and really losing it. I saw carloads of casualties and soldiers with headwounds staring at me as they drove by me on the 101 Freeway. They were in the crowd of people in Kmart as I was helping the kids try on shoes. I freaked out and ran out of the store. One morning, I watched out of my kitchen window as a rocket attack hit my daughters on the swing outside. I rushed out screaming and the next I knew my daughters were patting me and saying, "It's ok Mommy, don't cry." I called my friend, Lily, who was also a 'Nam nurse and got a referral to the Rohnert Park Vet Center. I am forever grateful for the Vets Centers that welcomed all of us that came flooding in after the dedication of the Vietnam Women's Memorial. We watered their carpets with tears as we crawled and cried out the pain.

In 1994 I started working with my local chapter of the Vietnam Veterans, #223 in Santa Rosa. I am currently the Women Veterans Committee Chair at the National Level. The Vietnam Women's Memorial Project was ten years of true grit. The Vietnam Women's Memorial was dedicated in Washington, D.C. on Veterans Day 1993. We women were ecstatic at finally being acknowledged. It was really only the beginning of the long road home for many of us that had successfully compartmentalized our feelings and closed the door on our emotions. It took years to be free from the guilt, sadness, rage and feelings of not doing enough—not being able to save more wounded. We were finally being able to recognize the good that we did, have pride in our service and our contribution to our country.

KATE O'HARE-PALMER

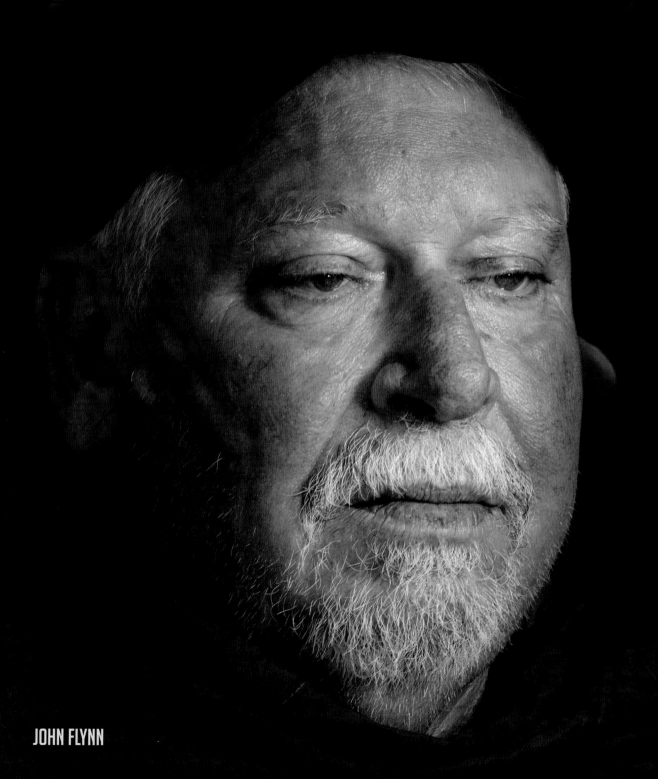

JOHN FLYNN

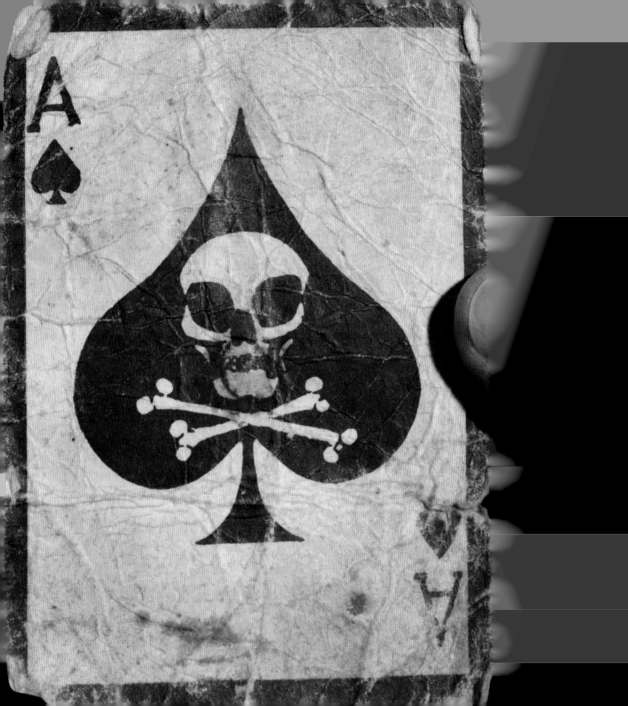

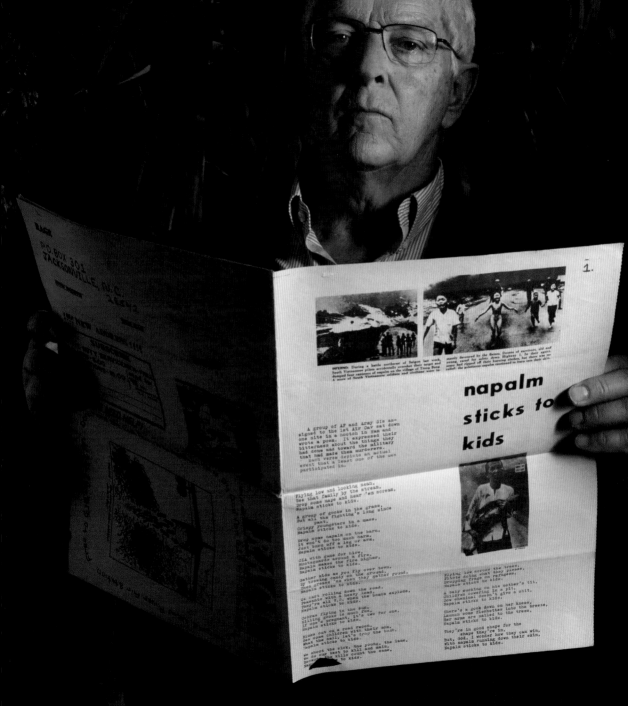

I got my draft notice in June 1968, which was for a two-year hitch in the Army. Just to show them, I went and joined the Marines for four years. Boy, did I show them. I was in numerous firefights and ambushes during my first 10 months with Fox Co. 2nd Battalion, 4th Marines (F/2/4), when I was mostly in the high jungles, empty of civilians, fighting North Vietnamese regulars. My last six months were spent in the lowland rice paddies south of Danang as a squad leader in Bravo Company, 1st Battalion, 5th Marine Regiment and that was a very different war. We fought primarily poorly armed VC. When we went into villages, we never found military-aged men—only old folks, young mothers, and children. Airstrikes were regularly called in on villages without cause or warning. Troops swept through and drove farmers from their land, putting them in "strategic hamlets." In the meantime, their villages and fields would be declared free-fire zones—supposedly devoid of civilians and only populated by enemy soldiers. Removed, sometimes 20 miles, from their ancestral homes and the rice paddies that were their only source of sustenance and income, and unable to tend the graves of their ancestors, many moved back to their villages, and ...became, by definition, "the Enemy." Some of them fought back the only way they could against our massive firepower—with booby traps. The land itself became deadly.

With Bravo 1/5 we usually spent the day sweeping for enemy and were back in the rear by the evening. But in April 1970, my company was sent out on a multi-day patrol, which was unusual for B/1/5 at that time. This location was south of the Thu Bon River, east of the Hoi An Marine base. We stayed there four days. Each day, the captain would send out a cloverleaf of security patrols, north, east, south, and west. On the third day, my squad pulled the north loop and, as we got to our furthest point, we took a couple of badly aimed sniper rounds—clearly a challenge to chase him down. Not willing to fall for that trap, I took note of the location and led my squad back to base. On the fourth day another squad was sent on the same route (a basic no-no) and, at the same location, also took sniper fire. That squad leader, green and eager, took off after the sniper. They had not gone far before they located a booby trap. Some of the men in the squad had never seen a booby trap and were keen to look. Somehow it went off, killing two, wounding two. The next morning, we were ordered back to Liberty Bridge to catch trucks to the rear. On the way, we had to pass through Le Bac 4. The captain ordered our lieutenant to have the squad that had lost men the day before to walk point. As the point squad got to the village, word came back down the line asking if there were any friendlies in this area. The captain answered, "no, this was a free-fire zone." Immediately there was some firing. When I moved up to the first hut in the village, I saw an old lady shot and dying. At the second hut, there was a pile of about eight people, freshly murdered, all women, children, and elderly. One baby's head was blown wide open and his liquified brain oozed down his face, and steam rose from his skull. At the third hooch there was a similar scene with several dead lying on top of each other.

By the time we saw what the point squad was up to, the damage had been done. It was clear that the captain had manipulated the situation by appointing the grieving and angry squad to take point. Other than challenge his authority, could we have made a difference? He would have had the backup of some trigger-happy boys who would take exception to any protest about the murders. So, we did nothing. And the Marine Corps did nothing. Some survivors from Le Bac 4 filed a formal complaint, so there was a cursory investigation—and nada. Everyone went home with medals and promotions and nightmares.

When I returned, I still had two years left in the Corps and was sent to Camp Lejeune in North Carolina. I left Vietnam angry about the war. There was a very strong and easy-to-find anti-war movement by mid-1970, so I sought it out. I managed to spend my two remaining years without getting into serious trouble with the command, but I became a committed anti-war GI. We published an underground newspaper for the last 18 months of my time, and it continued publishing after I left. It was a stressful time but fighting back was the best way available to me to deal with the trauma of my tour in Vietnam. The anti-war movement—specifically several caring and knowledgeable individuals who helped me understand what had just hit me—saved my life. Some of the self-destructive anger I felt, I could redirect to the Marine Corps, and that made all the difference.

PAUL COX

FRUIT CAKE

NET WEIGHT 4.75 oz.

AMERICAN BREAD COMPANY
NASHVILLE, TENN. 37210

CONTENTS: SUGAR, CHERRIES, ENRICHED FLOUR,
EGG PRODUCTS, NUTS (PECANS OR ALMONDS
OR ENGLISH WALNUTS), SHORTENING,
PINEAPPLE, WATER, CITRON, ORANGE
PEEL, LEMON PEEL, SALT,
PURE VANILLA.

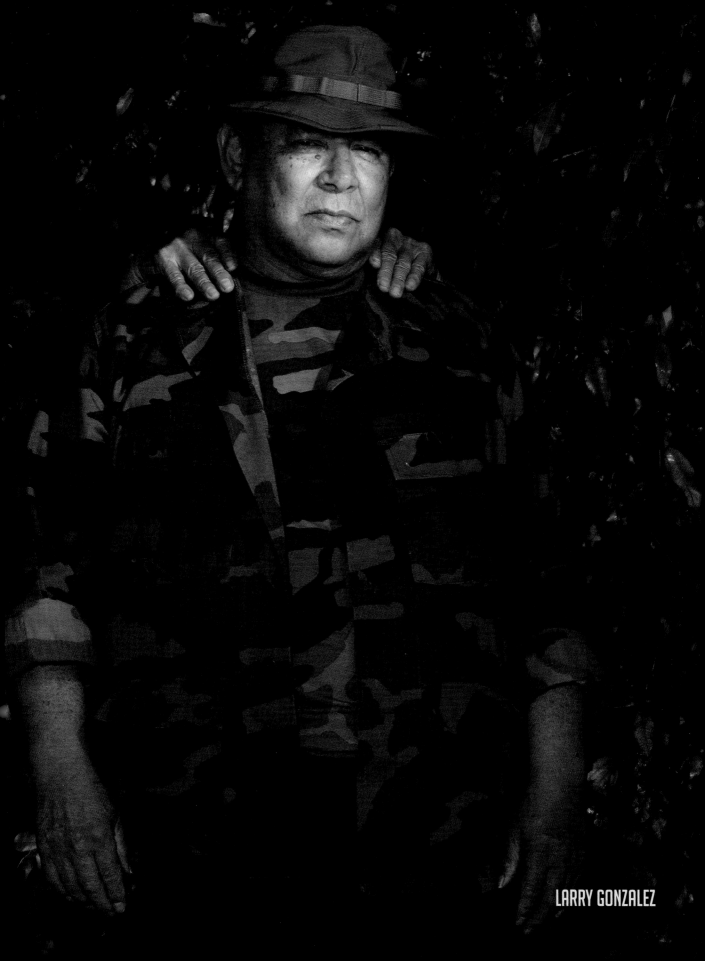

LARRY GONZALEZ

served primarily as an advisor and linguist with the ARVN 23rd Division, headquartered in Darlac Province in Vietnam's Central Highlands. I advised a special technical communications unit of that division and, at times, was with a 4–5-man team on intercept missions in the region. Our insertions were on high elevation points and brief, as we did not have the support to adequately defend ourselves if attacked. Consequently, we were extracted by helicopter at specific times after only a few hours. My main exposure to the trauma of the war occurred during a three-month period around the siege of Kontum City during the North Vietnamese Spring Offensive of 1972. I survived when thousands of others did not and this left me with a compassion for enemy casualties despite profound ideological differences. I also discovered that, even amidst almost paralyzing fear and the basic struggle to survive, the instinct to risk one's life for another being in peril remains. In an ambush, I risked my life to save a fatally wounded soldier and, by luck and the grace of the Divinity, my life was spared. One of the paradoxes war brings home to you is how supremely precious life is, while at the same time being extraordinarily fragile. Despite the dark and destructive capacity of human beings, I am an eternal optimist with regard to man's potential for goodness. As my time "in country" neared its end, I returned to the Central Highlands base at Ban Me Thuot for a few days, before transferring to the coastal city of Nha Trang for the final week. My colleagues expected me to start saturating myself in booze, however, I resumed my working out, helping local Vietnamese mothers with Amerasian children communicate with their now stateside boyfriends and attended to writing and reading. During those final days at the secure seaside base, I experienced severe anxiety waves at night, feeling the Viet Cong might burst into the premises, killing us at random. I later learned this condition was called "short timer's syndrome." The departure from Saigon for my flight back to the USA was unremarkable, with the exception of an elderly Vietnamese lady who held my hand, and thanked me for my service fighting for freedom. Our eyes both glistened. I had the good luck to be on the return flight with two of my linguist honors classmates, and having been processed out of the military, we paid the taxi driver extra to drive across the Golden Gate Bridge. It seemed to be a way of re-embracing America. I stepped off my final flight in Boise, Idaho, alone, in full uniform as a proud decorated soldier. No one was there to greet me. Some passengers offered discreet smiles but the prevailing mood was polite silence. I was not, at least, confronted with the jeering and aggression that many returning GIs experienced from war protesters. The irony and reprehensible contradiction of these self-styled "viceroys for peace" using abuse and violence. Finally, my mother drove up, and I was welcomed back to the world of a civilian and student. Driving down to Boise State a few days later to register for additional undergrad studies, I realized I was in no cognitive or emotional state

to pursue graduate work. On my way down the boulevard by the park area in my new economy Volkswagen, I noticed a duck on the side of the road, dragging a companion by the wing over the curb. Suddenly I went blind for several seconds, just holding on the steering wheel, as a wave of tears burst forth. I composed myself and proceeded to the university. A few days later, my twin brother invited me to join him on a small-game hunting adventure. Carrying a .22 cal rifle, I made a clean shot on a desert cottontail. As the bunny expired, it emitted a shrill scream. I felt paralyzed emotionally, told my brother I was done, and just walked with him for the rest of the trip. Some weeks later I went on a family camping trip up in the woods. I lay in the large tent at night, with branches gently brushing against the fabric but could not find sleep—I was back in Indochina. The nightmares I began to experience at intervals were evidence of what I carried back with me and internalized. A friend called and said he had heard that a marathon was being proposed in Vietnam. I contacted Sports Asia, a British sports group out of Hong Kong, who were organizing the event in conjunction with Viet authorities in Saigon/Ho Chi Minh City. I wrote to the organizer, sent some bio info, and my idea that, as a Vietnam veteran and a serious marathon runner, I might be able to recruit some wheelchair veterans. He endorsed the idea and formally invited us. I was able to recruit a small contingent of wheelchair veterans, coincidentally, all from California. Their presence would be a powerful visual symbol that a disability need not be an impediment to a productive life and that we were willing to extend a hand of peace to former enemies in spite of ideological differences. Sadly, on the day of the race, the Vietnamese race committee withdrew permission for the wheelchair vets to take part. They cited "security concerns" but we felt it may have been for fear that our US wheelchair vets would have far out-performed their Vietnamese counterparts. As this was the first event of its kind in Vietnam's history, completing the marathon, and crossing the finish line was extremely emotional. The line itself was the gate entering Independence Palace, renamed "Reunification Palace" after the Communist victory. As I was wearing a single of the American flag in the marathon, I wanted to make a visual statement that America and its veterans remained part of the Vietnam experience.

In Hanoi in 1993, I wore an "MIA/POW" singlet. I wanted to make a peaceful statement to Vietnam and the world highlighting concerns for those "Missing in Action." Prior to the start of the race, I had to hide the singlet under another shirt to avoid the ire of the Vietnamese authorities and race officials. Even though an invited USA Olympian won the race, the Associated Press photo of me in the shirt at the height of the race was seen around the globe. I make no apologies.

JIM BARKER

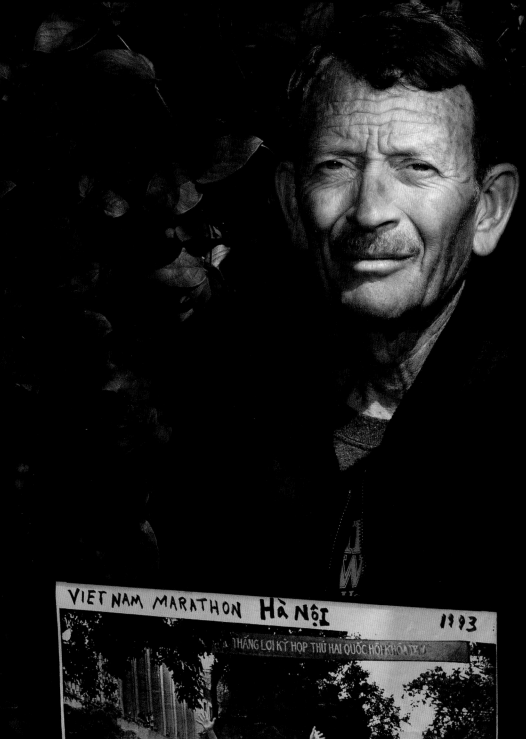

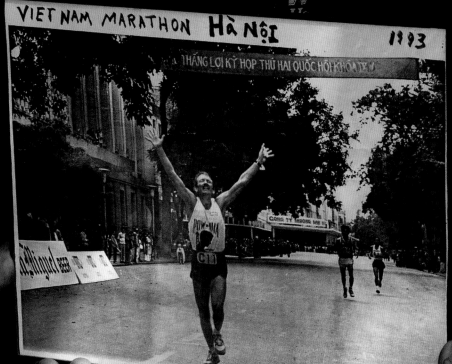

VIETNAM MARATHON Hà Nội 1993

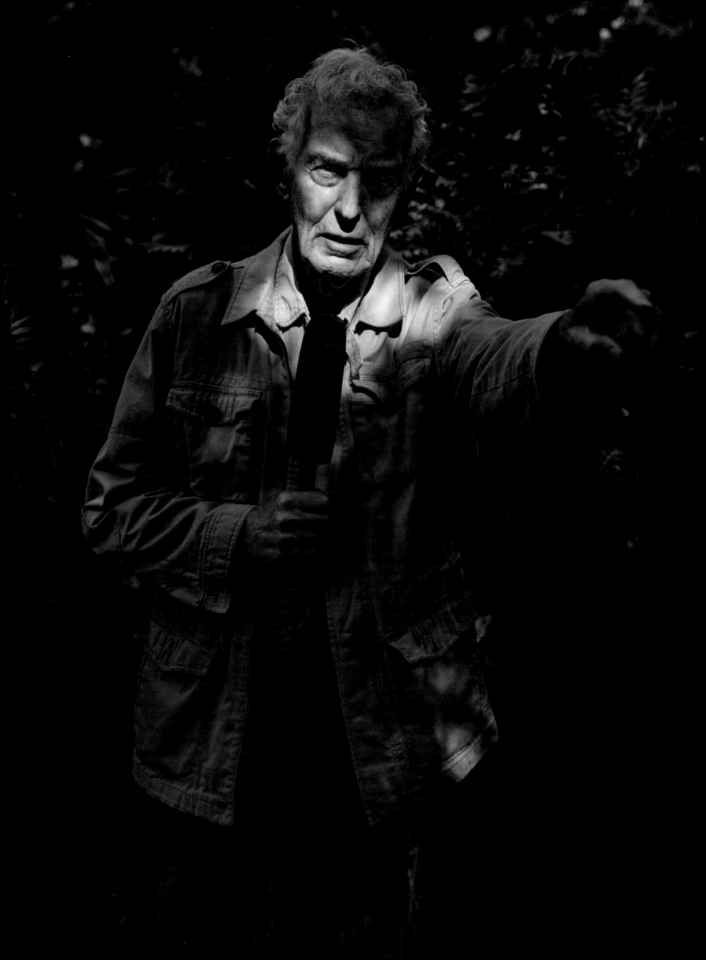

was there in 1972 and 1973. I was with ABC TV News. When I got the job, I was in Philadelphia as an anchor-reporter. They asked me, "Are you willing to go to Vietnam?" and I said, "Are you kidding? Of course, our nation is at war. What bigger story is there for a reporter?"

When I first got to Vietnam, I bought a few items from a very talented tailor we called the amazing Mr. Ming. One of the things I bought, aside from your standard correspondence khakis, was a white sports shirt. Well, pretty much on my first mission into the field, I wear the white shirt, to the great consternation of our troops. They said, "What the hell have you done? They can zero in on us from a mile away with that shirt on." They quickly got my shirt off—and they were a little physical about it. They were under mortar attack at the time I think.

I was never really scared. Too dumb to be scared maybe. There were times, of course. When we got ambushed, when we got too close to the fighting for comfort. Yes, especially when you're ambushed and you're face down in the dirt, while all the shooting is going on around you. You hug the ground, that's all you can do. My first story was in '72, in the fall. It was from a small village north of Saigon. We kept a distance while the planes were bombing and firefights were on within the village. Then afterwards, you go in and you can see the devastation. Bodies, wounded, people running, still in fear. Devastation, and death. Basically, the villagers took the brunt of it. Civilians always do. They just bombed the hell out of the village first, strafed it, and then there were firefights, pretty much aimlessly.

We had a great rapport with the American troops and pretty good with the South Vietnamese. Many of the officers spoke English, but not the troops. We had total access to our troops. I stuck my microphone in the face of pilots, generals, out in the field, and they didn't wince. It only changed after the war. In recent conflicts, they have embedded the reporters in military units. The embedding process is a real mistake and a mistake for journalists to go along with it, seems to me. That's why we're over there, to bring the story home. I don't know how else you'd do it. When there's a lot of carnage, it's sad, unfortunate, but the people have to know. In recent wars, of course, we don't really get that kind of coverage.

We could call from the Bureau in Saigon to Tan Son Nhut Airport, or Bien Hoa Air Base and say, "You got anybody flying up to the highlands?" We'd hop aboard if there was space. General Healy, Mike Healy who died earlier this year, helped me get a story once. He was called "Iron Mike." This was in the highlands of South Vietnam, Pleiku I think. On this occasion, I was working on a story in his area. We were having trouble getting a charter plane. The other networks are often on to the same stories. It's a question

of who can get to Tan Son Nhut first and put the film and script on the plane to Bangkok or Hong Kong. General Healy says, "You can't get a charter plane huh?" He turns to his aide. "Colonel, call my plane up from Saigon." The colonel said, "What?" Healy said, "We've got to get these guys a plane." Now we are talking about the general's personal plane down at Tan Son Nhut. The colonel didn't like the idea but he did it of course. We got on the general's plane in the highlands with our film and script. We had a plane ready to go at Tan Son Nhut to fly the stuff out. General Healy hated CBS for some reason. I never asked him why.

There's one other story I should tell. I was in Cambodia and Lon Non, son of Lon Nol who had taken over the government from Sihanouk, was going, I forget where, Paris or somewhere, to talk peace. So, I was in Phnom Penh airport and we spotted him. All three networks have crews out waiting for him, hoping to get interviews. We saw him go in a side door at the airport and so did CBS, so we both trundled after him, and got him inside and started interviewing. He was having no problems—his English was excellent. Suddenly, out of nowhere, we get jostled, more than jostled, shoved from the side knocking the reporters and their cameras virtually over. It was a particular woman reporter—she is still working today. Anyway, she was NBC; we were CBS and ABC who got in. She just threw everything into chaos and Lon Non says, "Who are these people?" Anyway, it ended very shortly thereafter. He said, "No, no more." I turned to her and gave her "What for?" I asked her, "Are you dumb? Look, what are you doing?" and she punched me in the face, right? I did a quick turnaround and I kicked her. This was all because she was left out. If she wasn't going to get the interview then you weren't going to get it. After that, I went out on the tarmac and some of my colleagues were making fun of me, "Here she comes, look out, oh no." I should point out, more importantly, that her cameraman, a Japanese guy, came up to me and apologized for her and he said she does things like that all the time.

My overall reaction to the war in Vietnam, as someone who was there, was that it was sad. Just overwhelmingly sad. Sad because it was unwinnable perhaps. Maybe sad because the extraordinary toll of civilians in a small country was really reprehensible. We're exporting wars, saying we're exporting democracy at the same time. It doesn't work. It doesn't happen. It was, as Charles de Gaulle said, a quagmire. He told us not to get in after the French were defeated in '54. We went through the same thing and did the same thing and got the same results, from the same people. Extraordinary.

CHARLES BURKE

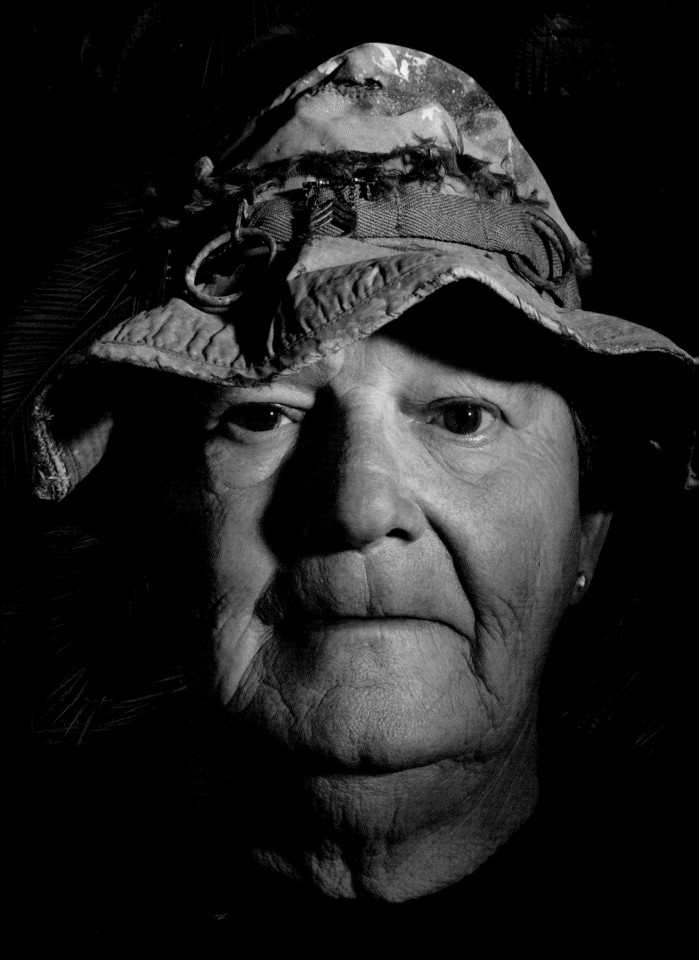

The cries in battle are much easier than the whisperers at home.
MARK S. VANTREASE

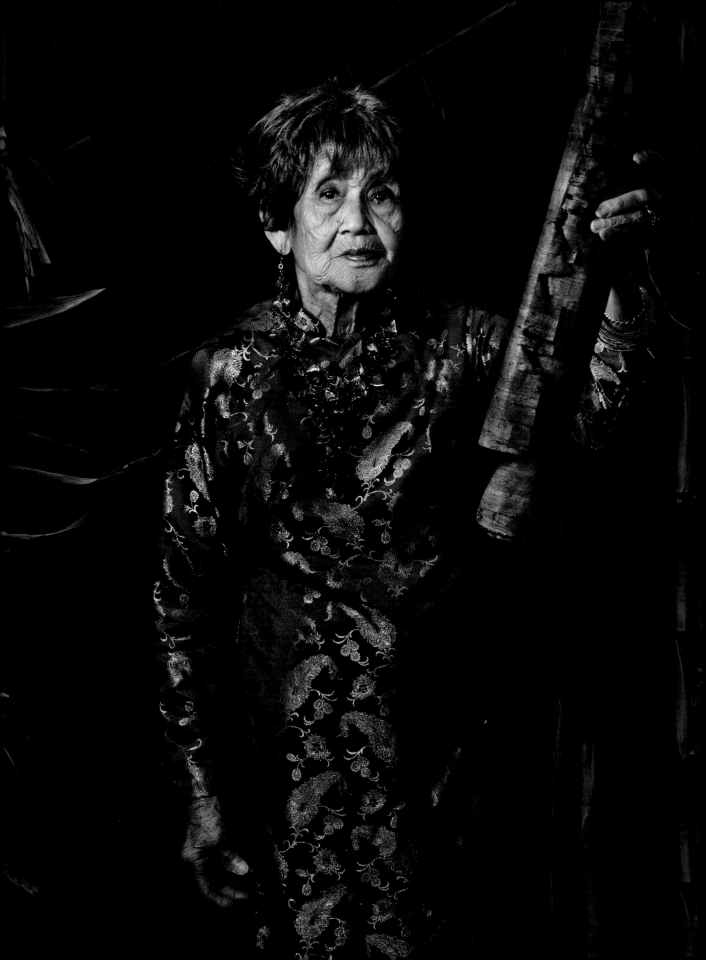

I was born in 1930 and grew up in Vietnam. My address was 31 Long Dan Street. It is now 8 Dinh Liet Street, Hanoi. I was forced to flee Hanoi by the fighting between the French and the Viet Minh. My father was a military officer in the National Guard of Vietnam. My younger brother was one of those who moved to southern Vietnam in 1954. I met my brother again in the United States on July 3, 1980 and that was when I learned of my nephew's death, fighting in the Army of the Republic of Vietnam. My brother had also been seriously wounded. My husband, also a soldier, was imprisoned by the Communists in Hanoi for four years.

We fled Vietnam, leaving our relatives and possessions behind, to seek freedom. We escaped in a small boat with a Chinese couple. Because the boat was too small, I was thrown overboard in rough seas. I managed to swim back to the boat but knew I had brushed with death. I would have faced prison had I returned to south Vietnam and the death penalty in the North. We hid in the coastal waters, eventually reaching Macau, where we were given food and water but not allowed to land. We eventually arrived in America on February 22, 1978.

My grandmother often said, "being human, we can't help missing our family and all our relatives and ancestors who had lived since the dynasty of King Tu Duc." I miss them so much. Words cannot express all I wish to say.

BACH DOAM TUYET

was born and grew up during the war, so it is hard for me to know what life was like before but I think our people certainly suffered from political and economic turmoil and chaos caused by the wars.

It was very dangerous for everybody once the war began. I was lucky enough to live in a city. For most of the war, urban areas only saw limited fighting. My life

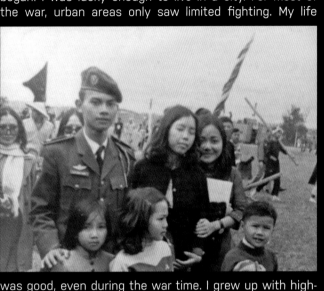

was good, even during the war time. I grew up with high-quality education. It was not until I jumped in battles after I graduated from the Military Academy that I experienced what war was like.

I did see combat and my memories are of its ferocity—it was like hell. I graduated from the military academy with the rank of lieutenant in 1974, the hottest time of the war. I specialized in the Airborne branch. I was sent to Phan Rang, a province in the center of Vietnam at the beginning of April 1975 with a mission to build a defensive station, which would stop VC encroachment from the north. My battalion was able to protect the area for a few weeks, but the VC brought three infantry divisions, artillery and tanks to the front. We had only two Airborne battalions and three Ranger battalions. The huge difference in forces left us at a huge and painful disadvantage. There was never any doubt that we would lose this battle. My superior committed suicide rather than be captured by the VC. The death of soldiers and civilians was an everyday occurrence. There were times I thought that I might die on the battlefield. I was almost killed by a VC soldier but, luckily, he passed me by. I was not wounded.

The Communist Government ruled the country strictly and with severity. Officers of the former ARVN and any of the southern population who had any involvement with the former regime were actively discriminated against. Many were, like me, imprisoned in concentration or "re-education" camps, de-naturalized and tortured, both mentally and physically. Many officers from an intellectual background felt hopeless and saw no light ahead for their future. More than three years later, I was released from the camp. Showing continued discrimination, the communist government ordered all military officers who left "re-education" to settle in remote rural areas, given the beautiful name of the "New Economic Zones." The name sounded like a promise of a great development, but it was just a way to push people like me away from city life. I was sent to just such a place to engage in manual labor, tilling the land, under government supervision for another few years before being allowed to return home. Not until my New Economic Zone time ended was I allowed to come back home and be re-naturalized. As a citizen, I should have been supported by the government to establish a stable life, but this was not the case. My background as a former military officer remained a bar and it blocked me from any opportunity. My college knowledge and skills were not used and I could only find odd jobs to survive. Fortunately, the US government implemented a policy to help former military officers of the Republic who had been kept in the Communist camps for three years or more. I was sponsored to immigrate to the US—I felt happy and safe to be in the USA. I have been treated kindly since I came here.

I still miss Vietnam a lot, especially considering that my parents and five of my siblings still live there. I used to fight against Communism to express the love for my country. Eventually, we, the Republic, were the loser. Because of that, we were labelled as "warriors for injustice," "traitors to the nation," or "lackeys of the US invader." It is true, we were unable to sustain the battle against the VC, strongly armed by its communist brothers, with little more than our bare hands. After the country was unified in 1975, however, millions of Vietnamese used any means they could to flee. I think this is perhaps the best indication of what people thought of the justice of the new regime.

THUY HANH

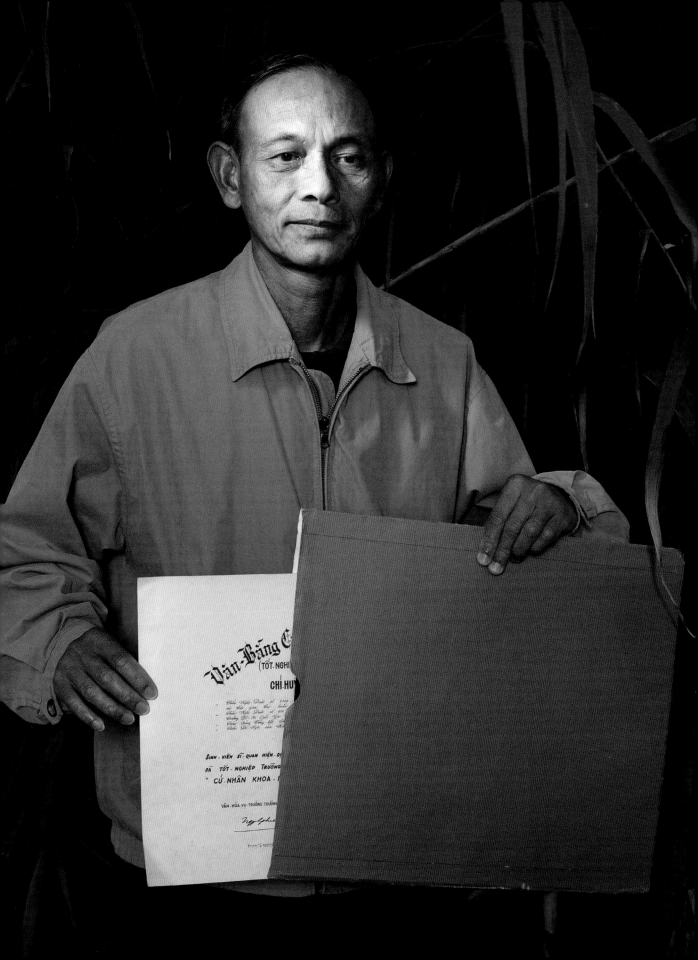

M y parents were born and grew up in the North, but they left for the South in 1954 to escape the Communists. My brother was born in the North; I, in the South. We both grew up in the South. Before the war, Southern people led a pretty good life. We lived in Dalat, a highland town—small, peaceful, and picturesque—and I have good memories of my wonderful childhood. I was an elementary student. After graduating from high school at the age of 18, Hanh, my second eldest brother entered the Military Academy in Dalat. It was the only military institute in South Vietnam that offered a higher education and conferred bachelor degrees on its students. This would likely set them on the path to becoming a high-ranked military officer in the future. I had huge admiration for my older brother and already saw him as a high-ranked military officer. He was an inspiration to all my other brothers, who dreamed of joining him as a cadet when they reached 18. All of us were proud of him and strongly believed in his bright future.

The Communists started their guerrilla war against the South Vietnamese government in 1959, supported by the Soviet Union and Communist China. The South Vietnamese were supported by the United States. It was an awful war during which our lives were full of worry and stress. It seemed that every day there was more bad news about a battle here or there. The war caused so much suffering; those with husbands or sons in the army lost them in the fighting while others lost loved ones, killed or missing, trying to flee the fighting. My home town was spared the fighting but I witnessed the suffering of the war at first hand when my family fled Dalat as the fighting closed in.

The VC pushed further and further into the South from the 17th Parallel while those forces already in the South carried out attacks and did everything they could to disrupt and destabilize life in the South. By the crisis of the war, with the Communists on their way to victory, almost half of South Vietnam had fallen to the enemy. Crowds of people flooded the roads, moving south to escape the cruel VC. My family were not all in Dalat at this time but scattered across the country. Hanh had graduated and been assigned to a combat unit, my next younger brother had entered the Academy and was studying there, my father worked in a central province and my eldest sister lived in another province with her husband, also a military officer. When a rumor spread that the VC were planning to attack Dalat, more and more panic-stricken civilians left the city every day. My mother made the decision to also leave for Saigon with my three sisters and three brothers. It was a long, exhausting journey full of pain, anxiety, and fear. The Communists had cut the roads from Dalat to Saigon so we had to make our journey in several stages, first by car, then by boat. It took us nearly a month to reach Saigon. Every day, we listened nervously for news of the war's progress. The next steps of our journey were planned accordingly to avoid areas that had fallen to the Communists. With updated information, we planned our trips accordingly to avoid where the VC occupied. My father also left his work to join us. With all the disruption of the war, it was hard for family members to keep in touch. In particular, we had no ideas as to the whereabouts of Hanh or my eldest sister. My sister was pregnant and remained at home, alone. Her husband had been on a business trip and could not get back to her as the province had been overrun by the Communists. Hanh, we knew, was with his unit battling the VC somewhere. We maintained contact with my father via telegraph, the only method available to us at the time. Fortunately, we were reunited during our journey and together found our way to Saigon. All along our route, the effects of the war were painfully and inescapably obvious. The rubber plantations along the state highways swarmed with evacuees, sheltering in fragile tents with no idea of what was to become of them. Seeing their plight, we could not help but wonder whether fate would soon find us in similar conditions. And there were the bodies.

At every step of our journey, people fought with each other to get a place on the transport—bargaining, bribing, arguing, jostling—anything to get a spot. On some occasions, deserters from the Republic's army fired their weapons into the air to scare people back and ensure themselves a place. People were terrified and desperate to escape and, sad though it was, it was understandable that no-one was willing to give up their place for another.

My mother prepared, for each of us, an individual emergency bag with our name, identification, water and a few dry provisions, against the awful prospect of us becoming separated amid the chaos of the war. I was only a little girl and the fear of losing my parents haunted me. This terror almost became a reality as we sought to escape from one port. Because of the mayhem, we could not all get on the same boat. Our belongings were hopelessly scattered; one sister and one brother were thrown into one boat and it departed as some of us were hurried onto another while other members of the family were still on the dock. We were all overwhelmed by the hopeless feeling that our scattered family would never be reunited. I sobbed, looking at the boat carrying my sister and brother further and further away. My sister, meanwhile screamed and reached back towards us as if her shrieks alone might stop the boat. Father stood, rooted to the spot, dumbfounded. My parents fought to get the rest of the family onto one boat and then pleaded with the owner and helmsman to help reunite their scattered children. Thankfully, just offshore, our boat was reunited with that carrying my brother and sister. Together again we hugged and sobbed. Belongings had been abandoned on the other boat but we were together again and that was all that mattered.

What followed was a hellish three-day sea journey aboard a small boat burdened with two cars and countless people, overloaded and constantly at risk of sinking.

Everybody could see the danger but what choice was there? The irony that we were risking our lives in this nightmarish fashion for the dream of living our lives free of communism was not lost on us. My father barely slept, comforting my mother and us children, constantly anxious- about the weather conditions—he still remembers the towering waves rising as high as the top of the boat. My 12-year-old brother occasionally whispered, "Dad, I'm scared." By contrast, I was so small and could not cope with the rough seas. I was sea sick, vomited the entire contents of my stomach and lay somewhere between asleep and unconscious for the whole trip. Eventually, the boat made landfall and my mother woke me. I was still semiconscious and could not even stand. Somebody carried me off the boat and there were teams from Buddhist and Catholic charity organizations there to help the evacuees. I vaguely recall a Buddhist nun attempting to feed me rice gruel, but I could not eat anything and just asked her for some water and fell asleep again. After about a week, we completed the final leg of our journey to Saigon by land. Our entire family was taken in by my uncle on my mother's side.

The war officially ended on April 30, 1975 when the Communists occupied Saigon. The country was now considered unified. We now sought to discover what had become of my eldest sister and my brother Hanh. My brother-in-law made his way to the province where he lived with my sister. There he found her alive and brought her to his parents' home in Saigon, where she shortly after gave birth. We could find no trace of my brother Hanh.

Our hopelessness gradually grew as more and more of his classmates and colleagues returned home until, with heavy hearts, we accepted that he had most likely fallen in battle. A few months later, he suddenly appeared at the house in which we were living. No words could describe our feelings when we saw him. What a blessing! All our family had survived the war. Hardship and adversity lay ahead of us, however, as the harsh Communist government imposed severe restrictions. The government actively discriminated against any Southerner who had connections with the former regime and former military officers like my brother and brother-in-law in particular. Unwilling to suffer under the Communist regime, hundreds of thousands of Vietnamese fled the country after 1975. My eldest sister and her husband left the country in 1978, eventually reaching the US, I did not have to suffer the hardships of the boat people who undertook harrowing sea voyages to seek freedom. My sister sponsored me to immigrate to the US and I settled here in 2008, no longer a young woman. Undaunted by the challenges presented by the cultural differences, I returned to school to pursue my higher education aided by the wonderful Californian appreciation of diversity. My parents and five of my siblings still live in Vietnam. I never stop missing them or my country. I dislike the Communist regime but love my homeland. What I appreciate most about the US is that it has afforded me freedom, democracy and opportunity.

THUY LUU

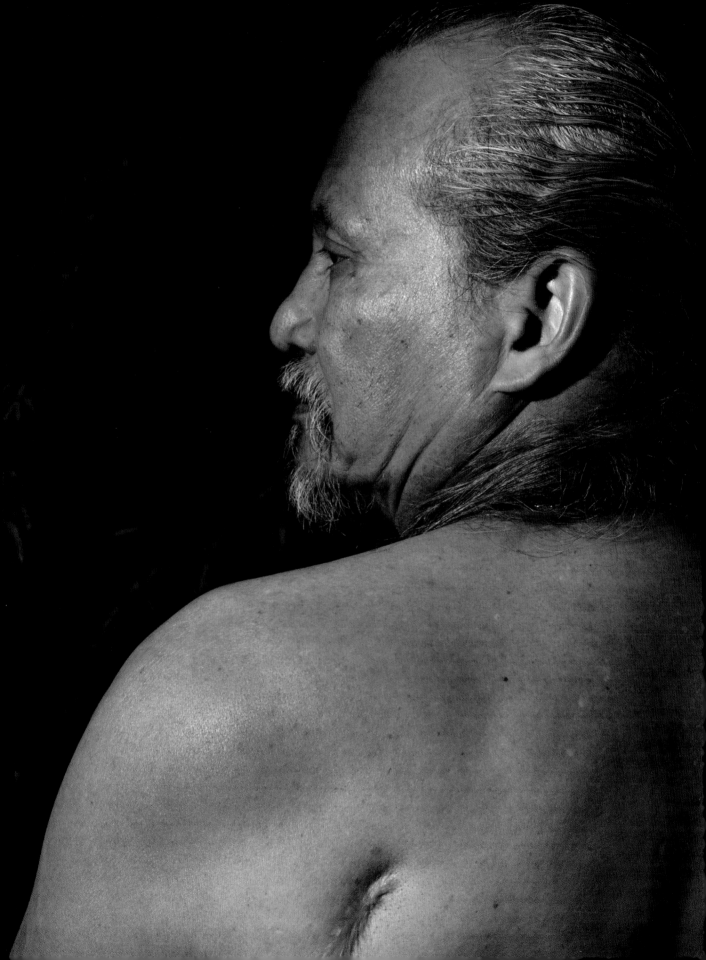

It was late 1970, and we were on our fifth mission. Our 4th Battalion was sent to Prey Totoeng, in Kampong Cham Province, about 124 km northeast of Phnom Penh. Our mission was to open up Highway 7 toward the city of Kampong Cham, which was occupied by the NVA along with most of the surrounding area. Highway 7 is one of the routes leading to central South Vietnam. When our battalion reached Prey Totoeng village, we clashed heavily with NVA forces for three days. During the fighting, my 1st Company was at the side of Highway 7 flat on the ground, surrounded by palm trees and shrubs and not far from a crater left by a bomb dropped by an F-105. I tried to make a dash for the crater as it would give me a better chance of avoiding the flying bullets. That's when two bullets struck me. One on the left side of my neck which exited my left shoulder blade. The second bullet struck my right leg and went straight through my left leg, leaving me with a total of six bullet holes in my body. At that moment, I thought I was going to die but fortunately I was rescued by my two good paratrooper friends.

In October or November 1971, our battalion were sent to Phuoc Tuy and Long Hai in South Vietnam to be trained by the US Green Berets. During this training, we carried out two missions against the Ho Chi Minh Trail. We were again engaged with the North Vietnamese, losing one man dead and one wounded, the latter only 15 years old.

I continued to fight against the NVA and the Khmer Rouge until the surrender on April 17, 1975. I lost three uncles in the war and ten members of my family were murdered by the Khmer Rouge.

CHANDARA VINOUKKUN

If it was not for a US Marine and for the church's sponsorship, I would not be here and thriving in the States. I'm forever grateful and indebted to American Vietnam veterans.

BIC TRUONG

Flying into California was like a dream come true. I was 11 years old but I can remember life seeming so different here. We came on July 3, 1980. The next day was the Fourth of July and was indeed a big celebration for us. Everything was bigger and we were not used to riding in a car. To this day, I still get carsick if I'm a passenger sitting in the back.

Some neighbors welcomed us, while others were prejudiced and hateful. My siblings and I were teased a lot and made fun of because we were non-Americans.

I don't miss Vietnam at all.

VENUS ADAMS

While my peers were being drafted and sent to Vietnam or other duty stations during the late 1960s–early 1970s, I was in school at San Jose State University majoring in Occupational Therapy and working to support myself. Assigned to the Menlo Park Veterans Association, working with Korean War and WWII veterans, another student, also of Chinese descent, had the habit of walking around the grounds. That was until we encountered Vietnam veterans, in treatment programs, who would stare at us and call us "gooks."

In the late 1980s, I worked at the National Center for Post-Traumatic Stress Disorder Program (PTSD) located at the Palo Alto V.A. Medical Center, Menlo Park, where I treated about 1,000 Vietnam combat veterans. On the first day of work, while being introduced at the community meeting with 90 pairs of eyes staring at me, I froze and felt I shouldn't be there. Twenty years after Vietnam and their reaction was as raw as if they were back "in country," not knowing if I was a friendly or "Charlie."

One day at a meeting, I took the last available seat, which happened to be next to a veteran. He started sweating profusely. It emerged that he had avoided all contact with Asians for a long time as his past experiences were so traumatizing. He couldn't move to another chair as there was no other space available and, by the time the meeting ended, he finally relaxed as he realized nothing bad was going to happen to him. It was a real breakthrough as he could see his anxiety was a result of his 'stinkin' thinking', which kept him locked in his misery and depression. Another time, a veteran was seated next to me and he reached out and touched me on the arm with one finger and then again. I didn't understand what he was doing. I eventually recognized that he saw he wasn't going to get a negative reaction and he wasn't going to get harmed.

HELEN WONG

APPEAL

OF SOUTH VIETNAM PEACE COMMITTEE TO G.I'S IN THE US EXPEDITIONARY CORPS

AMERICAN G.I's !

Johnson Administration had to end the bombing and strafing throughout the Democratic Republic of Vietnam.

This fact is a clear proof of big failure of the war escalation policy pursued by the White House and Pentagon Hawks, at the same time it tolls the complete failure of U.S Imperialism in its evil scheme of aggression against South Vietnam.

This is a clear proof of glorious victory won by the Vietnamese people, both in South and North, fighting for the defence of Independence and Freedom of their country.

This is a significant victory of the peace-and-justice loving people of the world and of America, tirelessly and uncompromisingly struggling for an end to the immoral war being waged by the Johnson—Rusk Administration in Vietnam.

And this is also a clear proof of victory firstly won by wise and conscientious G.I's determinedly refusing to go out to the field to uselessly die for more benefits for the arm-dealers and the corrupt puppet administration of Thieu—Ky—Huong.

But the Wall Street Hawks who receive orders of war materials and equipments still obstinately cling to their scheme of continuing fire and bloodshed in South Vietnam with lives of G.I's.

They will be unable to realize their dark designs.

The heroic and indomitable Vietnamese people will successfully check he bloody hands of aggression of the American war-mongers.

In the impetus of victory, millions of American people and people the world over will push up their struggle forcing the U.S Administration to end he war and restore peace in South Vietnam.

G.I's !

Directly bearing the brunt of hardship and danger in this ever harde and more dangerous war day by day, surely no one of you wish to be driven out to the field. Your dream must be the image of your ship landing home harbor, and the warm happy atmosphere of your family reunion.

For the early restoration of peace in South Vietnam, for an early home return, you should stand up for action by :

— Determinedly refusing to go out to the field, refusing to reinforce, refusing to take part in counter. Offensive and sweep operations !

— Not resisting the Liberation Armed forces; in contact, quickly lay down your weapons for lenient treatment.

You should join the people of Vietnam, of America and of the world in the struggle forcing the U.S Administration to :

— End the war, Restore Peace in S.V.N

— Bring American and Satellite Troops home !

— Let the Vietnamese affairs be settled by the Vietnamese people hemselves.

SOUTH VIETNAM PEACE COMMITTEE

A few days after reporting aboard the USS *Enterprise* CVN65, the operation to evacuate the last Americans out of Saigon commenced. The *Enterprise* remained on station until the operation was terminated and then headed back to her homeport—Alameda, CA. From Alameda to Vietnam and back to Alameda, my round trip was 29 days and I took part in a piece of history—the end of the Vietnam War.
LELAND HOUSE

IN MEMORY OF THE 58,000 MEN AND WOMEN
THAT NEVER RETURNED, 1959–1975

Acheson, Theodore T.

Specialist 5 (E-5), MOS—84C Motion Picture Combat Photographer, Department of the Army Special Photographic Office (DASPO) (not attached to MACV), US Army
Served 1967 to the end of 1969
Vietnam: Saigon, Con Thien, Gio Linh, Dong Ha, Quang Tri, Hue, Phu Bai, Danang, Vinh Long, Thu An, Khe Sanh, Pla Kvie, An Loc, Xaun Loc, Can Tho, Cam Ranh Bay, Chu Lai, Soc Tran, Loc Ninh, Ashau Valley (1968), Parrots Beak and Ho Bo Woods plus ETC.
Also served in Thailand, Korea, Japan, Taiwan and Okinawa

Adams, Lily

1st Lieutenant, Registered Nurse, US Army
Served in Vietnam 1968–1970

Adams, Venus

Vietnamese refugee/immigrant. Arrived from Hanoi in 1980

Aldrich, William

Specialist 4 (E-4), MOS—67n20 UH1H repairmen
F Troop, 3/17th Cavalry
A Company, 158th Aviation Bn. 101st Airborne Division, US Army
Served in Vietnam 1968–1969, Di An, III Corps; Ashau Valley, DMZ south to Danang, Camp Evans, Camp Eagle, Phu Bai, I Corps
Flew door gun 2 1/2 months
Served in US Army 1967–1970

Archibald, Frank "Archie"

Corporal (E-4), MOS—0331 Machine Gunner, A Company, 1st Battalion, 7th Marine Regiment, 1st Marine Division, Fleet Marine Force, USMC
Served in Vietnam 1968–1969, Dodge City, Operation Sherwood Forest, Arizona Territory, Danang
Service in the USMC 1968–1970

Arevalo, Gabriel

MP

Barbee, Stewart

Specialist 5 (E-5), MOS—84C20 (Motion Picture Specialist), DASPO (Department of the Army Special Photographic Office), US Army
Served in Vietnam 1969–1970

Barker, Jim

Sergeant (E-5), MOS—05B2IVN (Advisor/Linguist), MACV, US Army
Attached to 23rd ARVN Division, Ban Me Thuot
Designated acting captain for three months during the siege of Kontum, Easter Offensive 1972
Served in Vietnam 1971–1972
Served in the US Army 1969–1972

Bergman, Ernie

Seaman Apprentice (E-2), Navy Quartermaster, Surface Ship Navigator, USS Windham County (LST-1170) and USS Thomaston (LSD-28), US Navy
First tour—Arrived overseas February 1967, returned to USA February 1969. Served in all Tactical Zones except II Corps but mostly in I Corps and IV Corps. In I Corps, mostly between Danang and the DMZ. In IV Corps, mostly Dong Tam and surroundings areas
Second tour—Arrived overseas August 1969, returned USA March 1970. Served in all Tactical Zones except II Corps but mostly in I Corps and IV Corps
Active duty from September 2, 1966 to June 1, 1970. One enlistment. Left the service as a Petty Officer Second Class (E-5)

Berndt, Sam

Sergeant First Class (E-7), MOS—11D4P Airborne reconnaissance, B Troop, 2/17 Cavalry, 101st Airborne Division
Served in Vietnam December 1967–December 1968, Sung Bay and the Hue City area.
Served in the US Army from June 1960–July 1984
Retired as Sergeant Major (E-9), 2nd Brigade, 2nd Armored Division.

Bic Truong

Vietnamese immigrant/refugee. Arrived from Saigon in 1975

Blecker, Michael

Sergeant (E-5), MOS—11B4P Airborne Infantry, 2/327 Infantry, 101st Airborne Division, US Army
Served in the Republic of Vietnam 1968–1970, I Corps
Served in the US Army 1967–1970

Boyd, Thomas E.

Specialist 3 (E-3), Specialist 4 (E-4), MOS—82C20 Field Artillery Surveyor, 2nd Battalion, 40th Artillery, 199th Infantry Brigade, US Army
Served in Vietnam March 1967–March 1968, Long Binh area,
Served in US Army July 1966–July 1969

Burke, Charles

Reporter, CBS News Network, Vietnam, 1972–1973

Cader, Bruce

Private First Class (E-2), MOS 0331 Machine Gunner, Bravo Company, 1st Battalion, 5th Marines, 1st Marine Division, USMC
Served in Vietnam December 1968–December 1969, An Hoa, Go Noi Island, Arizona Territory

Cheney, John

Specialist 4 (E-4), MOS—Heavy equipment Operator, 8th Engineering Battalion, Support Command, 1st Air Cavalry Division. Served in Vietnam June 1967–May 1968
Was based at An Khe but served all over as needed
Discharged from US Army, Germany October 1969, Specialist 5 (E-5)

Connolly, Patrick

Lieutenant (O-3), Naval Flight Officer (NFO), attached to Fleet Air Reconnaissance Squadron 1 (VQ-1), stationed at NAS Atsugi, Japan. Rotated month-long deployments in Vietnam and Japan from September 1965 to June 1967. Most missions were conducted from Danang Air Force Base, South Vietnam in a EC-121 aircraft, and several missions were conducted from the aircraft carriers USS Midway (CVA-41) and USS Independence (CVA-62) in a EA-3B aircraft. Served in the US Navy from September 1961 to August 1967

Corbett, Thomas

Second Lieutenant (O-1), First Lieutenant (O-2), MOS—0302 Infantry Officer, 3rd Military Police Battalion, Fleet Marine Force, USMC
Served in Vietnam 1969–1970, I Corps, northern most part of South Vietnam from Danang to Quang Tri and the Demilitarized Zone
Served in the USMC 1966–1971 Four and half years
Platoon Commander, Company Commander, Battalion Operations Officer.
Left the USMC as First Lieutenant (O-2)

Cowing, Ken

First tour—Sonarman Third Grade (STG3), USS Bradley (DE-1041). March–May 1970 provided gunfire support off the coast of Vietnam to Army, Marine Corps and special forces units ashore as well as naval bombardment of designated targets
Second tour—Sonarman Second Grade

(STG2), USS Lockwood, March–June 1972 provided gunfire support off the coast of Vietnam to Army, Marine Corps and special forces units ashore as well as naval bombardment of designated targets
Also assigned to monitor North Vietnamese ports that had been mined by the US
Served 21 years in the US Navy
Retired as a Master Chief Navy Counselor (E9)

Cox, Paul
Private First Class (E-3), MOS—0311 Infantry Rifleman, F Company, 2/4 Marines (Feb–Nov 1969); HQ Company, 1/26 Marines (Feb–Aug 1970), B Company, 1/5 Marines (Sept 1970–June 1972); M Company 3/8 Marines (June 1972), USMC
Served in Vietnam February 1969–August 1970, Quang Tri Province, Quang Nam Province
Served in USMC August 1968–June 1972
Left the service as Sergeant (E-5)

DeCuir, Clifford
Rank in Vietnam: First Lieutenant (O-2), MOS—4200 Supply and Service Officer, 527th Quartermaster Detachment, First Logistical Command, US Army
Served in Vietnam January 7, 1970–December 22, 1970, Cam Ranh Bay, Danang
Served in the US Army January 22, 1969–December 24, 1970 (Active Service), December 1970-January 9, 1975 (Reserves)

DeHart, Michael
Staff Sergeant (E-6), MOS—11B40, Platoon Sergeant, Echo Company, 2nd Bn. 5th Cavalry, 1st Air Cavalry Division, United States Army
Drafted for two years; one-year training and one year in Vietnam
Served in Vietnam from August 1968 to August 1969, An Khe was base camp for the Cavalry

Diaz, Raymond
Specialist 5 (E-5), MOS—91B Combat Medic, D Company, 3/187 Abn Inf, 3rd Bde, 101st Abn Div, US Army
Served from December 1967 through October 1968 in Phouc Vinh, Saigon, Bien Hoa, Ho Bo Woods, Trang Bang, Dak To, Dak Pek, Song Be, Ashau Valley, Chu Chi, around Iron Triangle and War Zone D
Served October 1966 to October 1968 on active duty. Served from January 1970 to December 1989 with Texas Army National Guard,

reactivated January 1991 to September 1991. Active duty for Desert Storm. From October 1991 to September 1999 served as an Army Reservist in Panama as an IMA.
As Enlisted I was an E-7.8
Retired as Major (O4); served approximately 33 years

Dowling, Jim
First Lieutenant (O-2), MOS—Infantry 11A, Reconnaissance Platoon, E Company, 3rd Battalion, 21st Infantry Regiment, 23rd Infantry Division (Americal), US Army
Served in Vietnam October 1970–October 1971, Chu Lai & Danang

Drennan, Dennis
First Lieutenant (O2), MOS—31542 (Special Forces Qualified Infantry Officer), 5th Special Forces Group (Airborne), US Army
Served in Vietnam November 1968–November 1969. Assigned to and served with A-502 and B-23.
In the Army from September 1966–November 1969

Estrella, Gary G.
Lance Corporal (E-3), MOS—2533 (Radio Telegraph Operator), HQ & Service Company, 2nd Battalion, 9th Marine Regiment, 3rd Marine Division, USMC
Served in Vietnam 1967, Dong Ha (Base Camp), Con Thien (Combat Base), I Corps
Served in the USMC June 1966-March 1969
Left the service as Corporal (E-4)

Flynn, John
Lance Corporal (E-3), MOS—2532 Equipment Operator, Telecommunications Battalion, USMC
Served in Vietnam 1968–69 Hill 34
Years in the service 1966–1969
Left the USMC as E-3 Lance Corporal

Forbes, Don
Specialist 4 (E-4), MOS—05B Radio Operator, 7th Squadron, 1st Air Cavalry Regiment, US Army
Served in Vietnam Feb 1968–August 1968, Xian, Vinh Long
Served in Us Army August 1966–August 1968

Gagnebin, Leland A
Specialist 4 (E-4), MOS—11B20 Light Weapons Infantry, Rifleman, 3rd Brigade Air Cavalry Platoon, 101st Airborne Division, US Army
Served Vietnam July 1969–July 1970,

northern I Corps, Camp Evans, Ashau Valley, Annamite Mountains, DMZ, survivor of Battle for Firebase Ripcord; took part in Operation Texas Star, four-and-a-half-month-long, last American offensive of the war (March-July 1970)
Drafted out of Chicago, IL for two years active service
Served in the US Army January 1969–January 1971

Garoutte, Michael "Mike" A.
Second Lieutenant (O-1) when first arrived in March 1967; promoted to First Lieutenant (O-2) in June 1967. AFSC Pilot 006, 311th Air Commando Squadron (Part of the 315th Air Commando Wing. then 7th Air Force), USAF
Arrived in Vietnam, March 1967 Danang Air Base. Also stationed at Phu Cat and Phan Rang. Flew missions right across the country. Returned home March 1968
On active duty from November 1965 to August 1972 (six and a half years), then two more in the Reserves
Rank at Separation was Captain (O-3)

Gonzalez, Larry (Since deceased)
Specialist 4 (T), 69th Signal Battalion, US Army
Served from October 1965 to September 1967. Served in the Reserves until 1971 (but never had to go back)

Graham, Eugene
Lieutenant Colonel (O-5), MOS—406B Tactical reconnaissance pilot, 82nd Tactical Reconnaissance Squadron, USAF
Served in Vietnam September 1967–June 1968, Udorn Royal Thai Air Force Base
Served in USAF 1943–1977
Retired from USAF as a Colonel (O-6)

Granados, Fred
Sergeant (E-5), MOS—91E20 Dental lab Technician/91A20 Combat Medic, B Company, 2nd Battalion, 9th Infantry Division, US Army
Served in Vietnam 1967–1968, Operation Cedar Falls, Tet Offensive
Served in US Army May 5, 1966–May 3, 1968

Grandemange, George E.
Private First Class (E-3) upon arrival in Vietnam, MOS—91B20 Medical Specialist, 93rd Evacuation Hospital, US Army
Served in Vietnam September 1967–October 1968, Long Binh, Vietnam
Served from March 15, 1967–October 18,

Rank upon discharge: Specialist 5 (E-5)

Gray, Alex
Command Sergeant Major (E-9), MOS—1B50 Infantryman, B Troop, 2/17 Cavalry, 101st Airborne, US Army
Served from 1965–1969. Two tours in Vietnam

Gullett, Rob

Guerra, Miguel
Sergeant First Class (E-7), MOS—95B4P (Military Police), A Troop/B Troop, 2/17 Cavalry, 101st Airborne Division
Served in Vietnam April 1967–Dec 1968, Phan Rang, Duc Pho, Tam Ky, Dakto, Bien Hoa, Song Ba, La Chu, LZ Pinky, LZ Sally
Served in the US Army 1965–1973

Guzman, Nick
Specialist 4 (E-4), MOS—52D Power Generation Repairer, 88M Motor Transport Operator, 11C Indirect Fire Infantryman, 2nd Brigade, 11th Artillery, 101st Airborne Division, US Army
Served in Vietnam April 17, 1969–November 9, 1970, I Corps, Camp Eagle, Danang, Phu Bai, Quang Tri, Hue

Harris, David
Journalist, author, anti-war protestor

Hendricks, Pat
First Lieutenant (O-2), MOS—3448 Medical-Surgical Nurse, Letterman General Hospital, San Francisco, US Army
Served in the US Army from 1965–1968

Holstrom, Thomas

House, Leland
YFU (Yard Freight Utility) 7, 61 & 57, Lighterage Division (1966–67), assigned to Vietnamese River patrol Group 51 & 52 (1969–71), US Navy
Served in Vietnam April 1966–April 1967, November 1969-June 1971, April–May 1975
Served in US Navy July 14, 1965–September 0, 1976, Reserves January 1977–December 1989. Danang, Chu Lai, Dong Ha, Hue, Dong Nghi River, Rung Sat Special Zone, Upper Saigon River

Howard, Henry "Hank"
Technical Sergeant (E-6), Detachment 14, 38th Air Rescue & Recovery Squadron, US Air Force

Served in Vietnam 1984, Thailand 1985, Vietnam 1966
Can Tho Airfield, Ubon Royal Thai Air Base, Binh Thuy Air Base, Tan Son Nhut Air Base

Kern, Louis
Corporal (E-4), MOS—2533/8654—2533 (Radio Telegraph Operator), 8654 (Reconnaissance Marine, Parachute and Combatant Diver Qualified, 3rd Force Reconnaissance Company, USMC)
Served in Vietnam 1968
Dong Ha, Quang Tri, Khe Sanh, Qua Viet, the DMZ, Con Tien, Hill 950, I Corps
Served in the USMC April 16, 1966–January 11, 1969 (Active Service)

Kubitz, Kermit R.
Sergeant (E-5), MOS—11B40 Infantryman, A Co, 1/18th Infantry Regiment, 1st Infantry Division ('Big Red One') July 1969–February 1970; 11th Armored Cavalry February 1970–April 1970; A Co, 1/20th, Americal Division April 1970–September 1970, US Army
Served in Lai Khe, the Iron Triangle and Chu Lai

Kuchem, Robert
Lieutenant Junior Grade, Surface Warfare Officer, 7th Fleet Underway Replenishment Group Communication Officer, US Navy
Served 1965 in Gulf of Tonkin
24 years' service in total
Retired with the rank of Captain (O-6)

Larochelle, Ray
Ensign, Designator (MOS)—1315 (Aviation Pilot), Helicopter Attack (Light) Squadron Three HA(L)-3, Detachment 6, US Navy.
Served in Vietnam July 1967–July 1968, Dong Tam, Mekong Delta, IV Corps, Republic of Vietnam.
Served in the US Navy May 1967–May 1977
Honorably Discharged May 1977 as a Lieutenant (O-3)

Lazzarini, Tony
Specialist 4 (E-4), MOS67N20 UH-1 'Huey' door gunner, 25th Aviation Regiment, 25th Infantry Division "Tropic Lightning", US Army
Served in Vietnam 1966-67

Leary, Patrick
Chief Warrant Officer 2 (W-2), MOS062B Helicopter Pilot, Utility and Light Cargo Single Rotor, 189th Assault Helicopter Company, 52nd Aviation Battalion, 1st Aviation Brigade, US Army
Served in Vietnam November 1967–

November 1968, Pleiku, Central Highlands
Served in US Army March 1966–November 1971

Licata, Dave
First Lieutenant (O-2), MOS – 0505 Radio Communications Officer, 362nd Signal Company, Attached to 459th Signal Battalion, US Army
Served in Vietnam June 1969-June 1970, Nha Trang and Hon Tre Island (responsible for up to 30 men with signal sites in both locations. Also responsible for a signal site at Ban Me Thuot.)
Served in US Army 1968–1970

Locke, John (Since deceased)
42nd Dog Platoon, LRRP, 101st Airborne Division

Louis, Selwyn
Lance Corporal (E-3), MOS—0811 (Field Artillery Batteryman), Mike Battery, 4th Battalion, 11th Marines, 1st Marine Division, USMC
Served in Vietnam 1968–1969 Danang, Phu Bai, I Corps, Vietnam
Served under the USMC 1967–1969

Lowe, Ronald
Captain (O-3), MOS—1542 (Infantry Unit Commander), advisor to Vietnamese forces—Regional Forces/Popular Forces (RF-PF), Military Assistance Command Vietnam (MACV), US Army
Served in Vietnam 1968–1969, Duc Thanh District, Phuoc Tuy Province
Served in US Army 1966–2004
Retired as a Major General (O-8)

Lyons, Robert G. Jr.
Lieutenant Junior Grade (O-2), promoted to Lieutenant (O-3), VF-53 "Iron Angels", USS Ticonderoga and USS Hancock
Served in Vietnam 1965–1967, flew F-8 Crusader, 192 Combat missions, 20 plus combat decorations including the Distinguished Flying Cross
Served on active duty in the Navy April 1963 to June 1968, US Navy Reserves until March 1979.
Retired from the Navy as a Lieutenant Commander (O-4) in March 1979

Mather, Keith
Vietnam War resistor
Private Recruit (E-1), MOS—11B10 Infantryman, M-14 (Marksmanship Badge)/ Sharpshooter Badge W/Machine gun bar

Time in service 17 years, 2 months
USA Correctional activity Fort Riley, KS

McCandless, Gene
Private First Class (E-2); promoted to Lance
Corporal (E-3) and Corporal (E-4), MOS—
1833 Amtrac crewman/crew chief, 3rd
Amtrac Battalion, 1st Marine Division, USMC
Served in Vietnam 1968–1969
Served in the US Marine Corps 1967–1971
After Vietnam garrison duty in Camp
Pendleton, California
Rank on separation Sergeant (E-5)

McCardle, Leo P.
Specialist 4 (E-4) First tour (1966–67),
Specialist 5 (E-5) Second Tour (1969-
69), MOS—51L20 (Refrigeration & Air
Conditioning Repair), 526th Engineer
Detachment (1966), 628th Maintenance
Company (1966–67), 562nd General Support
& 204th Quartermaster Company (1968),
597th Transportation Company & attached
to 563rd Transportation Company (1968-
69), US Army
Served in Vietnam 1966–69, Pleiku, Central
Highlands, Quy Nhon area
Served in the US Army 1962–70, Reserves
1972–77
Discharged as a Staff Sergeant (E-6) 1977

McKown, Bill
Lieutenant Junior Grade (02), MOS—
Gunnery and Fire Control Officer –
Navigator, Destroyer Squadron 9, US Navy.
Served in Vietnam July 1967–September
1969, Tonkin Gulf, coastal waters North and
South Vietnam, inland waterways South
Vietnam.
Served three years in total

McNicholas, William (Bill)
Ensign (0-1), Lieutenant (0-3), USS Ingersoll
(DD-652) USS Somers (DDG-34), US Navy
Served in Vietnam December 1966–April
1967, April 1969-March 1970, Gunnery/Fire
Control Officer, USS Ingersoll (DD-652) and
Officer in Charge Naval Support Activity
My Tho, Republic of Vietnam; Senior Naval
Advisor Naval Advisory Group, My Tho,
Republic of Vietnam
Served in the US Navy August 1960–April
1970, US Naval Reserves April 1970–August
1992. Retired as Captain (0-6)

Milburn III, Harry Allen
Specialist 4 (E-4), MOS—13E20 Field Artillery
Operations and Intelligence Specialist, 'A'
Battery, 6th Battalion, 29th Artillery, 4th

Infantry Division, US Army.
Drafted for two years; Ft. Knox, KY; Ft. Sill,
OK.
Served in Vietnam January 1968–August
1969, II Corps, Pleiku, Dak To, Polei Kleng, An
Khe and surrounding areas.
Army Commendation Medal with "V" device
(for valorous conduct in direct contact with
the enemy).

Moragne, David Clifford, Jr.
Corporal (E-4), Sergeant (E-5); MOS—8652
(Reconnaissance Man, Parachute Qualified);
3rd Force Reconnaissance Company, 3rd
Reconnaissance Battalion, 3rd Marine
Division, USMC
Served in Vietnam April 1967–May 1968;
Point, Team 4-2; Team Leader, Teams 2-1 &
2-2; Phu Bai, Dong Ha, Con Thien, Khe Sahn,
I Corps/DMZ
Served in the USMC 1966–1970

Moss, Lawrence S.
Specialist 4 (E-4), MOS—11C (Indirect Fire
Infantryman), D Company, 5th Battalion,
46th Infantry Regiment, 198th Light Infantry
Brigade, Americal Division, US Army
Served in Vietnam September 1968–
September 1969, Chu Lai, Saigon. 2 years
in Army.
Served in the US Army March 27, 1968–
February 6, 1970
Discharged as a Sergeant (E-5)

Mullin, Ray
Petty Officer Second Class (E-5), MOS - 3122
(Ship's Serviceman) & 9548 (Corrections
Specialist), USS Sperry (AS-12), USS Coral
Sea (CVA-43), USS Reasoner (FF-1063)
Served in Vietnam 1972–1973, Tonkin Gulf
Served in US Navy 1970–1979

Neal, Jerry
Sergeant (E-5), MOS 11D (Armor
Reconnaissance Specialist), D Troop, 7th
Squadron, 17th Air Cavalry, 1st Aviation
Brigade
Served in Vietnam November 1968–
November 1969, Pleiku, Kontum, Ban Me
Thuot, An Khe
Served in the US Army 1968–1970
Left as Sergeant (E-5)
Nigh, Sam
USAF

O'Hare-Palmer, Kate
Second Lieutenant (0-1)/First Lieutenant
(0-2), MOS—3443 Operating Room Nurse,
44th Medical Brigade, 2nd Surgical Hospital

and 312th Evacuation Hospital, Army Nurse
Corps
Served in Vietnam 1968–69, Chu Lai, Lai
Khe, participated in five of 17 campaigns
during the tour

Parsons, Jack "Gunny"
Corporal (E-4), MOS—0311 Infantry, G
Company, 2nd Battalion, 7th Marine
Regiment, 1st Marine Division, USMC
Served in Vietnam June 1967–August 1968
Served in the USMC

Perschau, Richard
Senior flight surgeon, US Air Force
Served in Vietnam 1970–71

Petty, Ron
Specialist 5 (E-5), US Army

Rallojay, Francisco "Tony"
Quartermaster, Navigation Division, US Navy

Riley, Denny
Airman First Class (E-4), MOS—20450
Air intelligence Specialist, 388th Tactical
Fighter Wing, USAF
February 1966 to February 1967, Target
Room, Koran Royal Thai Air Base
Four years active duty, August 5, 1963 to
August 4, 1967

Robbins, Jonathan
First Lieutenant (0-2), MOS—2136
(Nontactical Unit Officer),
HHD 27th Transportation Battalion, US
Army
Served in Vietnam August 1968–August
1969, northern II Corps, Phu Tai, Binh Dinh
Province

Rogers, Robert
Seaman (E-2), OI Division—Radar, USS
Mount McKinley, US Navy
Passed the exam for Radarman Third
Class (E-4) and spent approximately three
months stateside; Radarman Third Class
(E-4), OI Division, USS Nueces. Volunteered
for Operation Sea Lords and was stationed
in IV Corps, Mekong Delta. Promoted to
Radarman Second Class (E-5) and returned
briefly to the US. Then stationed to USS
Coral Sea and transferred to USS Albert
David and returned to Vietnam
Served approximately 34 months in the
Vietnam Theater out of 45 months
Joined the Navy with a 48-month
commitment but left two months early to
return to school

Ruiz, Bobby
Sergeant (E-5), MOS 11B Infantryman, 101st Company, 1st Battalion, 3rd Brigade, 101st Airborne Division, US Army
Served in Vietnam 1967–68
Served in the US Army 1966–68
Discharged as Corporal (E-4)

Sanders, Dave
Sergeant (E-5), MOS—5525 Base Engineer, Civil Engineer, 377th Civil Engineer Squadron, 377th Mission Support Group, USAF
Served May 1967–May 1968, Tan Son Nhut Air Base
Served in the USAF from 1966 to 1970

Slattengren, Michael "Slatts"
Petty Officer Third Class (E4), Petty Officer Second Class (E5), MOS—8319 (Aviation Electrician's Mate), Patrol Squadron 22 (VP22) The Blue Geese, US Navy
Served in Vietnam: First deployment August 1968–January 1969, Vietnam
Second deployment November 1969–April 1970, Sangley Pt, Philippines, Cam Ranh Bay, U-Tapao, Thailand
Served in the US Navy April 1966–April 1970
Left the service as an Aviation Electrician's Mate (E-5)

Thuy Hanh
Second Lieutenant (Thiều úy), Vietnamese Airborne Division, Army of the Republic of Vietnam (Lục quân Việt Nam Cộng hòa)
Served 1974–1975

Thuy Luu
Vietnamese refugee/immigrant

Torney, Richard Geoffrey
Specialist 4 (E-4), MOS—95B20 (Military Police), Co B, 504th Military Police, US Army
Served in Vietnam November 15, 1968–November 15, 1969, Pleiku
Drafted January 10, 1968; discharged November 15, 1969

Tuyet Bach Doam
Vietnamese refugee/immigrant. Arrived in 1980 from Hanoi

Velez, Jose
Sergeant (E-5), MP, US Army
Served in US Army 1962–65

Valinoti, James
Specialist 5 (E-5), MOS—91C Senior Battalion Medic, 1st Battalion, 30th Artillery, 1st Cavalry Division, US Army
Served in Vietnam October 1968–October 1969, Camp Evans, I Corps, Long Bien, Tay Ninh, Quan Loi, Phouc Vihn, Lai Khe, Danang, Saigon, Fort Polk, LA; Fort Sam Houston, TX; Presidio, CA.
Served in the US Army April 1967–June 1970

Vantrease, Mark
Specialist 4 (E-4), Helicopter Crew Chief, US Army

Vinnoukun, Chandara
Corporal (Niey aek), 1st Platoon, 1st Company, 4th Bn., 1st Parachute Bde., FARK
Served in FARK May 1970–April 17, 1975

Walton, Darren
Corporal (E-4), Marine Division, USMC
Served in Vietnam 1968–1970
Danang, I Corps

Weber, Michael
Specialist 4 (E-4), MOS—91B10 (Medical NCO), 1st Medical Company, 18th Surgical Hospital and 71st Evacuation Hospital, US Army.
Served in Vietnam August 1967–October 1968, Pleiku, An Khe, Central Highlands

Wells, Jack
First Lieutenant, (O-2), MOS—0802 Feild Artillery Officer, A Company & B Company, 1st Battalion, 7th Marines; 3rd Bn. 11th Marines and finished at H Battery, 3rd Bn. 11th Marines
Served in Vietnam July 25, 1968–August 1969, I Corps, around Danang
Retired as a Lieutenant Colonel (O-5)
Served 1967–1992

Weston, Mark
Private First Class (E-3), MOS—11C10 Mortars/Recon-LRRPS/Ranger (Long Range Reconnaissance Patrol), E Company, 2/501st, 101st Airborne Division, US Army
Served in the Republic of Vietnam January–June 1969, I Corps, Ashau Valley; wounded at 'Hamburger Hill'
Enlisted in October 1968; Honorably Discharged October 1974.
Rank on discharge Sergeant (E-5)

Whalon, Pete
Specialist (E4), MOS—72B, Teletype Operator, 60th Signal Group, US Army.
Served in Vietnam May 1969 to March 1971, Saigon, Long Binh.

Served a total of 31 months in the US Army

Whindleton Jr., Zebedee
Combat Medic, 1st Air Cavalry, US Army
Served in Vietnam 1966–1967

Wong, Helen
First Lieutenant (O-2), MOS—3416 Occupational Therapist, Army Medical Department, US Army
Served with Vietnam veterans 1973–1975, Ft. Sam Houston, Texas and Ft. Lewis, Washington
Served 1973–1995, mainly in the Army Reserves
Retired as Lieutenant Colonel (O-5)

Yahiro, Jerry
Second Lieutenant (O-1), MOS—1542 Mortar Platoon Leader, 3rd Battalion, 12th Infantry Regiment, 4th Infantry Division, US Army
Served in Vietnam June 1967–December 1967, Central Highlands
Served in the US Army 1966–1969
Honorably Discharged as a Captain (O-3)

Yepez, Larry
Private First Class (E-2), MOS—0311 Rifleman, E Company, 2nd Battalion, 9th Marines, 3rd Marine Division, USMC
Served in Vietnam May 1967–July30, 1967 (wounded July 29, 1967), Operation Kingfisher
Served in the USMC 1966–1969

LIST OF WAR OBJECTS

P.6. *Handbook for US Forces in Vietnam. This handbook was distributed to Army, Air Force and US Marine Corps personnel and highlighted subjects such as Viet Cong military organization, tactics and techniques and personal hygiene tips.*

P.8. *The Vietnamese text on the reverse of the Ace of Spades "Death" card translates as "Death awaits Viet Cong cadres. Return [to the south Vietnamese side] rather than being killed." Their use does not seem to have been widespread—primarily by Special Forces units—and opinion on their effect ranges from claims that some Viet Cong troops would flee simply at the sight of them to claims that the VC were largely unaware of their use. It would seem that their primary psychological impact was as a morale boost for those US troops that used them.*

P.10. *Vietnam era medals. Top row right to left—Distinguished Flying Cross, Air Medal, Purple Heart, National Defense Service Medal. Bottom row left to right—Antarctica Service Medal, Vietnam Service Medal, Vietnam Gallantry Cross, Vietnam Campaign Medal, Navy Expert Pistol Medal.*

P.29. *Draft Induction Notice for William Joseph Green ordering him to attend his local board on August 16, 1967. Between 1964 and 1973 the US military drafted some 2.2 million men. The effect of the draft was discriminatory, with those from poor or working-class backgrounds significantly more likely to find themselves serving in combat and those from more affluent socio-economic backgrounds more likely to be granted deferments.*

P.38. *During the Vietnam War, some 62 per cent of US Army and Marine Corps combat wounds were inflicted by fragments.*

P.58. *An improvised grenade used by the Viet Cong forces. The guerrilla forces recycled almost anything they could lay their hands on and US troops were reminded not to discard items such as cans from their MCI rations that their enemies would swiftly turn into something like this.*

P.66. *This leaflet, circulated in 1969, is typical of the literature produced by the National Liberation Front forces seeking to portray the war as unjust and to suggest that ordinary GIs were being betrayed by their government. There is little substantive evidence of any US military personnel defecting to the communist side during the war.*

P.67. *The "Chieu Hoi," or "Open Arms," program was designed to encourage NLF personnel to "rally" to the government side. Although often touted as a success, with some 160,000 deserters and more than 11,000 weapons turned in to the government forces, critics said it did little more than allow NLF soldiers to rest, receive medical treatment and decent quality food before returning to their comrades. Evidence suggest that some individuals may have changed side as many as five times.*

P.71. *One of the nudes that were a feature of the popular Grunt Free Press produced in country as an alternative to official military publications such as Stars and Stripes. It's irreverent take on the war proved popular and circulation climbed to some 30,000.*

P.74. *This 1968 Thanksgiving letter template sent home from Thu Thua was apparently provided by two Red Cross girls visiting this soldier's unit and demonstrates a wry sense of humour. American Red Cross personnel worked in Vietnam and other parts of South East Asia, peaking at nearly 500 in 1968-69. Military commanders called the services of the Red Cross "indispensable" in their efforts to maintain morale.*

P.75. *The subscription page from an edition of Grunt Free Press—at $5 for 12 issues a bargain by any measure! From 1969, the magazine became more overtly Peacenik and critical in its outlook and each issue contained a double-page centrefold of an Asian girl.*

P.79. *Shell casing from a 105mm shell manufactured in 1968. The "LS-" code indicates it was manufactured at the Lone Star Ammunition Plant in Texarkana, TX.*

P.80. *The Christmas, or possibly Thanksgiving, 1969 menu for C Company, 173rd Airborne Brigade as served at the unit's base, LZ English in Bong Son, Binh Dinh Province. Troops in the field would have dined on rather simpler fare.*

P.96. *This less than flattering portrait of a lifer made a comeback in the December 1970 issue of Grunt Free Press on page 7 as part of a piece on "What is a Lifer."*

P.97. *Hardtack biscuits (sometimes referred to as "John Wayne cookies") from the B-2 unit of Meal, Combat, Individual ration pack, more commonly referred to by servicemen simply as C-Rations. These biscuits came in a can with an individual portion of canned cheese included. This came with Pimentos or Caraway Seeds or as plain cheddar cheese. In this case with the attractive name of "Cheddar Cheese Spread, Type II" including such mouth-watering ingredients as "Plastic cream" and "Locust Bean Gum."*

P.108. *A magazine from an AK-47 assault rifle, one of the weapons used by North Vietnamese troops and some Viet Cong forces, although the AK-47 was rarer among the more poorly equipped VC than is often believed. The US M-16 fired a lighter 5.56mm round and was generally more accurate than the AK-47. The heavier 7.62mm round and its operating system gave the AK-47 a distinctive sound.*

P.109. *A letter home to a loved one written from the field on the inside of a ration pack carton. It describes how the soldier's unit has been pursuing a group of VC for the past three days and this letter seems to have been written in a few snatched moments as dark was falling at the end of a long, hard day.*

P.110. *The AN/URC-64 SAR (Search and Rescue) radio was the US Air Force's most commonly used survival radio during the Vietnam War.*

P.122. *A can of Grape Jam manufactured by Baumer Foods of New Orleans from the B-3 "Bread" unit of an MCI ration pack. The jam also came in Apple, Mixed Berry, Seedless Blackberry, Mixed Fruit and Strawberry flavours.*

P.147. *An M26A1 fragmentation grenade was the grenade most commonly used by US forces in Vietnam. The M61 variant was identical to the M26A1 apart from an extra twist of wire attached to the lever for safety and known as the "jungle clip."*

P.156. *An aluminium water canteen painted olive drab green as used by the PAVN (People's Army of Viet Nam) forces, known by US troops as the NVA (North*

Vietnamese Army). This canteen was based on the communist Chinese PLA Type 50 or Type 51 canteen and supplied to the North Vietnamese in large numbers.

P.165 A standard 7-round magazine for the .45 caliber automatic pistol, M1911A1 which, despite having been adopted by the US Army prior to WWI, remained the primary sidearm of US and ARVN forces throughout the Vietnam War. Robust, reliable and with good stopping power, the M1911A1 remains in service with some US units to this day, despite the military having officially adopted the Beretta M9 in the mid-1980s.

P.169. A four-pack of Winston cigarettes from an MCI ration pack. The sealed accessory pack also contained a pack of toilet paper, a sachet of instant coffee, a sachet of powdered cream, a sachet of sugar, a 4-gram packet of salt, a two-pack of Chiclets chewing gum as well as a book of 20 matches "designed especially for damp climates."

P.187. Ace of Spades "Death" card left by some US troops on the bodies of enemies they killed as a warning or a threat designed to intimidate their opponents.

P.190. A can of fruit cake from the Dessert Unit of an MCI ration pack. The Dessert or "D-" unit of the MCI came in three varieties. D-1 was fruit which could be halved apricots, sliced peaches, quartered pears, fruit cocktail or the D-1A variant—Apple sauce. D-2 was cake which included Pound Cake, Fruit cake or Cinnamon Nut Roll or the D-2A can of Date Pudding or Orange Nut Roll. D-3 was white bread that came as a solid cylindrical piece wrapped in waxed paper.

P.212. This leaflet is representative of a huge range of literature—leaflets in particular—produced by the NLF during the Vietnam War aimed at US troops and designed to undermine their will to fight and increase resentment towards the war. The language is very much soviet-style, communist rhetoric and probably had very little impact on your average Grunt. Of more significance as the war progressed was the increasingly vocal and hostile reaction to the war back in the United States.